THE ART AND TECHNIQUE OF MATCHMOVING

Solutions Artist

Erica Hornu

Taylor & Francis Group

LONDON AND NEW YORK

First published 2010 by Focal Press

Published 2016 by Routledge
2 Park Square, Milton Park, Abingdon, Oxon OX14 4RN
711 Third Avenue, New York, NY 10017

Routledge is an imprint of the Taylor & Francis Group, an informa business

Library of Congress Cataloging-in-Publication Data
Application submitted

British Library Cataloguing-in-Publication Data
A catalogue record for this book is available from the British Library.

ISBN: 978-0-240-81230-4 (pbk)
ISBN: 978-0-080-96113-2 (ebk)

Dedication

To my parents, without whom this whole darn wacky adventure never would've gotten off the ground.

CONTENTS

Acknowledgement ... ix
Forword .. xi

Introduction What Is Matchmove, Anyway? **xiii**
"So, Wait a Minute What Do You Do, Exactly?" xiii

Chapter 1 Types of Matchmoves and Their Uses 1
What Does a Typical Matchmove Task Look Like in the First Place? ... 1
Planning ... 1
Gathering Data ... 2
Building Assets ... 3
Attacking the Shot ... 4
What the Computer Thinks About 5
What Kinds of Matchmove Tasks Are There? 8
What Kind of Matchmover Are You? 14

**Chapter 2 How Movies Get Made: What You Need to Know
About It, and Why** .. **15**
Parts of the Film Camera and How They Work 16
Information Gathering On Set 26
Communication ... 33
Back at the Office: Information Integration 33
First Steps: Setting Up Your Scene 37

**Chapter 3 Use What You Know: Common Sense and
the Mystery Plate** .. **45**
You Know More Than You Think You Do 45
Where to Start? .. 46
The Web Is Your Friend 47
Google Maps ... 48
Google Earth .. 50
Building the Set ... 52
Creating the Camera 58
Lining Up the Shot ... 61

Chapter 4 So. . .You Have a Video Plate 69
It's a Brave New Digital World .. 69
What Makes Video Plates So Different? 71
What to Do? ... 73
And Now, the Results .. 74

Chapter 5 Camera Moves Considered 79
Lockoff Shots .. 79
Pan and Tilt Shots ... 82
Dolly (Truck) and Tracking Shots 88
Crane Shots .. 88
Steadicam and Handheld Shots 89
Focus Pulls and Zooms ... 90

Chapter 6 Real-Life Shot: Lockoff Camera 93
Determine What Needs to Be Done 93
Review Your Information .. 94
Set Up Your Shot .. 96
Does It Make Sense? ... 113

Chapter 7 Real-Life Shot: Focus Pull 117
Determine What Needs to Be Done 117
Review Your Information ... 119
Color-Correct Your Plates .. 119
Set Up the Scene .. 120
2D Track ... 121
Survey Constraints .. 122
3D Solve ... 123
Does It Make Sense? .. 127
Evaluation ... 127

Chapter 8 Real-Life Shot: Camera Tilt 131
Determine What Needs to Be Done 131
Review Your Information ... 132
Set Up Your Shot .. 133
2D Track ... 133
Survey Constraints .. 140
3D Solve ... 142
Handoff .. 147

Adding Guestimate Geometry .. 151
Evaluation .. 156

Chapter 9 Real-Life Shot: Handheld Camera 159
Determine What Needs to Be Done 160
Review the Information ... 162
Set Up the Shot ... 163
2D Tracking .. 164
3D Solve .. 168
Refining the Solution Channels 172
One-Point Solve ... 183

Chapter 10 Character Rotomation Considered 187
First Off: What's Roto for? .. 189
How Do You Start? .. 190
Great, I Got a Rig. And I'm Scared 192
Rotomation First Pass: Animating Large to Small 193
Rotamating Dos and Donts ... 198
Which Channels to Key and When to Key Them 200
Finding the Next Set of Keyframes 202
Set, Delete, Set .. 203

Chapter 11 Know Your Character Rig 205
Embrace Your Inner Rotomator 205
Getting to Know You ... 205
Let's Meet Our Rig ... 206
Control: Master (World) ... 213
Control: Body ... 215
Control: COG (Center of Gravity) 216
Control: Hips .. 218
Control: Spine ... 219
Control: Neck ... 224
Control: Head ... 226
Control: Shoulders ... 230
Control: Arms ... 231
Control: Elbow .. 236
Control: Legs .. 239
Control: Leg, Pivot, and Roll ... 242
Control: Knees .. 246

Control: Fingers ... 247
You're Almost Ready to Start 257
Next Up ... 258

Chapter 12 Real-Life Shot: Character and Object Rotomation 259
Determine What Needs to Be Done 260
Part 1: Character Rotomation 261
Breaking Down the Clip .. 263
Hip Close Up .. 271
First-Pass Rotomation: Walking 274
First-Pass Rotomation: Sitting 281
Second-Pass Rotomation .. 284
Shot Part 2: Cup Rotomation 285
Constraining the Prop Cup ... 288
Animating Constraints On and Off 292
Animating the Cup Trajectory 293
Keeping Track of Cylindrical Spinning 294
First Pass Over the Pool .. 295
Finishing Up .. 300

Index .. 301

Thanks

In writing this book, I've spent a lot of time thinking about all the advice I've gotten over the years — not just about matchmove, but about the whole field of visual effects. In fact, I've worked with amazing people, all of whom — to a person — have been willing, even eager, to help someone with a question, a sticky problem, or something they might just be curious about. I tell my students that working in this industry is like going to grad school every day, and so it is — in a good way.

I owe an enormous debt to all my former colleagues at Sony Pictures Imageworks; in my six years there, I learned more about the filmmaking process than I could have any where else, save perhaps — *perhaps* — an actual set. The depth and breadth of the scope of talent there is unique, and I continue to miss it.

In particular, I must thank Charlie Clavadetscher, who recognized a potential matchmover when he saw one, plucked me from UCLA Extension obscurity and made a VFX artist out of me. I would know nothing if it weren't for Charlie.

Joanie Karnowski, Matchmove Lead extraordinaire, has been my sounding board for many years and was invaluable in her advice, commentary, and listening (and listening . . . and *listening* . . .) during this process. Not only does Joanie have the matchmove chops, the people skills, and the necessary sense of humor and kindness to be the best lead *ever*, she can joke about obscure sixteenth-century Swiss mathematicians with the best of 'em. Yay Joanie! Thanks so much!

Eric Peterson has helped me on so many shots in so many ways over the years that I can't even begin to enumerate them. Anytime I encourage you to talk to your on-set team, it's Eric I'm thinking of. No matter what shot I was assigned, or how long ago it had been shot, Eric could pull out a notebook complete with sketches, Polaroids, notes, and some funny story about the sequence. Eric has been extremely generous with his time in reviewing this manuscript and in providing some tales from the front lines. All that, and an amazing photographer as well! Thanks so much, Eric!

VFX Supervisor Jake Morrison provided amusing tales of effects shots gone wrong, along with much-needed and appreciated technical advice. Jake was one of my first sups at a shop that no longer exists; those kinds of things tend to bond groups of folks, and Jake has been a good friend and advisor ever since. I appreciate the help even more since he's been booked solid the entire time I've been working on this manuscript. Thanks so much, Jake!

A book like this is nothing without example files and footage, and I could not have created either without the help of Theo Waddell, cameraman, grip, and sounding board extraordinaire, and Yatin Parkhani, the coolest, most laid back actor/producer I've ever met. Theo and Ya gave so freely of their time, talent, and good humor (not to mention heavy lifting skills), on a day with Santa Ana winds, 100+ degree heat, and an only *slightly* organized shoot. To say they were patient, gracious, and professional would be quite an understatement. Theo and Yatin, I can't thank you guys enough!

I could not have completed the final chapters of this book without the Andy character rig, and so I can't thank creator John Doublestein enough for his kind permission in using Andy. Andy is a fantastic rig, one of the best I've ever worked with. Thanks so much John! Paula Combs of The Pixel Farm has been most gracious and accommodating in granting me evaluation licenses for PF Track. Thanks so much Paula — and it was great to meet you in person!

Joshua Grow, who in this tiny industry is of course a friend of several of my friends, worked slavishly on a character rig for me for weeks. Thanks so much, Joshua!

Andrew Duncan, a friend since college, stepped up to the plate when I needed some illustrations, and fine ones they are. I asked for them on insanely short notice, and Andrew really delivered for me. Thanks so much, Andrew!

I absolutely have to thank my editors, Dennis McGonagle, Carlin Reagan, and Melinda Rankin, and everyone else at Focal Press for their extreme patience with me through this process. I'm sure there have been more difficult and confused authors than I over the years — well, I hope so, anyway — but Dennis and Carlin have been really great to work with, and I appreciate their understanding and fortitude more than they know!

I couldn't have completed this book without the assistance of my parents, Chuck and Gloria. First of all, my dad took me to see *Star Wars* that one time, so this whole crazy visual effects career thing is *his* fault. More to the point, their generosity and patience during the last few months of writing have made this book possible. Now, yes, I promise I will stop, guys. I swear. No, really.

I *would* thank my cat Harper, but she's been nothing but trouble and is driving me nuts. As I write this, she's curled up next to me, asleep and adorable. Thanks, Harper!

Foreword

Just a couple of days ago, a college friend of mine shared a link demonstrating the use of some new digital Canon camera backs in place of Panavision film rigs for shooting driving plates on the television show *24*, with the comment that the "producers of the show are all too happy moving to Canon equipment, away from Panavision. Panny's long hold on the motion picture biz may be slipping as tech goes increasingly digital, allowing other camera [manufacturers] a chance at the trough. Cheapest, most reliable solution wins."

Before I wrote this book, I would have laughed. In my entire film – and television, for that matter – career, I've worked only with material originally shot on 35 mm film. Sure, in TV it's converted to video and has 3:2 pulldown and all that stuff, but it still originated on Kodak stock.

Occasionally I've gotten some weird one-off plate shot on a digital still camera for use in modeling a chair or something like that, but never, until this book and a job I had about a month ago, have I ever done a real shot with plates originating in a digital format.

Let me tell you something: I've been *really spoiled*. As of this writing, I've found that there aren't really hard and fast standards for video filmbacks. As you'll see in later chapters, there isn't really any standardized way to record a focal length when shooting with a digital camera, as there is in 35mm film photography. There is still quite a bit of confusion as to how exactly the image is captured on a digital chip; often, I found, much to my surprise, the images are squeezed – a situation less than desirable for matchmoving purposes.

Video plates take some getting used to, let's just say. Take the Canon example I just mentioned. The chips in the cameras mentioned are almost – but not quite – the same size, in inches, as a VistaVision plate, a very large film format used mostly for VFX work. Every piece of matchmove software has a preset for Vista – useless for this camera. It's just not the same size. So, will there be a new preset for that particular camera? Or will the camera manufacturers adapt? We shall see, but for now, we matchmovers are reduced to doing *actual math*.

The DPs in the clip go on to talk about the possibility of new prime lenses for their purposes – but what will they be? The difference in the chip size messes around with the relationship of the lens to the image (technical term). Now what?

It's a brave new digital world, and somehow I didn't notice, even though I do everything on an iPhone named – you guessed it – JackBauer.

I do not know Jack's chip size.

In the end, new standards for chip sizes will be agreed to, and new software will come with presets for whichever digital cameras win the battle for filmmaking supremacy over the next few years. It's an interesting time, actually, similar to the early years of motion pictures and all the different film gauges and formats that eventually evolved into the handful of standard formats we have today.

Until then, we matchmovers will just have to think a little harder about what we're doing when we set up a camera. Because everything else, from files crashing Maya to character animator's work getting deleted, two days of rain in a row, and who knows what else is matchmove's fault anyway, why not throw the evolution of an entire new generation of standards and practices in there too? We can handle it. This. Is. MATCHMOVE!

Los Angeles, February 2010

INTRODUCTION: WHAT IS MATCHMOVE, ANYWAY?

"So, Wait a Minute What Do You Do, Exactly?"

Don't feel badly if you're asking this question even as you've picked up this book. I was at a work party just a few months ago, at a well-respected, Oscar-winning visual effects house, and was asked that same question – by a character animator!

Whether you call it **camera tracking**, camera matching, or any other name, matchmove is definitely a mystery to most people – even some of the people you'll work for. Even I didn't know what it was when I took a course in it some years ago. Part of the reason for this is that if done right, you'll never notice a matchmove . . . you'll only see it when it's badly done.

So what *is* matchmove? In a nutshell, the matchmover takes information from a real-life set, where the actors, director, and all the other crew members who make movies shoot a film, and recreates that camera, including the focal length of the lens, the height, the tilt, and the position and motion relative to

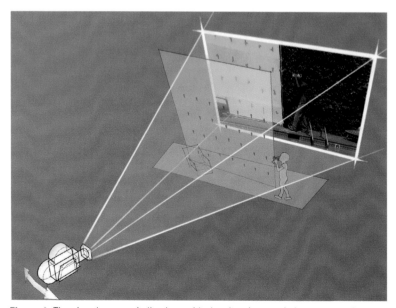

Figure 1 The virtual camera is lined up with the virtual set and characters at the beginning of the shot . . .

Camera Tracking

 The process of recreating a live camera move in the virtual CG (computer-generated) world. Often used interchangeably with matchmove, though the former implies the use of automated software and the latter implies a more hands-on approach.

Camera Tracking Software

 Software developed specifically to derive 3D information from 2D plates, using the relative motion in the plate as the basis for solving the resulting camera move.

Rendering

 The process of "photographing" the CG environment and creating 2D images to use for integration into the live action plate. Think of filming a scene and getting your film developed in one step.

Plate

The live action film from set, digitized for use in the CG environment.

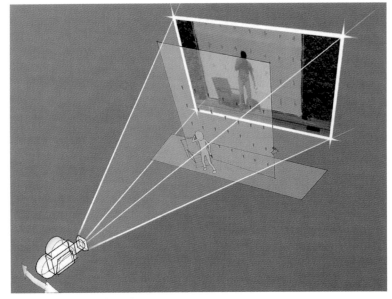

Figure 2 . . . and at the end . . .

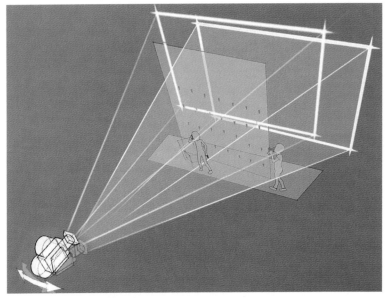

Figure 3 . . . creating an animated CG camera that matches all the properties of the real-life camera: lens, focal length, position, and movement relative to the subject.

the subject, in the CG environment. Then, when the CG world is created, it is "photographed," or rendered, with the virtual CG twin of the real-life camera: the same lens, the same position,

and the same movement, if there was any. In that way, the CG elements created in the virtual world will have the same perspective, the same depth, and the same relationships to the moving camera that the live actors and set pieces had to the live camera, allowing them to be seamlessly integrated into the live **plate** for the final shot.

After **3D camera solutions** have been created and approved, there are other elements that might need to be matched. If a full CG character interacts with a live actor, for example, a CG representation of that actor, or **CG puppet**, will need to be added to the virtual scene and its movements animated to match the live actor's movements. Or perhaps **CG effects** will be applied to a real-life actor – maybe he is covered with living goo, for example. In some cases, heads, arms, or other parts of the body may be replaced with CG elements; a very close match of the actor will be needed for the CG elements to blend seamlessly with the live action plate. Animated CG puppets are also needed to cast shadows and reflections on CG elements added into a scene.

As you can see, this can become quite involved! How does it get all done?

There are several **automated camera solvers** available on the market, such as Maya Live and MatchMover2010, Boujou, and PF Track, which can be an enormous help in a production of any size. Many facilities also have proprietary software used for matchmove tasks. Frequently, however, automated solvers don't get the entire job done: a camera solution from the solver can be close but not dead on, or the automated solver might not be able to solve the camera move at all. Many times, though, an automated solve can get you 80% to 90% of the way there.

In order to get that last 10–20%, it's crucial to be familiar with all the aspects of matchmoving, from the technical functions of a camera, to on-set data collection and the manipulation of that data in the virtual environment. In addition, a matchmover has to be *creative*. He or she should know how to attack a shot when little or no information is available from set. He or she should be familiar enough with lenses and cameras to be able to spot mistakes in the data from set and account for them. He or she should be able to do some detective work, and to use *all* the tools at his or her disposal, including researching on the Internet. Most of all, a matchmover needs to use good old *common sense*. A camera solution from an automated system might look okay when seen from the camera view, but a good matchmover knows how to make sure the solution is good from *all angles*. In other words, a matchmover must constantly ask him- or herself, "Can a camera really do that?" It's common

3D Camera Solution (Solve)

 The animation curves and focal length that result once the automated software has done its job. The term "solution" is used because the software crunches an incredible volume of numbers and equations.

CG Puppet (Rig)

 A CG character representing a real-life human, used for matchmove purposes. Can be very basic or an exact scan of a specific actor. Rigs representing specific characters or real-life actors are referred to by name: either the actor's or character's name, or sometimes a funny nickname that comes up at some point in production and sticks. Generic rigs used for stunt people or other unnamed people are usually referred to as some variation of "guy."

CG Effects Animation/ Simulation

 Of course matchmove is part of the overall visual effects pipeline, but Effects Animation itself refers to procedural effects, like sand, water, crowds, and other types of animation that are at least partially controlled by mathematical equations.

sense, when added to the rest of the knowledge and information at the matchmover's disposal, that makes the difference in any situation.

With this book, I hope to instill not only the technical skills necessary for successful manual matchmoving, but to also foster the curious, creative spirit that makes a hopeless-looking matchmove a successful one. I've included tips and tricks for seemingly impossible matchmove situations, from scouring the Internet for photographs of an actor's hands so that an accurate model can be built to using basic architectural knowledge in creating a quick virtual set. A creative matchmover, using common sense, can't be beat, and I hope to show you how to think outside the matchmove box.

TYPES OF MATCHMOVES AND THEIR USES

What Does a Typical Matchmove Task Look Like in the First Place?

Before we go any further, you'd probably like a basic understanding of what exactly goes on in the matchmoving process, right? You saw a very basic illustration of the **CG environment** in the introduction, but how does all that information get into the computer, and then what the heck do you do with it?

In the very big scheme of things, the matchmoving process goes like this:
- Planning
- Gathering data on set
- Building assets
- Reviewing data
- Attacking the shot
- Passing the shot on to other artists
 We'll also look at:
- How the computer thinks about all of this stuff

Planning

The first step in the ideal matchmove process is planning, well before any filming ever occurs. The matchmover going to set will read the script, look at concept art and preproduction digital tests (called "**Look Dev**"), and generally familiarize him- or herself with the information needed to recreate the locations, props, and cameras in the CG environment back at the office after filming. With a plan in hand, the matchmover goes to location.

Show

Any production you might work on. Though most people think of a show as a television show, "show" can refer to a film, TV show, commercial, or any other project. "What show are you on?" is a typical question.

Look Dev

Look Development. At the beginning of the show, various departments work together with the director to determine the look of the effects in the film.

Sup

(pronounced "supe") Supervisor.

Lead

The first rung of the sup ladder, a Lead is in charge of his or her department on a particular show, for example, Matchmove Lead for "Awesome Movie III."

DOI: 10.1016/B978-0-240-81230-4.00001-4

1

Survey Head

Device used by engineers and VFX artists to locate a designated point in 3D space. The device utilizes a laser to "ping" a point in space (for example, the edge of a building on set) and calculates its position using polar coordinates. These 3D locations can then be used to build accurate CG models of the set or location. Which features of the location are important enough to be pinged is determined by the operator who can then select specific survey points most pertinent to the matchmove process.

LIDAR (Light Detection And Ranging)

An automated version of a survey head that scans its entire environment using a laser, returning many more 3D locations than a single operator with a survey head. Produces much more detailed representations of a set or location, but the result is often too heavy to work with without modification.

3D Body Scan

A method used to create virtual models of actual people, using lasers to scan minute details of the person's form, which is later used to create a virtual double for him or her.

Gathering Data

On location, a variety of tools, from a simple sketchbook and measuring tape to advanced equipment like laser-equipped **survey heads** and **LIDAR**, are used to **survey** the location so that it can be recreated in the CG environment later on. The on-set team takes detailed measurements of the location or set, the buildings, furniture, trees, landscape features, light poles, chairs, cars, dishes, carpets – basically, anything that *can* be measured and *holds still long enough* to be measured, the on-set matchmove team will try to measure or otherwise document its shape, size, and any distinguishing details that might help in camera tracking back at the office, just as any site surveyor would. They'll try to photograph everything possible on location for reference later. They'll record details about the camera for every take – the lens, the **focal length**, the focus distance, distance to subject, height, tilt, roll, and anything else that can possibly be written down in the time there is. Basically, they try to get any and all information necessary to build a replica of the real-life

Figure 1-1 Shooting on set.

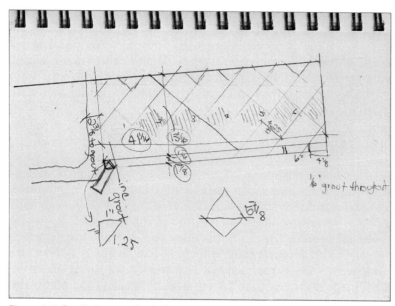

Figure 1-2 Detailed survey sketch from set.

set in the computer back at the office. The more detail recorded, the better.

At the same time, if the effects in the **show** require this level of detail, the actors are being **scanned in 3D** so that the show will have accurate **character models** to work with in the **CG environment**.

Building Assets

When the on-set team gets back to the office, all the information, measurements, survey data, LIDAR data, photographs,

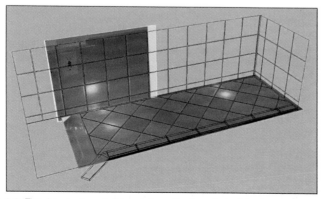

Figure 1-3 The virtual set created from information brought back by the matchmove team.

CG Environment

The computer graphics environment. The world as represented in the computer, interacted with through various types of software and represented in various ways. If you've ever seen a "Making of" featurette or TV show about visual effects and watched someone working on a computer, you've seen the virtual CG world!

Digital Models

Representations of people, places, and things in the CG environment.

Modeling Department

The artists responsible for creating the geometry representing the actors, props, buildings, sets, locations, and whatever else is needed in the CG environment.

Rigging Department

The artists responsible for taking the geometry, or "skin," of a character created by the modeling department and binding it to a skeleton-like structure for use in animating that character.

Character Models

 Digital models used specifically to animate people and other characters. These are set up by the riggers to be animated with an articulated digital skeleton.

Skeleton

 An articulated structure created mimicking the bones and joints of a human or other creature and attached to a virtual "skin," allowing it to be animated the way humans and other creatures move.

Prop

 Short for "property." On set, props are anything actors can easily move around and interact with. These are usually then recreated in the CG environment by the modeling department, though occasionally a matchmover creates his or her own props.

Practical

 The real-life prop, makeup effect, special effect, or other on-set, live-action element to be duplicated or extended in CG. If it's in the plate, it's a practical. I've been known to accidentally refer to an actor or two as "the practical guy" on a few occasions!

and other notes are assembled and disseminated to the rest of the facility. The **modeling department** creates **digital models** of the sets, locations, and characters. The **character models** are given **animatable skeletons** by the **rigging department**. Notes, camera details, photos, and anything else brought back from location are organized and made available by **production staff**. Then the fun starts!

Attacking the Shot

This is the beginning of the actual digital portion of matchmoving. Notice how much work is done before any matchmove-specific software is even touched!

After reviewing all the data from set, the matchmover creates a **virtual camera** based on this data. Part of this virtual camera is called the **image plane**, which is like a movie screen. It's attached to the virtual camera and moves with it at all times. The image on the virtual "movie screen" is called the **plate**, and shows the images taken on set – the actual film that was shot and scanned to be manipulated in the digital environment. In this way, when the matchmover looks through the virtual **camera view**, he or she sees what the camera operator saw on set (Figure 1-5).

The matchmover matches the focal length of the lens, and positions the camera in the same place in relation to the virtual set as it was in real life on the day of the shoot. Now, when looking through the **virtual camera**, the virtual set will line up

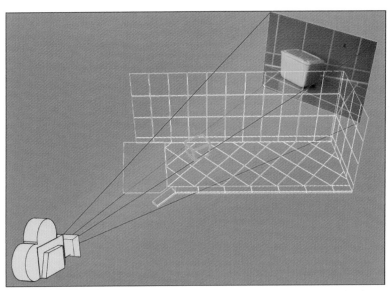

Figure 1-4 The virtual camera has a "movie screen," or image plane, attached to it, and displays the film actually taken on set. The camera can be maneuvered around the virtual set just as the real-life camera is moved around the real-life set.

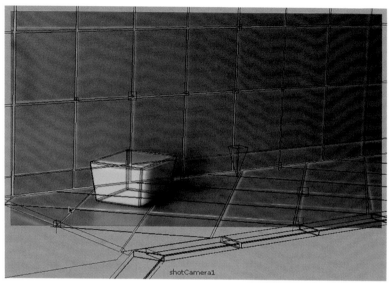

Figure 1-5 Looking through the virtual camera. The matchmover can see both the plate and the virtual set in this view and judge the alignment. This camera solution is a very good fit.

with the plate. The better the virtual set lines up with the plate, the better it's said to "**fit**."

At this point, the matchmover will turn to some automated software. If the camera on set did not move (called a "**lockoff shot**"), then the matchmover won't have to worry about animating the camera. However, the matchmover will want to get a more accurate fit, or camera solution, than what he or she can get just by eye. This is where matchmoving specific software comes in.

What the Computer Thinks About

How does this mysterious software work? Well, on the surface, it's actually pretty simple. You give the software some information, it chugs through some equations using the variables you've provided, and it spits out a solution. This solution is only as good as the information you give the software, of course!

So What Are the Variables You Feed the Camera?

You tell the software:

- That certain spots on the plate are important
- That they are important because they match certain points in the virtual set

Production Staff

The Production Staff is the organizational structure behind the creative activity on a show. From overall scheduling, budgeting, and communication with the studio, to assisting supervisors, coordinating dailies notes, to *making sure the snack drawers are filled* — the production staff does it all! You *definitely* want to be friends with them. Though "production" refers both to the producers of the overall project, as well as the in-house producers at your VFX facility, in the context of this book, Production and Production Staff always refer to the VFX production side of the overall show production, unless otherwise specified.

TIP: What's the difference between Special Effects and Visual Effects?

Special Effects include anything and everything done on set — rain, pyro, makeup effects, pneumatic dinosaurs, practical octopus arms, car crashes, burning houses, or any other practical effect you can think of. If it happens **on set**, it's Special Effects. Visual Effects is strictly postproduction, manipulating the live action film after photography. If it happens **to** the film, after photography, it's Visual Effects!

Matchmove-/Camera-Tracking-Specific Software

There are currently many software packages available on the market written specifically for camera tracking. Each have varying levels of automation and opportunities for artist intervention, and each has benefits and drawbacks. In addition, many facilities have written their own software (called "proprietary" software) for matchmoving. So although it's useful to be familiar with a popular package or two, it's much more important to *know how to actually matchmove* than how to work a specific software package — you never know what you'll be using from one day to the next! With that in mind, in this book, I try to remain as software-neutral as possible.

Virtual Camera

A representation of a physical camera in the CG environment. Also called CG camera, 3D camera, or, in a matchmove context, just "the camera."

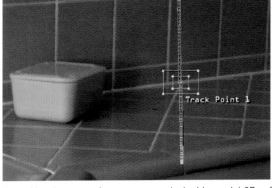

Figure 1-6 2D tracking: important features are tracked with special 2D software.

- That those points in the virtual set are located at these specific coordinates

Okay, but How Is That Done?

First, the important features on the plate are marked for the software by a process called 2D tracking. The 2D tracking software tells the computer where these features are on every frame of the sequence, in 2D (flat) space.

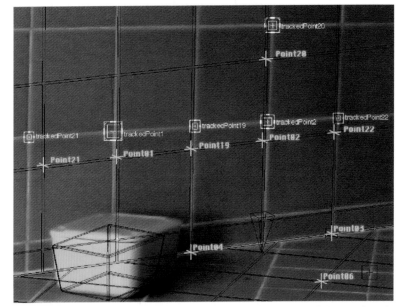

Figure 1-7 2D track points on the plate (white) are associated with 3D locators (aqua) on the virtual set (dark blue).

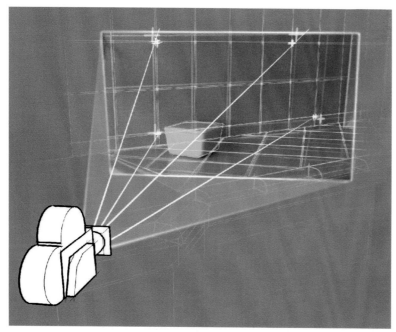

Figure 1-8 The "strings" (white) stretch from the camera to the 2D track points on the plate; in between, they also touch the 3D locators in the virtual set (white crosses) that are associated with the 2D track points (pink crosses), triangulating the position of the virtual camera by correlating the known measurements on the plate with the corresponding points on the virtual set. These known measurements were surveyed and recorded by the on-set matchmove team during the original shoot.

Once all the important features have been tracked on the 2D plate, the matchmover identifies the corresponding 3D locations of those points on the virtual set, using 3D elements called locators. The software computes the correspondence over time, and this correlation between 2D tracking points and 3D locators is the basis of the **3D camera solution** created by the matchmove software.

How do those numbers get crunched exactly? Well, I'm not actually a programmer, but I can tell you what the software is "thinking" about.

Imagine holding a string from the **film plane** of the virtual camera, and stretching it to one of the features on your plate. Remember, your camera and plate are locked to each other – they only move together. If you rotate your camera, the plate rotates out there in space. If you move back and forth, so does the image plane.

Now imagine that you have a few strings stretching from your camera to your plate – let's say four (Figure 1-9). Imagine that you move your virtual camera around so that those strings also touch the 3D locators associated with those 2D features. Your

Image Plane

A virtual plane attached to the CG camera, with the plate image displayed on it, like a movie screen. As the camera moves in 3D space, the image plane stays aligned with it (see Figure 1-4).

Plate

The original scanned film shot on set to be manipulated in the VFX process (see the section "Why Is It Called a Plate, Anyway?" in Chapter 2).

Camera View

A window shown in the CG environment representing what a cameraman would see looking through the CG camera (see Figure 1-5).

Focal Length

The distance from the lens of a camera to the film plane, usually given in millimeters (a 50 mm lens, for example, is a common focal length). See "Parts of the Film Camera and How They Work" in Chapter 2 for more details.

Film Plane

The physical location of the film being exposed to light inside a motion picture camera.

Camera Solution

The term used for the result of any automated 3D camera process. Also called a solve. "The solve is great up to frame 54, and then it goes all wonky."

Fit

The degree to which the virtual set lines up with the plate. There is never only one correct solution for any given camera in any given shot, but some solutions produce a result in which the virtual set seems to "fit" better with the plate than others. Fit depends on many factors, including reference points fed to the software, accuracy of onset data gathering, accuracy of 2D track points, and, sometimes, humidity, day of the week, and your horoscope.

Lockoff Shot

A shot in which the camera is fixed on a mount and is not allowed to move.

camera would line up with the virtual set and the plate perfectly, and there is only one place your virtual camera could be for all of the strings to touch all of the correct 3D locators at the same time, right? Now, say you did that on every frame of the shot. That's exactly what the matchmove software does – for every 2D position on a plate and every associated 3D locator in the virtual set, the software "stretches a string" from the camera through the virtual location and to the plate, maneuvering the virtual camera until all the strings line up correctly. The technical term for this is **triangulation**, which means positioning the virtual camera by correlating the known measurements on the plate and virtual set. These known measurements were the ones surveyed and recorded by the on-set matchmove team during the original shoot.

Essentially, you're telling the software, "Software, this bathroom tile *here* on the plate is right *here* on my model. This one right here is here on my model. This green box is right here on my model. I know how wide these tiles are, and how big the box is, so you can figure out the rest. Match it up – I'm going for coffee."

Sometimes it works out smashingly, sometimes not (in other words, you'll have to do some work!). But that's the gist of it.

So, let's look at what kinds of applications there are for this kind of computerthink.

What Kinds of Matchmove Tasks Are There?

Hopefully, that gives you a basic idea of what goes on in the office on a day-to-day basis. Matchmove isn't just an automated-button-push-and-it's-done-thing – it's very hands-on and can be demanding! It's also very challenging, and can be very entertaining as well. I promise.

There isn't just one type of matchmove – the term actually comprises a few different functions. Let's look at a few of these.

Camera Tracking

The most common type of matchmove is a camera track. In a camera track, you will create a duplicate of the live action camera in the virtual 3D world. This camera will have the same properties as the camera on the set, including **film back**, lens, height, tilt, and any movement the camera may have performed. You will typically (but not always) get information from the set, and you will use all this information, plus any other data you can gather, to help you place and animate the CG camera to match the live action camera.

Consider this example, in which the actor's head and hands will be replaced with a flaming skeleton:

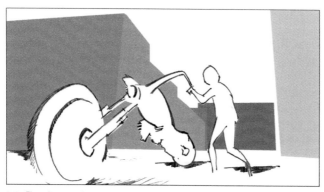

Figure 1-9 First frame of shot. Notice that it's very low to the ground.

Figure 1-10 The last frame of the shot. Notice it's directly over the motorcycle and in the actor's face; no camera on the ground could achieve this move!

In this shot, the live action camera is mounted on a crane, moving over the motorcycle and up to the actor's face (see "How do I know this is a crane shot?" on page 10). We want to match the motion of the camera in the live plate, animating the CG camera to match, so that when it's later used to "photograph" the flame effects on the actor's head, the flames will blend in seamlessly with the rest of the scene.

There are two ways to solve a camera track: **surveyed** and **surveyless**.

Surveyed Matchmoves

Many times, you will have a survey of the set your shot came from. This may be as elaborate as a full LIDAR survey, or it could be as simple as a few Polaroids with dimensions sketched on them to help you construct key **props** for your virtual set.

2D Tracking

The process of following the movement of a certain point, or feature, over time in a sequence of images.

3D Locators

In general, any point in the CG environment can be "located" by expressing its distance from a given coordinate point. In our environment, these measurements are given in units away from 0 along the X axis (side to side), the Y axis (up and down), and the Z axis (back and foreword from the computer screen). 3D locators are a type of 3D geometry used to mark locations in 3D space. On a CG set, they are placed on surfaces corresponding to the features tracked in 2D. For example, if the corner of a door were tracked in 2D on the plate, the corresponding door corner would have a 3D locator placed on it, designated and associated with that 2D feature.

Triangulation

The process of determining the location of a point in 3D space by calculating its relationship to known points.

TIP: How do I Know this is a Crane Shot?

I have a few clues. First and foremost, the camera report mentions the crane. Also, there were some photos from set where it was visible. But mostly, I can tell from watching the shot itself. It starts out really low, moves directly over the bike, and ends up right in the actor's face — that kind of motion can't be accomplished with a camera on the ground. Being able to imagine camera setup scenarios is a

Set data will also include the type of camera used (35 mm film camera or HD video camera, for example), as well as information about the lens used, and hopefully some information about the height and tilt of the lens at the beginning and end of the shot. These are normally estimates, but can be very useful as both a starting point and in determining whether your shot is working later on.

After gathering your data, you will then create 2D tracks corresponding to points on your virtual set. In the previous crane shot example, for instance, you might track features on the motorcycle and in the background (assuming that you have a model for those). Then you link the 2D data to the corresponding points on the virtual 3D set, and let the solver do its thing.

Surveyless Matchmoves

Occasionally, you may get a shot with no survey data, or no camera data, or no data at all; you will have to create a surveyless solution in this case. It's virtually impossible, these days, to have absolutely no information at all, because of all the information at our fingertips online; see Chapter 3 to learn how to glean clues from your shot in order to create a virtual set.

Sometimes, though, even your best efforts at set building won't work out; then you will try the surveyless method. In this method, automated software uses mathematical algorithms to pick hundreds of 2D points to track (versus the six or so you might need for a simple surveyed track), and then analyzes the motion of those points to create a camera move and a **point cloud** that approximates the 3D locations of those tracked points, in essence building a rudimentary set for you.

Instead of having known 2D and 3D locator values as in a surveyed matchmove, the automated matchmove software tracks hundreds of 2D points and analyzes the motion of these points in comparison to each other. When it recognizes that one large group of 2D track points moves together, the software presumes that group represents one 3D element in the virtual CG world. As the

Figure 1-11 The software tracks hundreds of 2D features automatically.

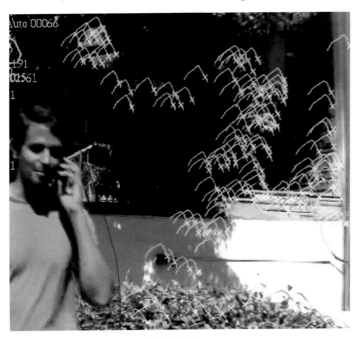

software goes through each frame in the sequence, detecting these groups of points representing single objects, it also compares the motion of those objects to each other, looking for parallax, rotation, and translation cues through mathematical equations. Then, after that analysis, it generates a point cloud, the actual **3D locators** generated by the analysis of the comparative motion of the 2D tracks. Think of it as hundreds of tiny locators that have been projected onto the plate, and then pushed out to reveal the 3D shape of the actual objects that were photographed, not unlike those boxes with the silver pins you push forward to reveal the 3D shape of your hand.

A fully automated solution like this is usually, but not always my last resort, though I know many artists who use automated solutions as the first step in their personal process with great success. I often find that surveyless solutions aren't worth the trouble, especially if you can create a rudimentary set to work with yourself. I've even been told by **sups** to spend no more than two hours on a surveyless solution, because if an automated solver can't get the shot done in that time, it probably won't ever get it.

Film Back

The dimensions of the image being captured on film. Also called the aperture. These dimensions are derived from the actual opening in the plate through which the film is exposed to light behind the lens in a motion picture camera. See "Parts of the Film Camera and How They Work" in Chapter 2 for more details.

Survey

(1) To physically measure and record the features and dimensions of a particular site, whether with a tape measure and notebook or more sophisticated tools like LIDAR or a laser survey head. (2) The data set resulting from that activity. (3) The CG model that results from the data from set.

Point Cloud

CG virtual set made up of many 3D locators representing a surface or location, so called because they can be very dense and look like clouds seen from above. See Figure 1-12.

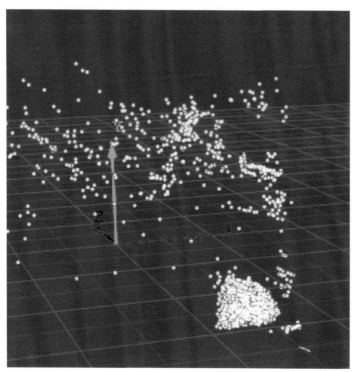

Figure 1-12 A point cloud is generated after software analyzes the movement of 2D tracks.

Final, Approved Camera

A CG camera solution that has been through a review process determined by production and approved for use in the rest of the pipeline. For the matchmover, a finished shot, to be passed on to the next artist and hopefully never to be seen again. Many departments and shows have rituals they perform whenever a shot is finalled, from polite golf claps to waving strange, laughing, toy pirate "final swords."

Motion Control (MOCO) Data

Data from a MOCO camera. The MOCO camera is controlled by computer, and the same data driving the physical MOCO camera can be transferred to the CG camera, and vice versa.

VFX Pipeline

The process, in sequential order, in which digital effects imagery is created. The pipe is by necessity a little different for every show, because every production has different needs driven by the type of effects needed — character, smoke, water, and so on. See Figure 2-21 for more details.

Object Matchmove

In addition to matching the camera in a particular shot, there may also be **practical** elements in your shot that also need to be recreated. This type of matchmoving, called object matchmove, can be done through an automated solver or by hand animating in your 3D software. For example, some CG element in the final shot might affect practical elements in the plate. In Figure 1-13, for example, the practical robot costume will have added arms, legs, and other elements, and the arms and legs interact with the set — he's tearing up the house! The destruction wrought by this robot will cause smoke, dust clouds, and sparks which will light and shadow the surrounding walls, floor, and other props. In turn, the room will be reflected in the robot's body. In this case, you will need to match all the props in the room, as well as the robot costumed stunt man in the scene after the camera move has been through the review process and approved as a final. If the furniture were moving, or bricks were falling out of the fireplace (which they did), you would to animate each to match the plate. In this way, artists

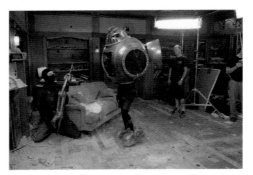

Figure 1-13 In this shot, CG arms, legs, and torso will be added to the robot costume, so matching the practical very closely is important. "Zathura: A Space Adventure" © 2005 Columbia Pictures Industries, Inc. All Rights Reserved. Courtesy of Columbia Pictures.

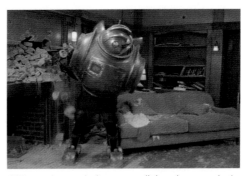

Figure 1-14 In addition to the practical costume, all the other props in the room must be matched so that the CG robot can interact with them. "Zathura: A Space Adventure" © 2005 Columbia Pictures Industries, Inc. All Rights Reserved. Courtesy of Columbia Pictures.

further along the **pipeline** will know how the smoke, dust, and robot interact with the practical elements when seen in the virtual world. See Chapter 12, "Real Life Shot: Character and Object Rotomation," for more details.

Character Matchmove

Character matchmove – which I refer to as *rotomation* – is, as you might guess, in the same family as object matchmove. Take Figures 1-15 and 1-16, for example. Once the camera matchmove has been **approved**, the matchmove artist would then import a CG character prepared by the modeling and rigging departments, and animate it to match Geena Davis' movements. Then this animated character is passed to other departments down the line, so that Margalo has a place to sit. The character animators will be able to time Margalo's movements with Geena's hand motion just as if she were a real bird on a real finger. In addition, both Stuart and Margalo need to know where to look when talking to mom, so Geena's face must be matched as well.

Some matchmovers are daunted by character animation, but you shouldn't be; I will outline many tricks and procedures later so that character matching will be your favorite task! See Chapter 10 for more details.

Other Uses

Sometimes, especially at the beginning of a show, you might need to perform other matchmove tasks in advance of primary photography. That sounds backward, right? Not necessarily.

Sometimes matchmoves are used to output motion control data in order to line up an existing plate element with elements that have yet to be shot. For example, one might get a shot of a miniature set with pyrotechnic effects, match the camera used for that element, and output that camera information so that the actors can be filmed separately with a **motion control** camera that mimics the camera used in the miniature set. This way the actors can be integrated into the miniature background seamlessly, with the same perspective and camera move.

Preliminary matchmoves can also be used to pass information on to other departments. For example, a sweeping, 360-degree camera move on a set which needs to be digitally extended might be roughly matched so that the modeling

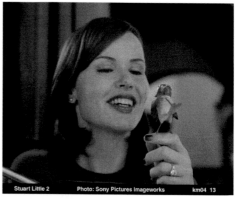

Figure 1-15 In order to interact with Margalo, Geena Davis' hands and face must be matched. "Stuart Little 2" © 2002 Columbia Pictures Industries, Inc. All Rights Reserved. Courtesy of Columbia Pictures.

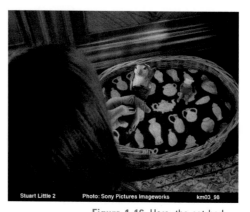

Figure 1-16 Here, the cat bed needs to be matched for Stuart's interaction with the fabric; Geena Davis' hands and face are matched so that Margalo has a place to sit, and Stuart and Margalo (and their animators) know where to look when they're talking! "Stuart Little 2" © 2002 Columbia Pictures Industries, Inc. All Rights Reserved. Courtesy of Columbia Pictures.

department can see how much set extension will have to be built. By matching the camera and then displaying the views seen in the shot, the modelers will have to build only as much as the camera sees and no more, saving time and money that can then be spent elsewhere.

As you can see, many different tasks fall to the matchmove department. The bulk of the work consists of camera matching, but there are also needs for object and character matching as well, and a single artist might be better at one task than another. Don't worry though; I intend to give you a solid foundation in each type of work—and also remember that a variety of talent is a good thing in any department, and a good supervisor will know how to "cast" each artist for shots they are more suited for.

What Kind of Matchmover Are You?

Just as there is more than one kind of matchmove, there is more than one kind of matchmover. What do I mean by "there is more than one kind of matchmover?"

I have found, in my years of experience, that matchmovers tend to fall into one of two categories: the very analytical, mathematically-oriented matchmover, who trusts in whatever solver he or she is using and uses more logic than intuition to arrive at matchmove solutions. Then there is the matchmover who just sort of gets a feel for the camera, works with it, and massages the solution around until it works.

There is no right or wrong type of matchmover to be; both these types get the job done, and both are needed, as they are typically well suited to different types of tasks. The more logical, mathematically-inclined matchmover is well suited for complex camera moves and object matchmoves that need to be pixel-perfect; the more freewheeling matchmover is often well suited to character matchmove, and situations with limited set data. Of course, if you are the only matchmover on a project, you'll need to be a little bit of both!

I am much more of the second type of matchmover than the first — I don't always trust software solutions; I'm not afraid to dump a solution that's not working and *just start over*. I'm also good at rotomation, which requires intuition and insight into human behavior more than theory. As you can see, it's a benefit for you to have at least some traits of both kinds of matchmoving personalities, so always keep an open mind, and find aspects to enjoy about each type of matchmove task!

Bibliography

Goulekas, K. E. (2001). *Visual Effects in a Digital World*. San Diego, CA: Morgan Kaufmann.

HOW MOVIES GET MADE: WHAT YOU NEED TO KNOW ABOUT IT, AND WHY

These days, many digital artists come to work right out of a computer science or digital arts program, and have never actually worked on a live set with a real movie camera. That's okay, but in order to be a really good film effects artist, you need to know at least a little about how your shot gets to you.

I've learned at least as much from sitting in dailies with the great John Dykstra as I have from my years in film school. Why? Because he *knows film*, what kind of stock should be used for one shot or another, how motion blur works in the real world, how lighting is set up, and on and on. He is a legend, and just listening to his commentary and critiques is an education in itself.

On the other hand, I've had co-workers who came to the studio with superb digital skills, but no live action film experience. Again, that's not a bad thing, but sometimes a purely digital focus can lead an artist astray, causing them to focus on tiny technical issues at their monitor without taking a step back and seeing the larger picture. Attention to detail is crucial in any effects shot; however, keeping an eye on the big picture, not getting lost in the digital details, is just as important.

Being familiar with the filmmaking process is crucial to your digital work. Not only will it enhance your skills and enjoyment of the process, but it might save you hours of agony to boot!

John Dykstra, Childhood Hero

First of all, don't say that in front of him. He hates it!

John started working in film after studying industrial design, and found himself working on a little film called *Star Wars* in the mid-seventies, for which he won two Academy Awards: Best Effects, Visual Effects, and the Scientific and Engineering Award for "the development of the Dykstraflex Camera (Dykstra) and the engineering of the Electronic Motion Control System (Miller/Jeffress) used in concert for multiple exposure visual effects motion

DOI: 10.1016/B978-0-240-81230-4.00002-6

picture photography." Clearly, he's a very innovative thinker, and he's not afraid to build something new if existing technology doesn't suit his needs. He carries that spirit into the digital age, but retains incredible, encyclopedic knowledge of all aspects of filmmaking. Sitting in dailies with him is not only an education; it's a hoot as well.

John's other awards include several nominations for Best Visual Effects, an Emmy for the original *Battlestar Galactica* series, and he (we!) won the Oscar Best Achievement in Visual Effects in 2005 for *Spider-Man 2*. The matchmove in that show was sublime, if I do say so myself.

Parts of the Film Camera and How They Work

First, let's look inside a typical 35 mm camera.

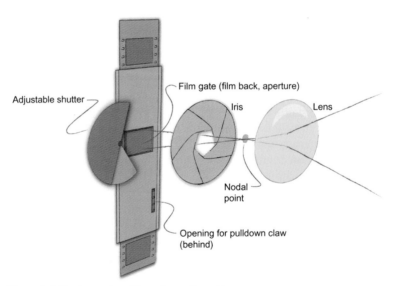

Figure 2-1 The internal workings of a motion picture camera.

Lens

The lens captures, focuses, and transmits light from the outside world to the film in the camera and creates the image you ultimately will use in your shot. You're most likely already familiar with this concept, but what does it mean when we talk about matchmove?

The choice and behavior of the lens will affect your work in a few ways. First, of course, you'll need to know the focal length used to shoot your plate on set; hopefully, that will be recorded in a camera report and you won't need to guess it back at your desk. You'll use this information to begin creating your virtual CG camera.

Bakeoff!

Ever wonder how the three nominees for the Academy Award for Visual Effects are nominated? Every year, the creators of seven films are chosen to make a presentation to members of the Academy, who then narrow the field down to the three official Oscar nominees. This event is called the Bakeoff.

But that's not the whole story. The Bakeoff is *fun*! It takes place in the American Motion Picture Arts and Sciences screening room — the Academy! — and after the members of the Academy who have come to judge the work are seated, the general public is allowed in — that's right, *you and me*! Sometimes you are even let off work early to go get in line for the Bakeoff — that's how great it is. I was on a show once and we were on mandatory 60-hour weeks, but my producer came and told me to get out and go to the Bakeoff — "Everyone should go!" It's like a college reunion — you see people at the Bakeoff you might not have seen in a year — since the last Bakeoff.

After everyone is seated and mostly quieted down, the presentations begin. Each team is allowed to introduce themselves and the title of the film, and that's it. Then they roll a 15-minute compilation of the work they did — only final shots, no before-and-afters, no "how we did it" scenes — finals from the film only. Then, the nominees come back up on stage and have a five-minute question-and-answer session — five minutes only! They're timed; there is a little red light on a stand in front of them that starts blinking when their time is up, and they are gently ushered off the stage when their time is over. The whole thing ends pretty late, and if you didn't eat before you got in line, you'll be starving, but it's a great time, and well worth it! Definitely go at *least* once in your career.

The Bakeoff is held mid-January at the AMPAS Samuel Goldwyn Theater at 8949 Wilshire Boulevard, Beverly Hills, California, 90211. Don't miss it!

Focal Length

The length of the lens, expressed in millimeters, has a huge effect on your image. When the camera is stationary, a **short lens** (28 mm or even 18 mm) will give you a much broader angle of view than a **long lens** (110 mm or even 300 mm). The shorter lens (wide angle or fisheye) gives a wider view of the scene, and the longer lens (telephoto or zoom) narrows your focus and moves the viewer closer to the subject when shot from the same position.

What does that mean to us? Understanding the way lenses affect the relationship between the foreground and background elements in a shot is an important skill to develop in match-move to help you spot mistakes in camera reports and to give you a quick idea, just from watching a shot, what kind of lens you're dealing with right off the bat. And who knows — you might get into the artistic aspect of lens choice, too!

When using a short lens, you have a wider view of the scene, and the relationship between the background and foreground elements is easier to see than with a telephoto lens. A telephoto lens will compress the apparent space between the subject and background (Figure 2-4).

Short Lens

A lens with a shorter focal length one that approximates "normal vision." A fish-eye lens is an example of a short lens.

Long Lens

A lens that has a longer focal length than one that approximates "normal vision." For example, a telephoto lens is a long lens.

Figure 2-2 In two photos taken from the same position, a shorter lens shows a wider angle view of the scene (right) than a longer lens does.

To have a subject appear the same size in frame using two different focal lengths, the camera has to be moved in relation to the subject, affecting and the relationship between the background and foreground.

Knowing the differences in the behavior of longer and shorter lenses will help you out of many binds, especially when you're given mistaken information from set. If you're confident in knowing that a longer lens tends to record a shorter depth of field, then you will be comfortable in disregarding a camera report that gives the focal length as 12 mm in a shot with a very shallow depth of field. For example, short lenses are often used for wide, establishing shots that show an entire location. They also tend to have very distinctive lens distortion (see the section "Lens Distortion" later in this chapter for more details). On the other hand, longer lenses tend to flatten out the perspective and depth in an image. Longer lenses are also often used for close-ups, because they give a more pleasing look – softer focus, less lens distortion. Nobody wants to be shot close-up with a fisheye lens, right? That's an easy way to remember that close-up equals longer lens (usually). These are the types of clues to look for if you suspect that your lens has been misreported.

Figure 2-3, 2-4 A telephoto lens (Figure 2-3) shows different relationships between the subject and background than does a wide-angle lens with the same framing (Figure 2-4). This is because the photographer has to change locations to capture the same framing of the subject. In these photos, though the floorboards line up when superimposed, the difference in relationship between the subject elements is apparent. We can also see the shallower depth of field the telephoto lens captures. Note also the flattening effect the telephoto lens has — this effect is often exploited by cinematographers in crowd scenes and to give a feeling of alienation.

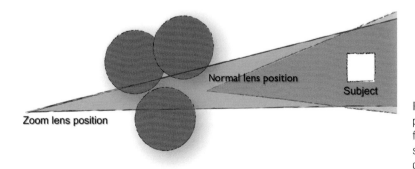

Figure 2-5 The different positions required to get the same framing required for long and short lenses, and obstacles that can show up.

Depth of Field

Depth of field refers to the part of the image that is in focus. In actuality, there is only one point in space at which the lens focuses in any given shot, but the human eye interprets the image to be in focus for some distance around that point. Depth of field is affected by the aperture and the length of the lens, among other things. And what does that mean to match-moving? You can use depth of field to make a good educated guess as to the length of your lens.

In general, a shorter lens (with a wider angle of view) will produce an image with a wider depth of field than a longer lens. In other words, your shot will have more of the subject in focus with a shorter focal length than with a longer one. Of course, this is a general rule, and the director or **DP** can manipulate the depth of field through lighting and aperture. However, here's a good rule of thumb: The shorter the lens, the wider the field of view and the greater the depth of field, and the longer the lens, the narrower the field of view and the shallower the depth of field.

How will this help you? Say you are working on a shot, and for some reason the lens wasn't recorded. You can certainly hazard a guess right off the bat as to whether it's under or over 50 mm by studying the depth of field, especially if there are other shots in the sequence with which you can compare it. Or, say you do have lens information from set, but it's just not working with the other set data you have. This happens more frequently than you might imagine, because being on set is hectic, to say the least. If you know your lens behavior, you can be confident in throwing out the reported 28 mm lens on the camera report when you can clearly see that the depth of field is limited to the actor's face – obviously, a much longer lens was used!

I once was assigned a close-up shot of an actor that pulled back slightly to reveal his head and shoulders, for example. The lens recorded on the camera report was 17 mm, which is on the shorter side for 35 mm photography, and shorter lenses are not very flattering for close-ups (something they teach you the first day of film school). Add to that the fact that the depth of field in this shot looked to be about six inches – directly in front and behind him were out of focus – and it was fairly easy to conclude that there was a mixup somewhere – this was no 17 mm lens. A quick review of the sequence and looking at the camera reports for similar shots confirmed my suspicion, but even if that information hadn't been available, I would have tossed that lens information no matter what, because it was obviously not correct.

DP (Director of Photography)

The DP is responsible for the overall lighting style and look of a film, executing the artistic vision of the director. He or she chooses cameras, lenses, film stock, lighting setups, and so on.

Figure 2-6 Shallow depth of field: only the top of the can is in focus.

Figure 2-7 Deep focus: more of the subject is in sharp focus.

Rack Focus

You've seen a rack focus – or focus pull – but might not have known what it was called. A rack focus draws your attention from one area of the screen to another sharply, to emphasize some element of the story. A focus pull is more subtle, and is used more to keep a moving subject in focus over time. Either way, a change in focus can complicate your matchmove.

Figure 2-8, 2-9 A focus rack directs the viewer's attention from one part of the frame to another.

A focus change is essentially a mini-zoom; to change the focal point of the lens, you must actually change the position of the lens in the housing. Keep in mind that the change is very small — usually well under a millimeter. Don't panic! The mention of a focus change might put fear into the heart of the heartiest match-mover, but really, there's no need to be afraid. Once you know how to identify a focus change in your plate, you'll be able to compensate for it in your solution.

Flatten

To remove lens distortion from a plate using 2D warping techniques.

Lens Distortion

Because lenses are curved in various ways to focus light onto film, the image created will have some distortion due to this curvature, no matter how good the lens design. This distortion is more evident the more extremely short or long the lens is.

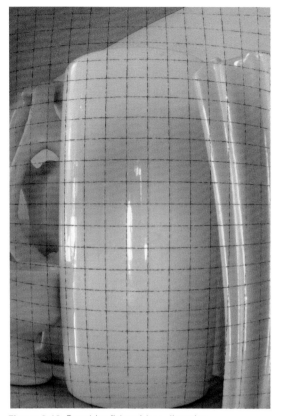

Figure 2-10 Barrel (or fisheye) lens distortion.

Figure 2-11 Pincushion (or telephoto) lens distortion.

As you may imagine, when your image is distorted like this, your camera track will be compromised, especially around the edges of the image. The process of correcting this distortion is called **flattening** (or unwarping) the plate.

When to flatten? Well, it varies. Some shows I've worked on ignore lens distortion altogether. Others flatten every plate. Most shows, though, take each plate on a case-by-case basis, flattening only the most severely distorted plates, or only plates that have CG elements that interact with the extreme edges of the plate, where even slight distortion can cause the elements to **slide**. The determination of whether to flatten a plate is generally made by the compositing or digital effects supervisor.

But *how* do you flatten a plate? Sometime during filming, the on-set matchmove team will photograph a grid, created

Slide

Phenomenon in which CG elements appear to slide, hover, or otherwise move contrary to the background plate, breaking the illusion of being integrated into the live action scene.

Motion Blur

The blurring of images in film caused by the speed of the object being filmed.

Frame Rate

The number of frames photographed per second in a motion picture camera. For sound film, this is 24fps.

Film Stock

The particular type of film used, in terms of its response to different lighting conditions. Some stocks are intended for use in daylight, indoors, under low-light conditions, and so on.

especially for this purpose, with each lens in the package used by the show. In other words, the on-set team will photograph every lens used on that production to calibrate each lens. That film is brought back to the studio, and software is used to create a correction algorithm, or "map," to apply to each plate, creating an undistorted plate for the entire pipeline to work with. So, for example, if your plate was shot with lens 28a (all lenses are marked and tracked with serial numbers), there will be a special algorithm that you'll import into your matchmove software to correct the lens distortion, based on the grid shot on set.

It sounds very complicated, I know, but mostly it's just tedious, because every lens has to be "mapped" — no two lenses are exactly the same.

Figure 2-12, 2-13, and 2-14
Shutter angle settings cause motion blur to lead, follow, or center on CG elements. Arrows indicate the direction of the character's motion.

Motion Blur

Everyone knows what **motion blur** looks like, but you might not know how it's actually created or reproduced in the CG environment.

Motion blur is captured on film because the subject being photographed is moving faster than the film can capture at a given **frame rate** (which in sound film is 24 frames per second). The amount of motion blur depends on several factors, including the speed of the subject relative to the motion of the camera, lighting levels, the **film stock**, and the **shutter angle**.

The what?

A movie camera doesn't shoot film in one continuous stream, as many people think; actually, it shoots 24 individual still frames per second. Otherwise, all you would see on film would be continuous streaks on screen, as if you took a long-exposure photograph.

To shoot 24 induvidual frames of film a second, a mechanical "pulldown claw" moves the film, one frame at a time, in front of the aperture, where it is exposed to the light by the rotating shutter. Then, as the shutter continues to rotate around to block the light from the scene, the pulldown claw moves the next frame of film down into position, and so forth, 24 times a second.

What does this have to do with matchmove? I'm glad you asked! The shutter angle of the camera on set affects the motion blur settings in your rendering software, and that's an important consideration indeed. This setting is **show-specific**, and in some situations might even be **sequence specific**.

Most of the time, the shutter angle will be 180° — the shutter is half-open, exposing the film for half the time it's in position. However, the director or DP may choose other settings for other effects. For example, closing the shutter more than halfway will

Adjustable shutter

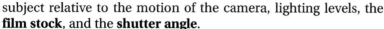

Plate slides in or out to adjust shutter angle

Figure 2-15 The rotating shutter (butterfly shutter) alternately blocks and allows the light to strike the film as it rotates. It can be adjusted to open to different angles, giving the director more artistic choices in shooting a film.

Shutter Angle

Setting in a CG package that controls how and how much motion blur is rendered. It's analogous to the shutter angle of the camera, which can be changed to create different motion blur effects (see Figures 2-15–2-17).

Sequence (Specific)

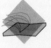

A series of shots that make up a single plot point. Many times, a sequence contains elements, locations, or characters unique to that part of the story, and therefore may require special protocols or pipeline procedures that pertain only to that sequence.

Why Is It Called a Plate, Anyway?

Originally, photographic negatives were created on big, heavy glass plates, and there were several methods developed for this process. Much in the way *Variety* still uses slang from the twenties (one of the many reasons I love this business), the term just stuck, and refers to the original photography from set that is digitized and used to create visual effects.

result in less motion blur and a staccato look to the action – an effect used often in war movies and battle scenes. Offsetting the shutter will cause the motion blur to lead or follow the action to different degrees.

This is very important to know, because it will affect the way you fit your geometry in your virtual set to the live action plate. If your show's motion blur settings are set so that the motion blur leads the action (Figure 2-15), then you will fit your geometry to the trailing edge of the action on the plate, and vice versa (Figure 2-16). If it's set to center on the action, then you will line your geometry up in the middle of the apparent motion blur on the plate (Figure 2-17). See Chapter 11 for more details.

Typically, the best way to know how to match the motion blur on a specific show is to ask either your supervisor or the Digital Effects Supervisor.

Information Gathering On Set

A film set is a busy, hot (or cold), dirty, exhausting place to be for a matchmove team. It can also be fun and rewarding. It definitely takes a certain kind of personality to be sent – and to want to go – to set! If you're the person assigned to go to set for your team, there are some very important things to remember.

The first thing to remember is: be invisible. Be polite. Stay out of the way. Remember that you're the low man on the totem pole in production hierarchy. Respect (and *know*) the hierarchy of the set and the way orders come down through the ranks. And for the Love of Matchmove, ***don't ask for autographs!***

So what information will you be looking for? Remember that you will be reconstructing the location in the virtual CG world back at the office. You need this model for many things: to help you reconstruct your camera and camera moves by comparing points on the CG set to points on the live action plate in specialized software. It will also be used by character animators for reference when animating the interaction between CG characters and the live action environment, and for effects animators when simulating phenomena like rain or smoke. The virtual set will be used by the entire facility, so it's important to measure and document it as accurately as possible so that it can be accurately recreated in the virtual world later.

Just like any other surveyor, you want to record any and all information that you think will be valuable later when constructing that virtual set. You need accurate measurements, photographs, and notes. You want to survey the set as accurately as possible (see "Survey Data and LIDAR" later in the chapter for more details). You'll measure and photograph props and practical elements. Any details you can get – a photograph

Sticks

Tripod.

Dolly

A wheeled platform, like a cart, used to move the camera when shooting.

Crane

A piece of equipment, similar to a cherry picker used by utility companies, used to move the camera up and down during shooting.

of a prop gun with a dime in it for size reference, or a window on set with a tape measure extended next to it to record its height — are valuable in reconstructing the virtual set later on.

The next thing to remember is: you can't get *everything*. It's just not possible. Whether you couldn't get a measurement because it would have put you in an actor's way, or things just moved too fast, or whatever, you're going to miss something. So the most important thing is to determine the most important information to get, and get it first.

Does the action take place around a table and chairs in front of a window in a room? First, get the table, the chairs, and the window, and then the other details for the room. Are you on a greenscreen set with a grid of identical dots on the back wall? Get the spacing between the dots and the distance from the camera to the action. In general, *think about what you would want in any given situation back at the office, and do your best to get that information first.* How do you know what's important? From your extensive matchmove experience — this is why only experienced matchmovers are sent to set.

Most of the time, especially on a big production, there will be a person dedicated to taking camera notes: what lens was used; the height; the angle; whether the camera was on **sticks**, a **dolly**, or a **crane**; and other information about each take for each shot. However, just because that person is there doesn't mean you shouldn't take those notes yourself! You never know when there might be a transcription error, or the notes for a sequence might get lost in a computer crash, or whatnot. Take as many camera notes as you possibly can — more notes are always better than no notes at all. But always make sure to get crucial information — set dimensions, prop measurements, camera setups — first, not at the last minute.

Setup, Next Setup

A physical lighting and camera setup for a series of similar shots. For example, one setup would work for one camera angle — say, of two actors talking to each other. All shots for this setup would be shot at once, and when the director is satisfied he has what he wants, he or she calls for the next setup, which might be an over-the-shoulder shot of one of the actors, or an entirely new scene.

True Tales of Matchmove: Eric Peterson, On-Set Data Collector, Matchmover Extraordinaire

I worked closely with Eric during my tenure at Imageworks, and he brings a wealth of Special and Visual Effects knowledge to the table. I asked him a few more questions about gathering data on set:

*How do you get all the survey and photos and everything you need, without getting in the way, especially if they move on to a **new setup** or even strike the set before you're done?*

As survey person, it is always a struggle to gain access to the set before they move on. So you are always trying to grab a little bit of whatever, whenever you can. It is rare that anyone will wait for you to get what you need. That is why bluescreen work can be so exhausting — markers on the screen get moved all the time and you can't always keep up. A set or location that can be surveyed before or after the fact is much more accommodating. Remember

that big aircraft carrier in NYC that was supposed to sail away and get restored? It was a location [I was on], and I had one day to get what we needed.

I think everyone has the fear instilled in them before they're allowed to go to set, and I for one know I'd be terrified to talk to anyone there. If you weren't there and I were on my own, who would I contact on the crew?

For the VFX world, usually the [Visual Effects] Supervisor. As far as interface with the crew, the 1st AD (first assistant director) is the place to start. Introduce yourself to him or her, and they usually try to accommodate you, or at least get the necessary department heads involved. Good ADs are golden, and by and large they are all good. Their job is to keep things running, and that's what they do. Good ADs are good people persons, and just know how to get things done.

What's it like on the Second Unit?

The working definition of Second Unit is [anything] not involving the principal actors. Otherwise the director would need to be there. So many VFX movies don't require actors in same way. On *Ghost Rider*, Eddie [Nicholas Cage's stunt double] did the lion's share of the work, because of all the face/flaming skull replacement. Second Unit is often where much of the stunts and VFX shots are done, so they can be as big or even bigger than the main unit. The director is always where the principal actors are, but it's not unusual for them to run back and forth between units, or evaluate something from Second Unit on video, and send out instructions based on that.

Greenscreen Markers

Sometimes, when working with greenscreen shots, I see meticulously placed tracking dots or identical tape Xs in a perfect grid on the green screen wall and floor. Although I appreciate the time and effort it must take to create such an accurate reference, unless every (or most) point is visible throughout the entire shot, a perfect grid of identical elements is almost useless back at the office.

Why would a perfect grid be useless? Imagine your shot pans across some action happening in the foreground, and you only see a fraction of the background at a time — as with a long lens (See? I told you you'd need to know this stuff). The background will be blurred as well, due to the long lens and motion blur. And, naturally, the action will block your reference markers some of the time. The result is that if you have an identical grid of identical markers, it's extremely hard to tell when one marker leaves the screen and another comes in — it's really easy to confuse them when they all look the same. Now, if you have more randomly (not crazy, just not perfect) placed markers with distinctive shapes, you won't have that problem, and your tracking will be much easier and less time-consuming.

Now, multiply that time savings over an entire sequence — or more — shot on that greenscreen stage, and you'll easily see how much time — and hair pulling — you'll save!

Figure 2-16 Random, easily distinguishable tape shapes are preferable to identical, perfect shapes in an exact grid.

Survey Data and LIDAR

If you're lucky – and I hope you are – you'll have survey or LIDAR (Light Detection And Ranging) data from set.

Both of these technologies gather a point cloud of 3D data representing the physical characteristics of an actual location, for example, a set or where production is shooting.

A survey head uses a laser to pinpoint locations in 3D space selected by an operator; the person gathering the data (hopefully, your own on-set matchmove person) can pick and choose the points he or she deems important, as his or her experience dictates. This method results in a detailed, systematic point cloud to bring back to the office, which contains only the data most salient to matchmovers. When the raw survey data is brought back to the office for use in camera tracking software, it will be converted into a CG model of the site, either by hand or through proprietary software.

A LIDAR survey also uses a laser to map the 3D environment, but it scans the set or location automatically. Because this data contains every point it could scan on the location, LIDAR survey sets are often too dense, or 'heavy,' to be used as is. LIDAR surveys are usually altered or rebuilt for use in a facility.

Both techniques have their uses, and sometimes one has to be used over the other, simply because that's what production provided for. Both are obviously more useful than no survey at all!

Figure 2-17 Eric Peterson in Chicago on the set of Spider-Man 2, using a Leica survey head.

True Tales of Matchmove: More Stories from the Set with Eric Peterson

I asked Eric explains how he gathers data with a Leica survey head on location, and how we used LIDAR data sets at Imageworks:

"The way [survey] works is, I set [the survey head] up and call some place 0,0,0 [the origin from which all other 3D locators reference their positions]. Then I ping a few points and keep track of them [in a notebook] so I can move around [to get coverage of the entire location] and relate my next setup to that same 0,0,0. But the goal is to systematically go through and outline geometry that can be used to matchmove. Groundplane, girders, walls, etc. Simple boxes. If LIDAR [were] used instead, they would set up, probably still get some sort of control points because they would have to move [to another setup location to get coverage] as well. But the difference is LIDAR is motorized — you kick the thing off and it just starts scanning an area within some parameter. I have to look through [the survey head] finder, carefully line up on a point, like the corner of a window, then push a button to send out a beam that is recorded [in on-board software] when it comes back. Then I lineup another point in the finder, hit the button again. Repeat . . .

For [*I Am*] *Legend*, I surveyed Park Avenue looking both directions from about 27th Street up to Grand Central at 42nd. You just establish some known points and keep leap-frogging up the street.

We did get LIDAR [at Imageworks] on occasion. And someone like (Supervising Digital Modeler) Kevin Hudson would try to reduce it to something we could use. Typically at Imageworks LIDAR was used for shows [for which] we did not or could not provide onset survey people, or if we were subcontractors on larger show. So we did use it, but the term 'survey' isn't really interchangeable with LIDAR. They are both efforts to map a set or place in 3D space, but the methods and results differ."

Notes, Notes, Notes

Meticulous note taking can mean the difference between a smooth, fun show to work on and — if not necessarily a disaster — certainly a less-than-pleasant experience for the folks back in the office. I am very fortunate to have worked with some on-set guys who take incredible notes, and who have made potentially impossible shots a breeze.

As I mentioned earlier, notes on lenses, camera height, tilt, and so on are invaluable, even though typically someone else is recording that information as well. Again, more notes are better than fewer. Matchmovers also know what information is *most* salient to the matchmove department, and that can make a big difference when collecting camera data. Typically, notes from set also include a **setup** diagram — it can be rough or very specific, including measurements. Sometimes the camera and lights are even surveyed, if there is time, which is especially useful if the lighting rigs can be seen in a sequence, common in greenscreen shots. Lighting diagrams are also useful for other departments, especially the **lighting department**. Other notes might include information about the different **takes** of each shot, what the production designation for each shot is (which usually is different from the VFX designation), which take is a **circle take**, and anything else that might differentiate one shot or take from another.

Props are very important, for two reasons: first, if a prop is small and is stationary in a shot, it could be a good object to track and to judge scale by. Many times, especially in interiors, props are the only parts of a set entirely visible throughout a shot. But you have to have accurate dimensions to use them! Often, if your set guys have time, they are surveyed. If not, an excellent way to record props is to systematically go through them and photograph them with a tape measure.

Lighting Department

The VFX department responsible for creating virtual lighting for the CG elements to be integrated into the live action plate. In some facilities, The Lighting and Compositing departments are integrated; in others, they are separate.

Take

Any of several versions of the same scene. The director often asks for another take, for any variety of reasons.

Circle Take

The take, or takes, the director is happiest with on set. It will actually be circled in that day's camera reports so that it will be processed for review later.

Figure 2-18 Capturing prop measurements on set.

Primary Photography

The main shoot for the project. It includes the primary cast and crew, major locations, and covers the majority of the script.

Secondary Photography (Second Unit)

Usually conducted by an assistant director or even the Visual Effects Supervisor, secondary photography shoots elements that don't require the primary cast.

These measurements are *invaluable*, and I can't stress that enough – they have saved me from doom on more than one occasion. Other measurements of note include hardwood floorboard widths, carpet pile heights, heating and air duct grates, picture frames, tables, chairs, and anything else you can get your hands on to measure. Outdoors, measure parking space dimensions (often surveyed), curb heights (ditto), and whatever else doesn't get surveyed.

The second reason that prop dimensions and details are so important to gather is because CG creatures and effects often interact with them. Shadows will fall on them, a character will pick them up, they will magically change into a kitten, or vanish in a whiff of smoke. For the matchmove department, this means you will have to do a close object track of the affected prop or props, and then you will pass this information, along with your camera data, down the production pipeline.

Communication

All this information gathering is great — fantastic, in fact — but it does no one any good if it isn't communicated to the matchmove department back at the office. Because VFX production often coincides with **primary and secondary photography,** at least at the beginning of the show, your on-set team will be out of the office until the **shoot wraps.** Consequently, you will be working on shots while survey is still being completed, notes are still being taken, measurements are still being gathered. *Effective communication of notes is key.* If you are on set, communicate often with your coordinator back at the office to make sure that your notes are being effectively disseminated. If you are back at the office, communicate often with your coordinator about the availability of notes from set. *If* the culture of your show permits – and make sure it does first, by asking your lead or coordinator – you might even communicate directly (politely, and patiently – they are *incredibly* busy) with the guys on set with questions about notes. Make friends with the on-set team! I've said it before and I'll say it again: they're heroes and they'll save your life.

When the on-set team comes back to the office, they will have more time for questions, but remember that they are just as busy with shots as you are, so don't overdo it. That said, they like to know that their hard work is being used and appreciated, and are generally happy to help, so if you have questions about a shot, *ask.* Sometimes set notes don't get disseminated in a timely fashion, because the production staff gets overwhelmed, or for various other reasons. Depending on the show and my relationship with the folks in question, I might even ask the on-set team if they have anything notable for every shot I start. You wouldn't believe the time and stress I've saved with that habit – as well as the fun stories from set I've heard!

Shoot

Live action photography.

Pickup Shots

Additional footage shot after primary and secondary photography — sometimes long after.

Wrap

(1) End of work for the day on set; (2) End of the entire shoot; (3) End of the show for the VFX facility. It's a very serious union penalty to call wrap on set for the day and then call crew back for more work — wrap isn't called lightly.

Back at the Office: Information Integration

The Graphics Pipeline: An Overview

If you've never worked in a visual effects facility before, you might feel overwhelmed by the sheer volume of information and different tasks and meetings and who knows what else going on all around you everyday. It can take some time to learn what all the departments do, and what happens to your camera information once it leaves your hands. It's a good idea to know at least a little bit about what happens to your data, though, so that you can anticipate problems and be proactive. That's the kind of matchmover who keeps getting asked back.

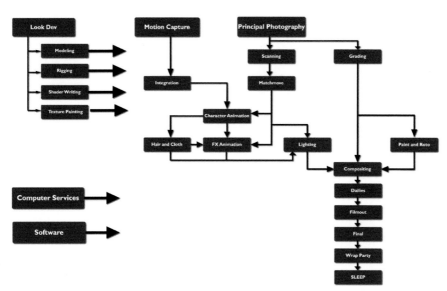

Figure 2-19 Simplified VFX pipeline.

Let's look at a very basic visual effects pipeline:

As you can see, even a stripped down, generic pipeline can be a little confusing! Here is a quick breakdown, as they relate to the matchmove department:

Visual Effects Side

Scanning

The scanning department takes the actual film from the production company and scans it, creating digital files for the whole facility to use.

Color Grading

The folks who ultimately decide how to color-correct the incoming raw footage for use in the facility.

Computer Services

Sometimes called technical assistants, render watchers, or various other terms, these folks keep the render farm running, make sure that publishing is working, and a host of other day-to-day functions running so smoothly that one might think that they do nothing at all, which couldn't be farther from the truth.

Software

The folks who write all the in-house software, and make the in-house software work with the off-the-shelf software. They often work with Look Dev to create show-specific tools as needed, often on the fly.

Look Dev

Artists from various departments who work on developing the "look" of a show — including characters, sets, and other styles — before full production starts.

Modeling

Responsible for creating sets, props, and characters for production. Characters and certain props are passed on to Rigging before they can be used for matchmoving or animation.

Rigging

Responsible for creating skeletons and other systems for animating otherwise static models.

Integration

Responsible for integrating motion capture data and transferring it to rigged CG characters. Often, the motion capture animation will be tweaked by character animators.

Matchmove

Responsible for recreating camera information and camera moves, along with matching practical elements and actors that interact with CG elements.

Effects Animation

Responsible for various dynamics based animations and effects, such as water, sand, snow, fire, and so on. Character and prop motion from matchmove is especially important to hair and cloth, and care must be taken to ensure smooth motion that continues both before and after the beginning and end of the shot.

Hair and Cloth

A subset of effects animation relating to cloth simulations, hair, feathers, and other similar effects. Character and prop motion from matchmove is especially important to hair and cloth, and care must be taken to ensure smooth motion that continues both before and after the beginning and end of the shot. For more details, see Chapter 11.

Character Animation

Responsible for bringing the virtual characters to life. Digital characters often interact with the virtual environment, so it is imperative for a matchmover to accurately reconstruct the location and action in a shot for the character animator to interact with.

Shader Writers

Responsible for procedural appearance of virtual characters, sets, and props. This department works closely with texture painters, modelers, and riggers.

Texture Painters

Responsible for the painted appearance of virtual characters, sets, and props. This departments works closely with shader writers, modelers, and riggers.

Lighters

Responsible for recreating and enhancing lighting conditions found on set to create photorealistic images for later integration with on-set photography. They rely on matchmove for elements needed for shadow casting, reflections, refractions, and the like.

Painters/Rotoscopers

Painters use software or directly paint out undesirable elements from film frames, such as wires, rigs, or other elements. Rotocopers create animated 2D mattes used to integrate live action with CG elements. They work closely with compositors.

Compositor

Responsible for the final look of the shot, integrating all of the elements from all other departments. They rely on match-movers to provide accurate camera and character data so that there is no slipping or **popping** in the final composite that would give away the illusion of reality in the final shot.

Note that in some facilities, Lighting and Comp is the same job function – lighters do their own compositing, or compers do their own lighting, depending on how you want to look at it.

Models and Modelers

All information from set — be it a full LIDAR scan or simply the plates from principal photography — will be sent to the modeling department, unless you work at a very small shop, or for yourself, in which case, of course, you will be doing your own modeling.

The model department will extract the salient data from the survey or LIDAR data, and other measurements taken on set to build virtual sets and props in a 3D software package. Modelers are also responsible for converting 3D scans of actors into useable data for use throughout the studio pipeline, including matchmove. Riggers will then take those character (and

Popping

Similar to slipping, a visible jump in the position of a CG element against the live action plate caused by an inaccurate camera solve.

occasionally prop) models and create virtual **articulated skeletons** for them so that they can be animated.

What *is* the salient data? What **level of detail** is needed? It depends. If, for example, a surveyed building is seen in only one shot and it's in the far distance, it might not even be modeled at all. A few pieces of geometry, like a cone, at each survey point will be enough to indicate its location. A detailed building façade that features prominently in several sequences, however, will be modeled in great detail. If the data gathered on set isn't sufficient for this level of detail, the modelers will refer to reference pictures, the plates themselves, and experience with similar structures to fill out the details.

Sometimes you will need a model that hasn't been built. It might be on the list for the modeling department and they just haven't gotten to it yet (very common in the early stages of a show), or it might have been deemed unnecessary. If it's something simple, go ahead and build it yourself. For example, if there is a chair in your shot that would really help your camera track, and there is no interaction with any CG element and the chair, make a simple cube to represent it. It doesn't need to be fancy — just reasonably accurate. If the on-set guys have measurements for it, all the better!

What if the chair simply receives or creates a shadow? This is a situation where you would need to confer with the lighting and compositing departments (through your lead or coordinator, unless your show culture permits you to contact them directly – see sidebar "Show Culture" later in this Chapter). How detailed does that chair need to be? Can you get away with a couple of cubes slapped together, or do you need something more accurate? Have a chat with the powers that be.

Sometimes, though, you'll need a model from the modeling department. Say, for example, that chair *does* interact with a CG character, and you need a tight match – for example, if a character picks it up. At that point, you would contact your lead or coordinator and let them know what you need.

First Steps: Setting Up Your Scene

Read the Notes from Set

Before you import models, create a camera, or anything else, *read the notes*. Know what happens in the scene. Trust me — this will make 90% of your shots go much more easily. It's better to spend a minute or two reading the notes and scene description than spending *days* on a shot, *then* reading the notes, and

Articulated

Made up of bones connected to each other with joints that move in ways similar to human joints.

Level of Detail (LOD)

The amount of complexity required in a CG model for a particular task. The farther an element is from the camera, the lower the LOD requirements are.

Tip: ALERT!

Be *very* careful when creating your own color-corrected plates **not to write over the existing plates** (called "stomping"). Make triple-sure that you've created *your own directory* for them and that your render settings point to them, and then check again. If you have any doubt at all, ask your lead!

realizing, "Darn, if I'd only known that *three days ago* I could have finished this shot in three hours!"

Review the Shot and Sequence

I can't overstate the importance of finding out *what's going to happen in your shot*. It's absolutely critical that you know what is going on in your shot, what characters will be in it, what effects, how detailed it will be, and so on. You will approach a shot that only needs some clouds added way in the background much differently than a shot with the very same plate needing an extreme close-up of an actor turning into a werewolf. If nothing else, make *sure* you know what your shot is about.

Importing Models, Creating Cameras

It's likely that your show will have an automated system for either or both of these tasks, especially if you work at a larger shop. This makes it less likely that mistakes will enter the pipeline. Make sure that you know whether any automation is in place for importing models or creating cameras on your show. This usually shows up as some sort of **plug-in** written for your software, but make sure to follow whatever procedure is established where you are working.

Likewise, there will probably be a set scene structure used at your facility that is common across all departments. Sometimes, the importing and camera creation processes will automatically create this structure for you. If it doesn't, I generally write a small **MEL script** to do this for me (sharing such a script with your department is often much appreciated). However you get your scene elements in order, make sure that they conform to show

Plug-in

A small program written to extend the capability of an application.

Scene Structure

The method in which data is organized shot by shot at a facility.

MEL Script

A very simple kind of plug-in created with Maya Embedded Language, usually from within Maya itself. For my purposes, this is generally used to perform repetitive or complex tasks that can be automated and turned into a one-click button.

Figure 2-20 Plate before color-correction.

Figure 2-21 Different color-correction passes may be necessary for different portions of your matchmove task. Though this pass wouldn't look good on the big screen, the increased contrast and slight blur will help the accuracy of the 2D tracking software.

Color-Corrected Plate

The manipulated live action plate, after various methods of changing the contrast, brightness, and other values have been performed.

Noise

Undesirable flaws in an image caused by film grain. In 35 mm film, the blue range of color is most often the noisiest.

standards. If you don't, your camera track will break the pipeline and trouble will ensue. (see Chapter 3 on naming standards).

Prepping Your Plates

Generally, you will be using raw (non-color-corrected) plates to track. This is mostly due to the fact that when plates come into the facility, matchmove needs to start immediately, and **color-correction** is a process that happens later on in the pipeline. It's not really a big deal though, because the final color-correction doesn't really have any bearing on matchmove.

That's not to say that color-correction has no effect, though. It's common for plates to come in too dark, too grainy, too low- or high-contrast, or otherwise hard to track in 2D. At this point, it's very handy for you to make your own color-corrected plates.

In general, you will find that the blue channel in any (film) plate will have the most **noise**; I usually get rid of it by switching it with either the red or green channel, depending on which one has the better detail for my purpose.

A small amount of blur — one to three pixels at the most — also helps in 2D tracking, suppressing grain. Finally, adjusting contrast will create a more trackable plate. Note that one set of color-corrections might be good for one area of a plate and another for elsewhere, especially in dramatically lit shots. See Chapter 7 for more details about color correction.

Creating the Camera

Now we are up to the meat of the subject. Obviously, we will be looking at creating cameras in much more detail throughout

Aspect Ratios

The relationship between the height and width of an image. Closely related to the filmback, the aspect ratio is calculated by dividing the width of an image by the height. For example, widescreen film has an aspect ratio of 1.85:1, often abbreviated to just 1.85. See Figure 2-23 for a comparison of film gauges and aspect ratios.

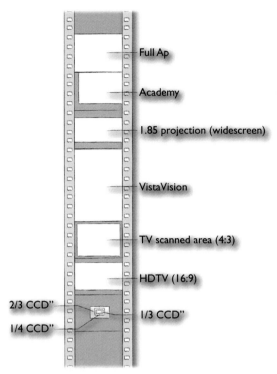

Figure 2-22 Common aspect ratios in use today. Many matchmove packages have presets for these standard formats. Note how much smaller commercially available video chips are.

Publishing

The process, often automated, of officially notifying your show that your task on a shot has been completed and approved. This usually involves creating a new version of your file, cleaning it up to include only the elements needed by the rest of the pipe, and locking the animated elements so they can't accidentally be changed down the line. It might also include other show or sequence specific processes. Publishing often also kicks out several email notifications to specific departments and people as to the status change of the shot.

Shadow Casting

The calculations performed in the CG environment necessary to create CG shadows. Shadows are cast by calculating the path of light rays from a CG source to a CF surface.

the rest of the book, but here we will look at the virtual camera's relationship to the real-world camera architecture.

The aperture plate (also known as the film back) in the physical camera holds the film in place and has an opening, called the film gate, that allows light coming from the lens to expose the film. This opening, measured in inches, translates to the "filmback" measurement in tracking software.

There are various standard **aspect ratios** in current use, and most tracking programs have preset options for you to choose when creating your camera.

The aspect ratio you chose will ultimately affect your tracking solve. This is because the film back, or aperture, and the focal length both work together to determine the field of view in the plate. The field of view comprises everything seen from the camera's perspective in that particular shot with that particular lens and aperture combination. If the aperture changes (in the physical camera or by scanning a smaller portion of the image in post

production), then the field of view changes, and so by necessity, the apparent focal length of the lens will change. See Chapter 4 for more details.

As I mentioned, most tracking software will have presets for standard aperture settings. If, by chance, your setting isn't there, don't despair! There are many excellent resources on the Internet to help you get filmback or video camera information. For more detail, see Chapter 3.

Your show might have automated processes to create your cameras. Make sure to check in with your lead about any procedures or updates for this important step. Automation of this sort makes sure all cameras and other elements will go through the pipeline smoothly; it's no reflection on your skills. Even if your show doesn't have an automated system, though, there are probably standards you need to adhere to. Make sure to follow any procedures set, and then work your matchmove magic!

Publishing

All this great work you produce won't do anyone any good if you don't pass it on properly down the pipeline. This process is most commonly called **publishing**. Always keep in mind that anything which interacts with the CG environment needs to be passed to the artists down the line: objects that cast shadows, receive shadows, are touched by a CG element, reflect or are reflected in a CG element, and so on. A common mistake beginning matchmovers make is to not publish a floor or ground plane; of course, in most cases, it would be needed to **cast a shadow** onto. Many times a plane representing glass is forgotten, but that would be needed for **reflections and refractions**. If you are in doubt, ask your lead what to include — a simple email along the lines of "I've included the ground, chair, and table in my final scene. Do I need to include any more props?" is all that is necessary. Learning more about the visual effects pipeline beyond your own task is very helpful for knowing what to include (or not include) in your published matchmove scene; be curious about other departments and how they work. It can only help you! And believe me: making sure to include all the information needed in a matchmove scene right out of the gate (as opposed to having it come back time and again needing more information) saves time, frustration, and makes you look good in the long run!

Reflections and Refractions

 Much like shadows, reflections of CG elements in practical elements are calculated by casting virtual rays of light between the CG element and the CG representation of the practical element. Refractions — the bent images seen through glass or water — are similarly calculated. These elements are created to enhance the reality of the final image.

Dailies

 The presentation and critique of work from the previous day. Depending on the show, this could be all work on all shots viewed by the entire crew in the morning (often very fun) or could be department-specific, viewing only that department's output and attended by only that department's crew (and occasionally the lead from the next department in the pipe). This kind of dailies is often called Sweatbox, as is the room it's held in. Most shows hold some combination of full crew and sweatbox dailies.

Show Culture

What's all this about show culture? Why wouldn't I be able to just call someone directly and ask the question I need to ask? What's with all the middlemen and formality? Doesn't it just get in the way of my getting the job done?

That's a great question, and one I wish more artists would ask!

Just as production on set has a strict command structure and way of doing things, so does the production structure in a visual effects house. In general, visual effects artists are really cool, open people — even the greats — and are willing to share. But when it comes to getting things done, command structure is in place for good reason.

Although the work we do is cutting-edge, creative, and fun, it's also high-pressure, complicated, and short on time. Clear and accurate communication and an awareness of the demands on everyone's time, are absolutely critical to successfully delivering the best work possible on time and on budget.

So you can see that if artists on the front line, so to speak, start calling each other, asking questions, reporting problems, making requests, and so on, without supervisors and production in the loop, chaos is sure to ensue. Lack of communication of problems especially can mean disaster in terms of time lost on a show.

Always report problems, questions, requests, and so on to your lead or coordinator. Which one? Well, it depends on the show. That's what I mean by show culture. Every show is different, so make sure you are clear on this particular issue as soon as you're assigned to a show. Find out how they would like to be informed — email? Phone? IM? Try to keep a copy of the communication for your reference as well, and keep track — don't let things fall through the cracks. Be proactive: leads and coordinators are busier than you can imagine!

That said, don't be afraid to ask for help if you need it. Most shows have a "15-minute rule" policy, and it's one you should take very seriously. If you are stuck on a problem for more than 15 minutes, call your lead or a coordinator and let him or her know. Often, it's a simple fix, and you'll be on your way again in no time. Even if it's not, it's much better to let someone know you're stuck after fifteen minutes rather than eight hours. These policies are in effect for good reason — always respect them.

Does your show let you call people directly? Make sure to ask. A simple "Hey, do you mind if I ask so-and-so if he needs a really accurate chair for that one shot?" might help your lead or coordinator out enormously, and be perfectly fine in the culture of your show — just make sure to copy the right people on your email, so the right people know what's going on. If you're friends with the lighting supervisor, so much the better. Chance meetings in hallways are perfect places for this kind of thing, *if your show culture permits.* Just make sure to shoot an email to the right people afterwards — "I saw so-and-so in the hall and he said just a box was okay for that chair in that particular shot." That's a pretty easygoing show, but it relies on *everyone* following the Golden Rule: stay in touch, keep the right people informed, don't go off on your own and start changing things. If you don't, you'll definitely get yelled at in **dailies** and you might even go to a less relaxed way of doing things!

A more formal show culture communicates through department leads and coordinators. All of your communication will go through one or both of them — again, make sure which one and how they prefer to communicate. Don't call another artist or department lead unless specifically asked to. If another artist calls you directly with a request or problem, say something like, "Let me check into that for you," and contact your lead or coordinator. They may have you work directly with the other artist after all, but always check in first. You might be able to get some things done in chance hallway encounters, but always check in with your lead or coordinator first

and let them decide how to proceed. It sometimes feels like you're being unhelpful, but following the structure of the show instead of fighting it is actually the more helpful way to act in a situation.

Why such different styles? Well, it takes all kinds of people to make the world go 'round, doesn't it? Some producers or leads are just more comfortable with one way or the other. You are probably also more comfortable with one or the other. Sometimes a tight schedule dictates a more formal structure in order to meet a deadline, or the culture changes mid-show to adjust to changing deadlines. You'll definitely encounter both styles over your career, and the important thing to remember is that whichever structure you are working in, it's not personally directed at you, and you should go along with the flow. Follow that rule, and some day you'll be able to set the tone of your own show!

Reference

Goulekas, Karen. (2001). *Visual Effects in a Digital World*. San Francisco: Morgan Kaufmann.

USE WHAT YOU KNOW: COMMON SENSE AND THE MYSTERY PLATE

You Know More Than You Think You Do

More often than not, you will get a plate to track — and be missing a valuable bit of information. Even the best-laid plans for recording data on set can fall apart, and things might be overlooked — you wish you knew how wide those floor boards are, for example, or how deep the area rug is. Sometimes it's hard to know in the heat of the moment what measurements will and won't be important when you're on set; even if you have the best guys on set getting matchmove information for you, some things will slip through the cracks.

Sometimes, the shot in question wasn't intended to be a VFX shot in the first place, so no information was recorded at all. You won't even know the lens used, much less have any measurements from the set, information about the height of the camera, props, and so on. What do you do when you have absolutely no information at all?

Actually, in this day and age, you have tons of information. You can use **imdb.com** to get actors' heights. Google Earth has invaluable information. Google Street View can be extremely helpful in outdoor shoots as well. Any location can be searched on the Internet — you can find photos of other angles of your location, which will be helpful in determining locations of buildings and other features. You can even find topological maps online through the USGS (United States Geological Society), in case you need to model hills or other terrain.

In addition to this wealth of knowledge, you also know many, many things about the world around you — you just don't *know* you know. So many objects that surround us in everyday life are standardized to some extent. Many of these standardizations are in fact encoded into laws — like fire codes, building codes, the ADA (Americans with Disabilities Act), and so on. It's

DOI: 10.1016/B978-0-240-81230-4.00003-8

virtually impossible to look at any location and not find at least one thing that isn't standardized, be it a door, parking meter, pool rail, staircase, 2×4, or something of the like.

Furthermore, there's the phenomenon I call "*you live in the world.*" By that I mean that you move about a very tricky environment, coordinating tons and tons of information coming in through your five senses from all around you at an astonishing rate, and you do it without even really noticing it — you're just walking down the street. But if one aspect of that delicately balanced system of incoming stimuli and outgoing response is off, you know it instantly — you see something out of the corner of your eye and your head snaps in that direction without your even thinking of it, you start to trip over a crack and you catch yourself before you know you're falling, you see a trick of perspective when two sidewalk grids cross each other and feel temporarily dizzy. Because you live in the world, as I like to say, you have instincts and subconscious knowledge of the "way things work" that are invaluable to matchmoving — if you open yourself up and let them work for you. A lot of times, this is as simple as putting familiar objects in your scene — CG people, cars, or other familiar objects appropriate in scale and subject matter to your shot — and seeing how they feel. You'd be surprised how often this kind of instinctual testing really gets you back on the right path in a particularly tough matchmove.

When you combine your knowledge of these kinds of standard measurements with the individual data you can collect online, and with a little educated guessing and your native instincts about the real world, you should be able to handle any kind of camera track or matchmove thrown your way. Who says matchmoving isn't an art?

Where to Start?

Believe me, I know the panicky feeling you get when you are confronted with a plate, a deadline, and nothing else. Resist the urge to panic! Go get a cup of coffee, do a little friendly complaining about your situation in the kitchen (not too much — you don't want to be labeled a whiner), and then start your data mining.

If your shot is one of a sequence, you have it made. Maybe this shot wasn't intended to be a VFX shot originally, but now it is. This is great — you have tons of information about the surrounding shots, so it should be easy to figure out the location of the camera in the set, you should be able to make an educated guess about the lens based on the other lenses in the sequence, you already know about any props, actors, and so on. You're in great shape.

But what if it's just a random plate, unrelated to anything else you've been working on — some second-unit footage, maybe, for which no information was recorded? Well, now it's time to gear up your web browser!

Figure 3-1 I found this photo on the Internet while searching "parking space dimensions" online for another shot I was working on.

Here is your new plate. Your boss wants to use it to demonstrate a new skyscraper he plans to build. Or maybe have some dinosaurs stomp through. You have no information about it whatsoever — except that it seems like everyone is having fun. Help!

The Web is Your Friend

To start with, obviously this scene takes place in a parking lot, and it looks like a tailgate party. I see a University of Texas logo on top of the smoker (upper-lefthand corner). So I'm going to make an educated guess that this scene is in a parking lot near a stadium in Austin, Texas.

On the Internet, I search for "University of Texas stadium." I'm looking for a map or a plan of the campus that can help me locate this particular parking lot. The building on screen left of our plate is obviously a parking deck, and the building on screen right is an office or classroom type building. I'll use these clues to get me started.

On the University of Texas web site, there is a useful campus map that shows the area around the stadium, and features photographs of each building:

Manor Garage-MAG (formerly PG5)

Stadium Area

Figure 3-2 A photograph on the UT web site resembles one in our plate, and gives us a starting point. The map gives us valuable information about the surrounding area.

It looks like the parking deck on screen left of our plate *could be* the Manor Garage. I'll look around a little more to see if that other building in the plate is on the campus map.

After looking through the map a little longer, I don't see anything that looks exactly like the building on screen right. More investigation is required. But as you can see, we've already found out quite a bit about this scene.

Figure 3-3 The intersection of 23rd Street and Robert Dedman Drive.

Google Maps

From the campus map, I can see that the stadium and the Manor Garage are near the intersection of 23rd Street and Robert Dedman Drive. I'll look that up on Google Maps.

The Satellite View in Google Maps makes it easy to see where there are parking lots around the stadium, and I know the parking deck to the east of the stadium is a good place to start. The Street View feature is also available for this area, so I'll set the Street View Icon Guy (technical term!) down near the parking deck and look around. In fact, I see that there is a parking lot immediately to the south, which seems like a good place to start.

Though I can see the parking deck, I don't see the other building on screen right of the original plate. I'll look around different parking lots in the area to see if I can identify that building on the right. Luckily, it has rather distinctive windows, so it shouldn't be too hard to find. Use the information available to you!

Figure 3-4 Street View, with Street View Icon Guy (highlighted).

Figure 3-5 Building with distinctive windows (center top).

And there it is! It did take a couple of minutes, but I found the other building. It seems I've made a mistake in my earlier assumption, though, that the parking deck on the left of the plate was Manor Garage. That's okay – it was just a preliminary assumption, a place to start.

Remember that the goal is not to be right on the very first try and then give up if you're wrong; the goal is to use your intuition and common sense to get the information you need.

Tip: Roll with It!

Original assumption wrong? No problem! As you gather new and better information, throw out theories that no longer work. It's the nature of discovery!

So I simply revise my assumption: this is clearly the building on screen right of the photo, so let me look around and see if I can find a view around this area that coincides with my plate.

I really like the look of that parking lot next to our building. I wonder what it would look like to stand there? I can virtually "drive around the block" to check the views and see if anything looks right.

 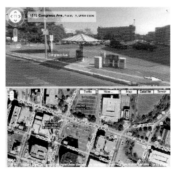 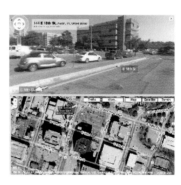

Figure 3-6, 3-7, and 3-8 "Driving around" the virtual block.

This view (Figure 3-6) shows only the one building — I don't see the parking structure I'm looking for. I'll keep "driving" around the block.

You can see that we are now at the corner of Congress Avenue and East 18th Street, and what have we here? That building peering through the trees above the bus stop canopy sure looks like a good candidate for the parking deck (Figure 3-7)! I'll keep "driving" around the block. I have a good feeling about this!

Figure 3-9 Google Earth view of location.

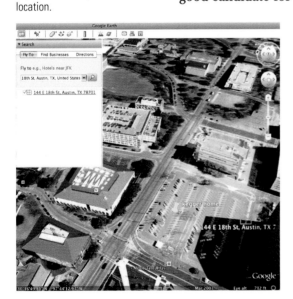

And voilà! When you compare Figure 3-8 to the original plate, you can clearly see that we are in the right location. Obviously, the tailgate party in question took place in the parking lot at the corner of Congress Avenue and E Martin Luther King Blvd. in Austin, Texas.

Google Earth

"Great," you're saying to yourself, "I know where some kegger happened sometime in the past. How does this help me match this camera and scene *today*?" *I'm glad you asked.*

Let's take a look at our location in Google Earth. Google Earth is an amazing, free application that allows you to virtually fly around the world. Whereas in Google Maps you can see a map view and hopefully a street view, Google Earth lets you fly around any location, often in 3D. It's an invaluable tool.

Let's see what our parking lot looks like in Google Earth. I plug in the address...

And here we are, at our tailgate party! (Figure 3-11)

Google Earth will allow me to fly around the parking lot in three dimensions. I make sure to select the "3D Buildings" option so that it's easier to visualize our shot.

Now all I have to do is swoop in and approximate the location of our shot.

Figure 3-10 3D Buildings option (in blue).

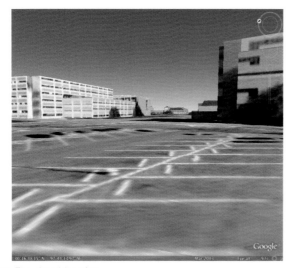

Figure 3-11 The virtual location.

Fantastic! We now have a ton of information about the dimensions of our set. We can adjust our eye height (noted in the lower-righthand corner) and move around the parking lot as needed to line up our shot. All those parking spaces will make it pretty easy when the time comes.

Another invaluable tool in Google Earth is the Ruler function. As you can see in Figure 3-12, I've measured the length of a parking space, and it's about 665 cm. Of course, parking spaces are generally standardized and we can look them up to be more accurate, but just imagine all the uses this tool can be put to! I've never been to Austin myself, but I can get reasonable measurements of this parking lot from satellite photos using this tool. Amazing! I feel like Jack Bauer.

Figure 3-12 The ruler tool shows the parking spaces are about 665 cm long.

Building the Set

Now that we have this treasure trove of information, we can start building our set.

If you are comfortable modeling in Maya or some other program, and want to spend the time using the measure tool in

Naming Conventions

Most places you'll work at will have set naming conventions and shot trees (the way in which their files are organized on the servers). *Always* follow these conventions. All automated processes, from backup to render queue allocations, depend on proper naming conventions, and you simply won't be able to get your work done efficiently — or at all — without following the rules. You might think you know a better way — and maybe you do. But unless you were hired to rethink the naming conventions for the facility, **don't**. It's unprofessional and wastes valuable time.

That said, other shops will be a little more, freewheeling, let's say. This is when it's *most* important for you to develop a standard naming convention for yourself, and to stick to it like glue. For example, use Maya's (or that of whatever software you are using) standard project structure, and organize your files neatly according to it. If you have data that doesn't fit into that structure, such as After Effects projects and renders, create a file system for those and stick to it for every project you do; look at the shot tree structure in Figure 3-13.

This might seem a little over-organized, but trust me, it will save you in the long run.

One other convention to follow is UNIX file naming. It's easy to be lazy when naming files these days, as most operating systems will recognize files with spaces, illegal characters, even ones missing extensions. Not so with UNIX or LINUX systems. "But I'm not working on a LINUX system," you say. Well, someone you hand your files to might be, or someone who backs the information up might be, or the render farm your files go to might be. Even if your files never go to a LINUX system, however, they most likely will pass by someone who is familiar with it — and you will look rather amateurish if you can't name your files properly. It could mean the difference between future work with this person or not. So don't fight it!

Proper LINUX naming conventions prohibits spaces, dots other than the dot before the extension, and all special characters except the _ (underscore): ~!@#$ %^&*()—+={[}]|\?/><, all are verboten!

Figure 3-13 Typical file structure for a single shot.

Most studios name files in one of two ways:

- you_know_more_v01.ma
- youKnowMore_v01.ma

The second example is called "camel case" — because it has humps. I tend to use it a lot myself, but both are equally acceptable. Note the **padded versioning** — v01 rather than v1-it helps keep the versions in proper order when listing files. Either format is acceptable, the point is to pick one and *stick with it for every element you create*. You'll look professional, and what's more: you'll be able to find files when you need them!

Google Earth to virtually survey your site, by all means, go ahead. I myself am not the best modeler (though I get better every shot!), and because I already have a satellite photo of the site right here in Google Earth, I'm going to use a much easier tool to bang out a quick and dirty set for myself: Google SketchUp.

Once in SketchUp, I can easily import the Current View (of the kegger location) in the open Google Earth port (seen under the SketchUp window in Figure 3-13) as a ground texture. Very cool feature!

Figure 3-14 Google Earth open under SketchUp.

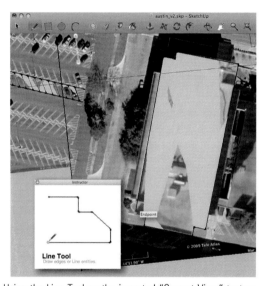

Figure 3-15 Using the Line Tool on the imported "Current View" texture.

Using the line tool, I trace important features in the parking lot, and then trace the main part of the building to screen left in our plate.

In Google Earth, I can estimate the height of the building by creating a polygon parallel to the ground that intersects the building in question and adjusting its height. As you move the polygon up and down, you can gauge the height of the building.

We see that the center mass of the building is about 23 meters tall.

Padded Versioning

To "pad" the version numbers of files with leading zeros, in order to be able to list them in sequential order. For example, files named **foo**_v1 and foo_v15 would display out of version order in a directory list. However, **bar**_v001 and bar_v015 would list in proper order, up until bar_v999 (which hopefully will never exist).

Foo, Bar

generic file names used when giving examples. Typical usage: "When you render file foo.mb, the result is bar.001.rgb."

Tip: Neutral Ground?

I said I'd do my best to be software-neutral in this book, so why am I being so specific now? Well, in this chapter I thought it would be a good idea to really show specifically how I go about creating a location model from nothing, and these are the actual tools I use. Because they aren't matchmove-specific, I think it'll be okay.

Figure 3-16 Add a polygon in Google Earth to estimate the height of a building.

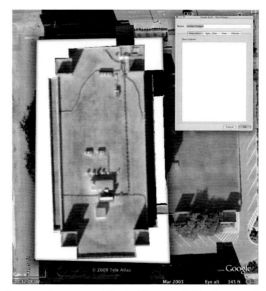

Figure 3-17 Draw a polygon around the building, parallel to the ground.

Figure 3-18 Adjust the height of the polygon to estimate the height of the building.

Remember that civilians on the ground supply the models in Google Earth, so this height might be an estimate rather than millimeter accurate, but it's good enough for our purposes.

Next, I'll use the tape measure tool to create a guideline for the height of the building: The units are in millimeters, so I enter 23000 into the box.

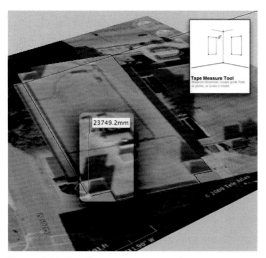

Figure 3-19 Use the tape measure tool to create a guideline for the building model height.

Figure 3-20 Enter 23000 mm in the guideline box.

Next, I use the Push/Pull tool to create the center mass of the building. I click on the outline that I created with the line tool, pull up, and click near the guide point created by the Tape Measure tool to snap to it.

Fast and reasonably accurate! Going along in that fashion, I create the rest of the pertinent features of the site.

Figure 3-21 Snap to the Guide Point — click near the guide line to invoke.

Figure 3-22 Other buildings are created, now to import "sanity check" models!

Figure 3-23 Importing familiar forms like people and vehicles is one of the most effective ways to judge the overall "feel" of your camera solution.

Now that I have my models built, let's bring in some reference as well — what a supervisor of mine calls "sanity check" models: people, cars, and the like, to put in the foreground and use to get a feel for how the shot is working (see Chapter 6).

Remember that there are some trucks, people, and an Airstream in the foreground of our shot — these models will help a lot with the sanity check!

True Tales of Matchmove: Sanity Checks Will Save You!

Not long ago, I was working on a couple of spots that featured shots of a woman working out in front of a flat panel TV and a product shot of the box the exercise videos come in ended up being done in CG. Because the product shot wasn't originally intended to be a CG shot, I didn't have any information from set at all, except for some publicity "behind the scenes" type photos shot on the day. From those, I figured out that the location was an actual home, not a stage, I was able to identify the kind of camera used (very lucky), and had a good snapshot of the Sup I was working with back at the office standing next to a piece of furniture that was also in my plate — so I could gauge about how big that was. Great place to start!

I built a quick little model out of some basic shapes, created the camera, got all my guestimate furniture lined up, solved for the lens, and everything was looking good, until (much like in the tailgate party shot) I checked the

location of the camera. It was much farther away from the background than possible — because this was a real apartment and I could see how big the room was from the reference photos, I knew it wasn't possible for the camera to be located so far away.

So I backtracked a little, checked my measurements, and was a little puzzled. Everything seemed to check out. Finally, I pulled a human model in, to see if that would tell me anything.

It sure did! The whole room — except for the couch — was way too big! The way the camera was positioned in the plate, it was difficult to see how far the couch was from the other pieces of furniture, making it hard to judge the scale of the other props in the room. Turns out, I had made the flat panel too large — 50" rather than the 42" it turned out to be. Then, I'd scaled everything else around that too-large TV, and had simply moved the sofa closer to camera, making it seem larger, and therefore in scale with the rest of the oversized room, and everything looked fine. Since I had no information from set, these are all easy assumptions/mistakes to make.

But when I brought my CG person in, the mistake was obvious immediately. The TV and other furniture *towered* above her! Once I got her in the scene, I was able to quickly fix my mistake, rescale and reposition all the geometry, and came up with a good camera very quickly. Even though the plate didn't have a person in it, putting a CG person in your scene puts everything in perspective — literally and figuratively — really quickly.

One more sanity check: There is a scale on the ground map in SketchUp, so I create some geometry for that by tracing it with the pencil tool so that I can check that the scale translates correctly when I export this model to Maya.

Figure 3-25 Export OBJ models for import to Maya.

Figure 3-24 Create geometry for the scale indicator to import into the matchmove software.

I select the models I want to export, set dimensions to centimeters, export them as OBJ files, and import them into Maya, which I'm going to use as my matchmoving software in this instance.

Tip: Need More Help?

Google Earth and Google SketchUp are both very popular software packages, and are well documented online. If you ever have to build a model from scratch like this, there are tons of tutorials, free models, and more to get you started online.

Figure 3-26 Set options: make sure units are set to centimeters, or the default units for your facility.

Figure 3-27 Imported OBJ set from SketchUp, verifying measurements with the imported scale geometry.

Creating the Camera

So far, we have done a lot of data mining in order to get a good camera lineup for a photograph about which we have no information. We've discovered the actual location of the photo, built a reasonable model for it, and have it ready to go in Maya. We're done, right? Time to go home!

Not so Fast. We Need to Create a Camera for Our Scene!

Since we have no way to know what kind of camera was used for this photo, we're going to have to make some assumptions. I'm willing to bet that this is a snapshot taken by an attendee at this event, and was probably taken with a consumer grade point and shoot digital camera – you know, the kind everyone has in their pocket these days.

I poke around on the web a little, researching the size of the chips on these types of cameras, since the chip size in a digital camera is analogous to the film gate in a film camera. There is an excellent web site, **dpreview.com**, which gives information about a variety of cameras on the market, and their various chip sizes. For more information on chip sizes and how they relate to film gates, see Chapter 4.

The chip size in a digital camera is analogous to the film gate size of the Maya camera (which itself relates to the image size of the plate used, in inches). Therefore, whichever chip size I decide to use, I need to convert it to inches before I enter it in Maya.

After poking around dpreview.com, I see that many consumer cameras have a similar chip size to mine, a Sony DSCW130, so I choose that one. It measures 5.75 mm × 4.31 mm, or 0.2264 in × 0.1697 in.

Let's create our camera: In Maya, Create >>Cameras >>Camera.

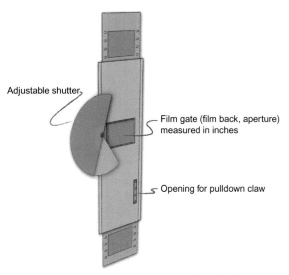

Figure 3-28 The CCD (chip) in a digital camera is analogous to the filmback in an analogue camera, so that's the dimension we give the matchmove software.

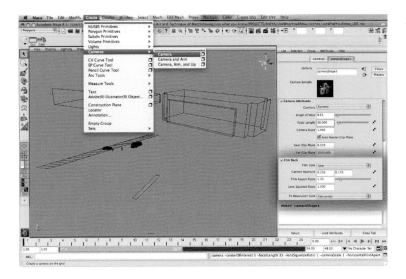

Figure 3-29 Creating a camera using the Create Camera Menu.

Figure 3-30 Enter the film gate information.

Figure 3-31 Create the Image Plane in the Environment tab.

Figure 3-32 Name your camera immediately according to the proper naming conventions on your show. Sometimes this process is automated, especially at big shops.

In the Attribute Editor, enter the film gate information we calculated from dpreview.com (Figure 3-30).

"Far Clip Plane" should be set fairly high, since we are working with full-scale buildings. How high? I usually add a couple of decimal places in the box and see how that goes. It's not scientific, but it works.

"Fit resolution gate" refers to the way your plate is visualized in the camera view port in Maya; I prefer Horizontal or Overscan, so that I'm sure I'm seeing the entire plate at all times.

Keeping in mind your meticulous adherence to your naming conventions, name your camera immediately in the attribute editor.

shotCamera is the name I happen to be most comfortable with, though you should come up with a name with you are comfortable and will stick with. If your facility has a standardized naming convention, make sure to use that.

Now, create your Image Plane: in the shotCameraShape tab of the Attribute Editor, open the Environment tab. Click Create to create the Image Plane. I also made some comments about my camera in the notes section.

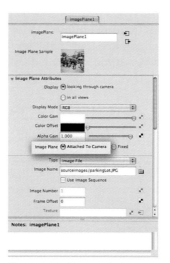

Figure 3-33 Be sure the image plane is attached to the camera!

Figure 3-34 Adjust the depth of the image plane. Adding a couple of zeroes at the end of the number in the box should do the trick.

Under Type, select Image File, then select your image. Choose RGB from the Display Mode drop down menu (unless you need an alpha channel – right now it's unnecessary) and make sure the image plane is attached to the camera. You will want to move the Image plane back, away from the camera, so that it doesn't block your view of the models in the scene (Figure 3-34).

Lining Up the Shot

Now you're ready to look at your scene through the camera you've just created!

Before you do that though, sit back and think a minute. Look at your plate. Where was this picture taken from? To me, it looks like the person who took the picture was standing on top of something tall to get a good view of the scene — maybe in the back of a pickup truck, pointing the camera slightly down. A six foot tall guy standing in the bed of a truck would hold a camera about, let's see, typical truck bed is...I Google "F150 bed height," it's about 36", Dodge Ram, 20", Chevy Silverado, 37", so let's call it 30". This gives us a starting out height of 102 inches or 259 cm. I plug this value into the camera's Y translation channel box.

They're standing in a row of parking spots that are slanted away from the viewer, and judging from the angle at which I see the two buildings in the background, I'd guess the mystery photographer is generally somewhere along a 45° angle from the corner of East Martin Luther King Boulevard and Brazos Street. Also notice the trees in the plate, most notable the one to screen left; it's clearly in the parking lot itself, while the ones to screen right are along Brazos Street.

Figure 3-35 Highlighted features: trees, parking spaces slanted away from the photographer.

Figure 3-36 Display the camera's field of view.

Tip: Wait...*What?*

 Why is this lens *so* much shorter than I'd originally thought? It's because I was thinking about lenses for 35 mm cameras, not a camera with the much smaller filmback we have here. When the filmback size changes in a camera, the relationship between the lens, the field of view, and the focal length all change as well. The 38 mm lens I'm thinking of will actually be much shorter for the much smaller chip in the consumer grade point and shoot. For more information and details, see Chapter 4, So...You Have a Video Plate.

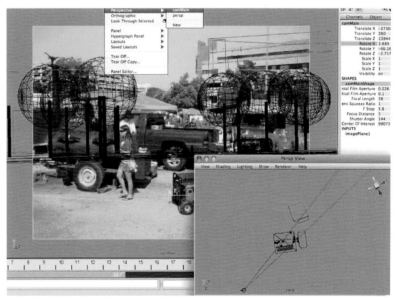

Figure 3-37 To get the framing in the plate with the current lens, the photographer would have to be way across the street (lower right panel)!

Tip: Tearing Off Panels

Quiteoften it's useful to have different viewports open at the same time, but it's always preferable to have your shotCam port open to full size so you can see as much detail as possible. Tearing off a copy of a panel is the best way I've found to do this.

Figure 3-38 Panels>Tear Off Copy

Keep in mind that you must tear off the view you want — so if you want the Perspective Camera, tear that view off, and so on. Another advantage to this trick is that you can use the Show Menu in your Tear Off panel to show different components of your scene, shade it differently, etc. It's a great trick!

Figure 3-39 With the perspective panel torn off, reset the main window to the camera view. This is an excellent setup for checking back and forth as you work!

There are three candidates for the screen left tree, but I suspect it's the center one pictured below. It seems to be in line with the highlighted tree on Brazos Street (Figure 3-35).

So using some common sense and research skills, I've decided that the best place to start my camera is at the big

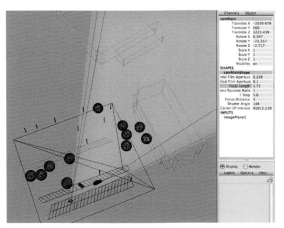

Figure 3-40 Shortening the focal length widens the field of view.

yellow X, about 259 centimeters above the ground, and most likely at the shortest focal length the camera has to start with, 38 mm. Let's see how we do:

Notice I went back and modeled the trees, light poles, and more parking spaces after I considered more carefully where the photo was likely taken. That's OK; as I said before, the goal isn't to be spot on on the first try, but to use intuition and reasoning to get to where you're going. It's a process.

When I turn on the Camera Manipulators to show the field of view encompassed by the focal length chosen, I can already see the lens is way too long – in other words, the field of view is too narrow, and doesn't include nearly the scope we see in the plate. That means one of two things: the photographer is much farther away from the foreground subjects than I thought, or his lens is much shorter than the specifications I found on the web (entirely possible, and completely true, as I later found). Of course, there is one other possibility – this photo could be stitched together from a few pictures, but it looks too uniform for that, so I'm going to throw that assumption out.

How far away would the photographer have to be to get the field of view we see in this photo with a 38 mm lens?

Wow, way back across the street (Figure 3-37) – which, if you recall, is a very busy intersection – and you can see that the lens is completely wrong in terms of perspective. Obviously, he has a shorter lens. Regroup!

I'm going to move the camera back to my original position and play with the focal length.

Using the channel slider, I adjust the focal length until it more closely resembles the field of view in the plate.

How does that look?

Tip: Scrubbing Channel Box Values

I find it much more intuitive, most of the time, to scrub values in the channel box for fine tuning rather than using manipulators or entering numeric values directly into the channel boxes themselves. To do this, you must set the switch between manipulators, no manipulators, and channel sliders (by clicking the axes):

Figure 3-41 Manipulators, no manipulators, sliders (scrubbing in channel boxes).

Next, you will want to set the rate at which you will scrub. Click the round icon next to the axes to choose between slow, medium, and fast slider settings.

Figure 3-42 Slow scrubbing

Figure 3-43 Medium scrubbing

Figure 3-44 Fast scrubbing

Medium and fast settings are good for translations, especially when you are working on full-scale models. You will almost always want to use the slow setting for rotations, unless you have a much more steady hand than mine!

To use the channel slider (scrubbing), highlight the channel you want to adjust, and middle mouse click and drag in the port. It's a very fast and intuitive way to work.

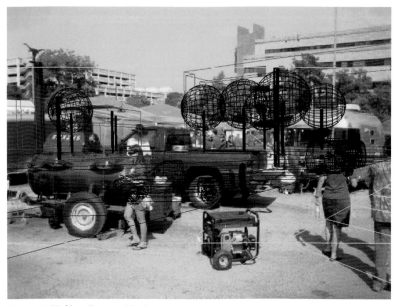

Figure 3-45 New lineup with shorter lens.

Right off the bat, you can tell that's much closer. The trees and buildings are more in proportion to each other, the ground plane is much more believable, and though the truck and camper are too far away, they are in the correct perspective as well. We are definitely on the right track.

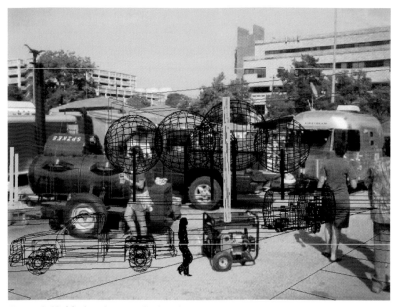

Figure 3-46 Moving closer to the location.

I can tell that the light pole in the middle there is clearly the one behind the camper in the plate. With that in mind, I'll start adjusting the position of the camera, rotating it on the Y axis

Figure 3-47 Still closer, adjusting X rotation and Y translation. Note the experimentation with focal length in the channel box.

Figure 3-48 Adjusting X and Z translation, Y rotation. Note the experimentation with focal length in the channel box.

and skootching (technical term) it on the X and Z axes to line the light pole and buildings up (Figures 3-47, 3-48).

Closer… I'm wondering about the height of the parking deck across the street. Obviously the camera still isn't quite right, but the height of everything else is pretty close. I remember when I was modeling it that it seemed a little short for a five or six story parking deck. I also recall that models in Google Earth are built by regular folks like you and me, and that heights might be estimated – and maybe not quite accurate. Or, it could be it's on a rise in the landscape. I'm not going to sweat it too much, as long as it's in the correct perspective and everything else looks good.

Figure 3-49 Final lineup. At this point, I would turn to automated software to fine-tune my fit. Note the final focal length – around 6 mm – close to the rough calculation I came to when figuring the Zoom Factor for a chip of this size in Chapter 4.

Much closer. Looks like I was wrong about our photographer standing on something, though; 170 cm is actually about my height, 5'7", so our photographer is probably around 5'10" or so. As I've said before, and will keep saying, you don't have to be spot on the first time, but adjust your assumptions as more information comes in, use your intuition, and use your research skills to get you where you need to go.

I'm going to adjust the focal length some more, and ease the Y rotation and X and Z translations accordingly, until I reach this lineup:

Though it's obviously not perfect, after an hour or so of easing and methodically testing focal lengths from 2 mm to 10 mm, I'm confident that I'm in the ballpark, since the best fit always falls in the 6 mm range. Notice I didn't end up in the area I originally assumed the camera was, and also that our photographer seems to be standing on something after all. It's OK; roll with it, as long as it makes *some* kind of sense.

Obviously, had I come up with a solution where the camera was underground, or a mile high, that would be suspicious! But the difference between standing on the ground and standing on a truck is well within tolerance in this case. Also, I can't get the parking deck to fit; I'm just not very confident in that model, and I'm not going to worry about it. For my purposes, this is good enough.

Normally, in a professional environment, you'd have access to some kind of automated software to be able to get a much more precise fit, and be able to solve for the focal length. That would be my next step in this case, after my first quick lineup. Since I had the camera in the wrong part of the parking lot at first, it would take a little longer than normal to get a good lineup and solve for the lens, but again, the point is to use common sense, and keep feeding the information you gather along the way back into your solution as you go.

So there you go! Now, next time you get a shot with "absolutely no information," you'll know better – and look like a hero for solving it!

When "It SHOULD WORK!" *Doesn't*

Perhaps the most hated phrase in the English language, right after "it's not you it's *me*," is "But it *SHOULD WORK!*"

Many times, you set up a shot just as you have a million times before, and for some reason, it just won't work. The software won't lock onto your models the way it should, your image plane won't display correctly, or any other of a hundred other things will go wrong or just not work as expected. Instead of trying over and over to get your problem to work, clicking and clicking and clicking your mouse on the same three buttons over and over and *over with the same result* – **STOP!** I'm going to impart a piece of wisdom I've learned after some hard, hard knocks and long, long nights:

Just because it SHOULD work, doesn't mean it WILL.

I know. Computers are infallible, as are the geniuses who program them, right?

No.

Get that out of your mind right now. I know you want it to be true, but it's not. In fact, I find it's easier to just assume that **computers are magic**. So you'll have to get creative when you run up against an "it should work!" type problem.

First of all, most places I've worked have a fifteen-minute rule: if you run up against a wall and can't solve the problem in fifteen minutes, get help. That's a good rule of thumb. If you've been doing the same thing, over and over, for fifteen minutes, and it's not working, chances are good it won't work, *ever* (at least not without intervention). So what should you do?

Take a deep breath. It's hard to give up a path when you've committed to it, and I know that sense of panic when you realize you've got a problem — especially if it's a BIG problem. Don't freak out, it only makes it worse. Calmer heads will prevail.

Quit out of your software, reboot your computer, and try one (and *only* one) more time. You'd be surprised — this solves about 98% of all problems. Don't forget**, *computers are magic*.** If your computer is really overheating, let it cool down a bit first, or get a fan.

If rebooting doesn't help, open up a whole new project, import your models fresh, create your camera fresh, and try again. Again, you'll be shocked how many times this will solve the problem, and you'll never figure out why. It just will. Computers? Magic.

If your fresh new scene still has trouble, try opening it on someone else's machine. Also have someone else open it under their own login. Sometimes your user environment can become corrupted or modified in such a way as to conflict with software. It's rare, but it happens. (If you are working in an office, this is easy, but if you're by yourself, unfortunately you'll have to go out of house to try this step, or skip it.)

Contact your supervisor. Something weird is going on if you've started a fresh new scene and nothing works. Don't be afraid to contact your Sup — it could be that there has been a change in software you haven't been informed about yet which is causing the trouble, or some other piece of information that hasn't been passed along yet that's the solution to your dilemma. It could be as simple as a change to some preference somewhere, and he or she was just about to send an email about it! So ALWAYS keep your Sup in the loop after you've tried the above steps (and have checked your email). If she is also stumped, it's most likely time to call in tech support.

SO. . .YOU HAVE A VIDEO PLATE

It's a Brave New Digital World

The advent of high-quality, relatively inexpensive high-definition digital cameras has caused a sea-change in independent film making. Now, like never before, indie directors can realize their visions more quickly and cheaply than ever before, making it possible to actually get their ideas out there rather than just sitting in the pages of a screenplay on a shelf. This is a really exciting turn of events, and some really great work is being seen by wide audiences that never would have been before – even just a few years ago.

Of course, there is another side to this coin. Digital video imaging systems are tricky, to say the least, for matchmoving. As fantastic as it is to shoot your opus in the morning and start working on the effects that evening, it isn't actually that simple, especially if you haven't planned your workflow out in advance. Why is this? Let's take a look.

Though digital cameras are certainly being used on feature films right now, the vast majority of features are still shot on 35 mm film. As one would expect, then, most matchmove systems (and most matchmover's brains) are set up for various 35 mm film situations. Of film plates you'll get, most will be 35 mm full aperture (usually just called "full ap"). After that, you'll likely see 35 mm Academy ap, 35 mm VistaVision, and, occasionally, though hopefully not, some kind of anamorphic plate.

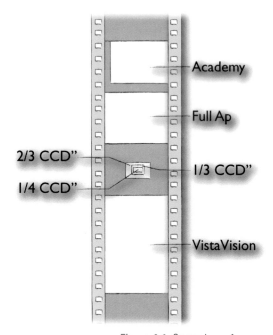

Figure 4-1 Comparison of Academy ap, full ap, VistaVision, and commercial CCD sensor sizes. Note how much smaller the chip sizes are!

DOI: 10.1016/B978-0-240-81230-4.00004-X

Figure 4-2 Squeezed plate from set. The camera squeezes the larger frame size onto a smaller image plane, resulting in a "smushed" plate.

Figure 4-3 Unsqueezed version of Figure 4-2, manipulated in software to display accurately.

User
Same as Device Aspect
Video Source [4:3]
16mm Theatrical
Super 16mm
35mm Academy
35mm TV Projection
35mm Full Aperture
35mm 1.85 Projection
35mm Anamorphic
70mm Projection
VistaVision
Imax
HDTV from Video Source [16:9]
HDTV from Super 16mm
HDTV from 35mm Academy
HDTV from 35mm TV Projection
HDTV from 35mm Full Aperture

Figure 4-4 Most matchmove packages have presets for common filmbacks.

These are well-established filmbacks, and haven't changed in years and years. Any matchmove software will have presets for these apertures, and you won't have to look up their sizes or worry too much about them at all, really (though of course you should be familiar with them, or at least know *where* to look them up). Rarely, your show might have some reason to have a custom filmback — don't forget to ask your supervisor about that before you start your first shot. But in general — standard old full ap is most likely what you'll get. Unless you have a video plate, that is.

What Makes Video Plates So Different?

Video chips, or CCDs, are the light sensors in a digital camera that are analogous to the film/film gate in a 35 mm camera. They are *much* smaller than a frame of 35 mm film (see Figures 4-1 and 4-5). They are also, in general, a different aspect ratio — in other words, the proportion of the width to the height of a CCD is different from that of 35 mm full app.

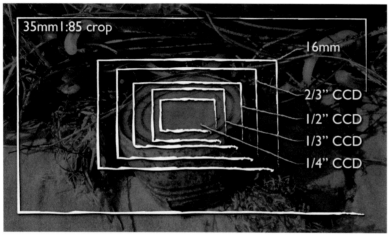

Figure 4-5 Comparison of images captured by various filmbacks, with the same lens and from the same location. The smaller the filmback size, the more cropped an image it captures from the same vantage point as does a larger back. Therefore, the resultant image from a smaller filmback is the same as that of a larger filmback with a longer (zoom) lens.

Okay, so what's the big deal with that? Well, *everything*, it turns out. We could, at this point, go into a lot of math and optical theory, but let's keep it simple for the moment: *when you change the size or aspect ratio of your filmback, you change the lens.* That's it in a nutshell.

What? How Does Changing the Filmback Change the Lens?

I know it sounds a little counterintuitive; the *physical* lens that was used can't change just because you mess around with the size of the film gate! I know that's what I thought when I first was introduced to this concept in film school. But it does make sense.

Tip: So Many Names!

Film gate, back, aperture, and aspect ratio refer to very similar concepts, and are often used interchangeably. The gate is the actual, physical apparatus at the back of the lens that holds the film in place in the camera, and has a hole in it, the aperture. The aspect ratio is the relationship between the height and width of the gate, or of the resulting image after it has been cropped to some other theatrical ratio, like 1:85 (widescreen).

Because the CCD is much smaller than a frame of 35 mm film, it crops the image as compared to the same image captured with a 35 mm camera in the same location with the same lens – just as with the 16 mm camera from school. To get the equivalent "cropped" – or "zoomed-in" – image with that theoretical 35 mm camera, we would have to use a lens with a longer focal length. In that way, changing the size of the filmback results in a practical change in the focal length of the lens used for your shot.

That's the short version. So what does it mean to you, the matchmover who just got 20 digital video plates to track by the end of the week? Let's look:

- You'll need to realize, right away, that you in fact *are working* with video footage.
- You'll want to know the camera used to capture your footage.
- You'll want to have more set data than less.
- You'll need to rely more on common sense than usual.
- You'll need to *remain calm.*

We're in Luck

As it happens, the footage used for this book was shot with a digital video camera, a Sony HVR-Z1U. This particular camera, it turns out, is full of surprises from a matchmove standpoint, and makes an excellent example for this book!

Once I received the footage, I brought it into some 2D software to deinterlace and color-correct for tracking (see Chapter 6 for more details). While that was cooking, I researched the camera on the Internet and found that it has a 1/3" CCD. Looking that up, I found that the chip measures 4.8 mm × 3.6 mm, which converts to 0.189 in × 0.142 in – the numbers I will enter into my matchmove software for the filmback. Remember, the CCD is the analog for the piece of film shot *and* the film gate in a camera, so that is the measurement I'm looking for to build my virtual camera.

Normally, that's where you would go on your merry way, and matchmove to your heart's content. In this case, however, there was more trouble on the horizon.

I immediately ran into trouble when I set up my camera; the aspect ratio of my plates (16:9, or high definition) didn't match the aspect ratio of my filmback (4:3, or standard definition). This might not surprise you, if you are used to working with video plates, but if you aren't, be prepared!

I went back over my numbers, retraced my steps, went back to my compositing software, and realized that my footage was actually *squeezed* (see Figure 4-2).

What does "squeezed" mean? In the case of this particular camera, I found out, after some more research, that it means it can capture both 16:9 resolution and 4:3 resolution on the same chip; in order to capture 16:9 without cropping, it squeezes the image coming from the lens horizontally onto the chip, so that the pixels are skinny and tall. Later, the footage is unsqueezed in software, returning the pixels to square, and creating a 16:9 image from a 4:3 CCD.

When something unexpected like this happens in your career, and it will, and most likely late at night right before a deadline, the best thing to do is not panic. The thing to do is *make it work*, and I'm going to give you three perfectly valid ways to do just that.

What to Do?

I've worked on a couple shows with anamorphic plates (sometimes called CinemaScope, or just Scope); it seems like every VFX supervisor deals with squeezed footage in a different way. There are two basic ways to attack the problem, though.

Method 1

Keep the plates squeezed throughout the entire pipeline, but display them unsqueezed to the artists. All the actual imagery remains squeezed, but looks normal, through software manipulation of the display.

Method 2

Unsqueeze the plates in 2D software, and work with them that way through the whole pipeline, re-squeezing them at the end.

I've seen it done both ways. Of course, because this is video footage, and I already don't know what the lens is going to turn out to be, why not really get crazy and try a third option.

Method 3

Throw caution to the wind and see what the software comes up with.

In the spirit of scientific investigation, I tried all three ways for the purposes of demonstration (and for my own sanity).

After much consultation and research, I devised and tested these three methods of attack (and now you don't have to):

1. Use the actual chip measurements (0.189 in × 0.142 in) and then modify the image plane in software to display unsqueezed.
2. Let the software derive a filmback from the 16:9 plate itself and go from there.
3. Use the actual chip measurements (0.189 in × 0.142 in) but multiply the width by the factor required to make the 4:3 pixels into 16:9 pixels (1.3333), and plug those numbers in to the software. In other words, create a fake 16:9 filmback by stretching a 4:3 filmback width-wise, and load the 4:3 plates into it.

And Now, the Results

Method 1:

Use the actual chip measurements (0.189 in × 0.142 in) and then display the 4:3 plate unsqueezed in the software. First, I created a camera with a filmback of 0.189 in × 0.142 in (4:3) but with a squeeze correction so that the 4:3 plate is displayed in the matchmoving software as 16:9.

The results from this setup are perfectly adequate; the camera ends up in about the right place according to the information I have from set, and when I place reference characters and stand-ins in the scene, they make sense, too (Figure 4-8).

The lens solves at around 20 mm. At first that seems really short to me (check out the shallow focus; that means a long lens), but then I recall that the chip is much smaller than 35 mm full ap. So an equivalent 35 mm lens would be longer. So that makes sense.

Figure 4-6 Squeeze correction set to .75 (the inverse of 1.3333).

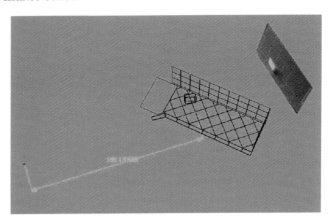

Figure 4-7 According to notes from set, the camera is in the correct position. I think this method works pretty well.

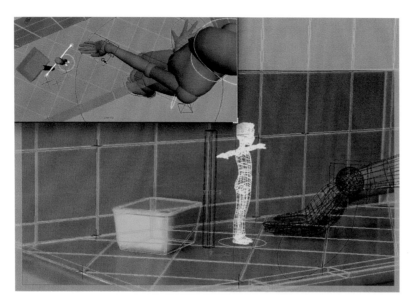

Figure 4-8 Sanity check: Everything makes sense!

Method 2:

Let the software figure out the filmback from the un-squeezed (16:9) plates and let the chips fall where they may. I must admit, this is the solution I trust the least. I like to have more control over what I'm doing, but of course, there are always times when you just won't have any information about your footage, so you'll have to make do. In this situation, creating a good set model – even if it's only from hints and educated guesses – will be crucial.

Figure 4-9 Preset filmback calculated by software.

Figure 4-10 The camera is in the right spot. . .but the lens is very long!

Maya creates a camera quite readily with no intervention from me.

After working through the shot, the result is . . . acceptable, but not optimal. The camera winds up in the same general area as the first solution, but the lens is radically different – 140 mm!

Initially, that gave me pause, but then I considered the size of the aperture Maya calculated – it's huge, 1.78" × 1". That's much larger (in inches) than 35 mm full ap. So of course, an equivalent 35 mm lens would be shorter. When I put the test characters in the same place as they were in the previous test, they make sense and look fine.

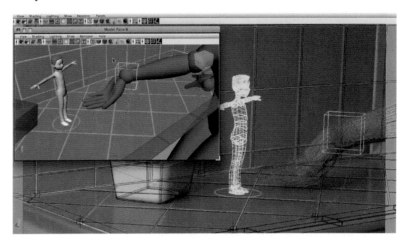

Figure 4-11 Everything seems to check out, but I still don't like that long lens!

This method, therefore, looks to be valid as well. But, as I said, it makes me nervous and I most likely would never use it unless I absolutely had to. This is because, if for no other reason, Sups and other folks up the pipe would wonder why the lens is so different from the camera report. That can be hard to explain to someone's satisfaction, especially if they don't know a lot about cameras and matchmove!

Method 3:

Use the 4:3 plates; create a fake 16:9 filmback to put them in. This method is a little hard to describe in one sentence, but is essentially the inverse of Method 1. Instead of altering the image plane to display an unsqueezed version of the 4:3 plates we are using, we are creating a false 16:9 filmback based on the math used to unsqueeze the plates themselves.

So, I created a camera in Maya with a 16:9 filmback measuring 0.252 in × 0.142 in (.252 in is .189 in × 1.33).

Figure 4-12 New, fake filmback.

Predefined Filmbacks	User	
Film Aperture	0.252	0.142 inches
Device Aspect Ratio	1.775	
Pixel Aspect Ratio	0.998	Auto-compute
Ready To Track		
		Copy to Render Settings

Results: just as good as the previous two. This method was suggested to me by a highly respected VFX supervisor (who then went on to ask how I got myself into this mess). Again, the camera ended up in the right place, the lens was around 20 mm as in the first solution, and all the characters looked fine and made sense.

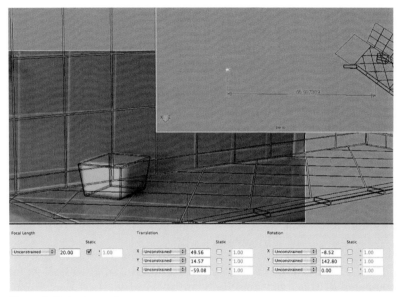

Figure 4-13 Looks good!

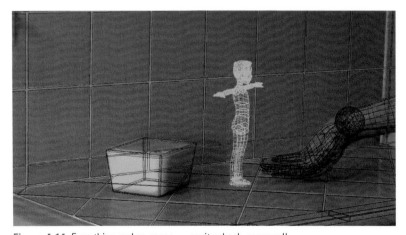

Figure 4-14 Everything makes sense — sanity check approved!

Nice.

As something of an afternote, after even more research into this camera, I found a note on a message board that mentioned something really interesting: the writer said he'd never been able to get footage from this camera to line up perfectly using

the standard 1/3" CCD measurements. He'd used the measurements from the manual, *which are different*, and had much better results! The measurements he gave as coming from the manual are 4.98 mm × 2.8 mm — not even the same aspect ratio as a standard 1/3" CCD! This just goes to show, as I keep mentioning, that you *need to keep your head about you at all times*, and keep seeking new information when you're stuck instead of beating your head against an immovable wall.

As it turns out, this new information didn't help me out much for this particular shot, and I'm happy with the solution I got — it suits my needs and the needs of the shot. I *will* keep it in my back pocket for future shots with this particular camera though. And of course, if I were working within a pipeline with more than one person, I'd pass that information along to the appropriate folks.

In the end, I would use either the first or third method, though I've found after completing all the shots in this book that Method 3, the fake 16:9 back, is easier when it comes to displaying your plates in the 3D software — messing around with the image plane as in Method 1 isn't really that tough, but it's a bit of a pain. So *Method 3 is my overall favorite* in my particular pipeline for this book.

Hopefully, this somewhat abbreviated tour through the wonderful world of video plates will keep you on an even keel when you get a weird filmback and aren't sure what to do with it. Hopefully, you'll have a long and fruitful career without ever having a big surprise like this, especially hours before a deadline! But if you do, now you'll have some tools at your disposal to know how to handle one.

CAMERA MOVES CONSIDERED

Now that you've gotten your feet wet and seen a little match-moving in action, let's look at the meat and potatoes of the matchmove world in more detail: camera tracking.

In general, you will find that you'll get one of a few types of camera moves to match. These include:

- Lockoff
- Pan and tilt
- Truck/dolly/tracking
- Crane
- Steadicam or handheld
- Focus pull or zoom

You may also find shots that combine one or more of these moves. Not to worry! There are ways to handle each of these types of shots. Let's look at each one in a little more detail, and good ways to attack them.

Tip: Fly In, Fly Out

Always remember that pretty much everything on a set can be moved around to some extent. Walls, floors, ceilings, permanent seeming fixtures — all can be pushed around at the director's whim. Don't be surprised to find that not everything in even the most meticulously surveyed set will fit, and never assume that just because something looks solid and permanent, it actually is.

Lockoff Shots

A lockoff shot is simply a shot in which the camera is motionless — it is locked on to a tripod or some other motionless mount. This is the easiest type of shot to track, of course, as the camera doesn't move, so you don't have to animate it. All you have to do is solve for its initial position and lens, and you're done.

If you have survey information, make sure to focus on aligning your camera to the most important areas of the set. Find out what's happening in the shot; for example, if your scene is in a small room and a CG character will come in and sit on a chair, clearly you will need to accurately fit the floor, walls, and chair. You might have to adjust the position of props in the room — in fact, you almost always will, because of course props get moved around on set for almost every shot. You also might need to adjust the model for the room a bit, to make it fit better.

DOI: 10.1016/B978-0-240-81230-4.00005-1

Fly (In or Out)

To move a flat (or other piece of stage setting) in or out of the set.

Flat

Painted or otherwise non-permanent frames resembling large mounted canvas are used to give the appearance of real buildings, walls, or other permanent structures on film, but are actually lightweight, and can be flown in or out easily per the requirements of the shoot.

This happens all the time; keep in mind that what looks like a solid wall on film might actually **fly out** — it might just be a **flat** that can be moved closer or farther away from the camera, depending on how the director wants to frame the shot! I find quite often that a shot will fit everywhere perfectly except for one pesky wall — and that one wall is consistently off over its entire length. That's a clear indication that it probably flies out. It's always a good idea to let your lead or Sup know that you've changed the model, though, just in case!

Of course, if *everything* in your shot is off, you most likely don't have a good solve for your camera. Because, of course, you've already read the notes from set, and know what's going on in the scene, you'll be able to quickly reference similar shots in your sequence and see if perhaps the data you have for this particular shot is off — maybe it's been transcribed inaccurately, or something of that nature. Many times, you'll see that two lenses were used for a particular shot, and the wrong focal length was reported back to the office. No big deal — that's why you read the camera reports before you start your shot!

If there are other, similar shots in your sequence, compare the data for your shot to those. You'll most likely find that the camera height, location, tilt, lens, or some other information just was written down incorrectly, or transcribed incorrectly, or

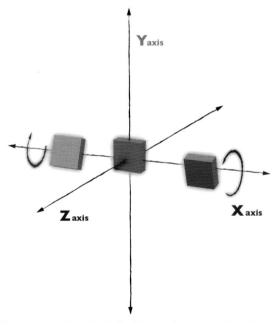

Figure 5-1 Rotation about the X axis. Positive rotation is away from the screen, negative towards the screen. Tip: the X axis is always denoted in red, both on the grid itself, in curves in graph editors, and occasionally in channel boxes. XYZ=RGB when indicating axes.

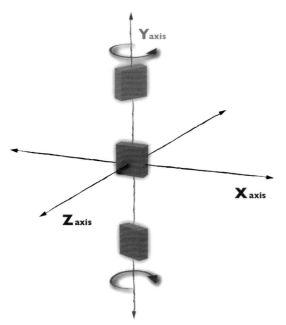

X Translation

Movement along the X axis (side to side).

Y Translation

Movement along the Y axis (up and down).

Z Translation

Movement along the Z axis (forward and back).

Figure 5-2 Rotation about the Y axis. Positive rotation is away from the screen, negative towards the screen. Tip: the Y axis is always denoted in green, both on the grid itself, in curves in graph editors, and occasionally in channel boxes. XYZ=RGB when indicating axes.

X Rotation

Rotation about the X axis (see Figure 5-1).

Y Rotation

Rotation about the Y axis (see Figure 5-2).

Z Rotation

Rotation about the Z axis (see Figure 5-3).

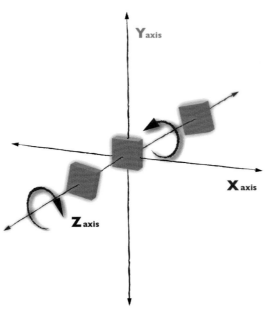

Figure 5-3 Rotation about the Z axis. Positive rotation is to the right, negative to the left. Tip: the Z axis is always denoted in blue, both on the grid itself, in curves in graph editors, and occasionally in channel boxes. XYZ=RGB when indicating axes.

Jitter

Any small, chattering, high-frequency movement in a shot. Often refers to small movement in the image caused by the mechanical pulldown claw in a motion picture camera.

Film Weave

Horizontal movement in a filmed sequence caused by an improperly loaded film negative, dust in the motion picture camera, malfunctioning pulldown claw, or various other mechanical problems on the shoot. Similar to jitter, but at a lower frequency.

somehow or other misreported down the line in the heat of the battle called *feature film production*. Just gather your new data and move on. In fact, if there are several identical shots to yours in the sequence, you should probably just import one of the already completed ones to your scene, make any adjustments necessary, and call it done! And notify your lead or coordinator about the change, if your show likes to work that way (see Chapter 2, "Show Culture," for more details).

Often lockoffs will have some **jitter** due to **film weave** due to improper film loading, a malfunctioning pulldown claw, or some other technical reason. To compensate for this problem, sometimes the compositor will stabilize the shot, or he or she might simply use the first frame of the shot as a plate and add film grain to it, so that it looks like any other normal shot. Other times, the situation might actually call for you to track that slight motion. Generally these calls are made on a shot-by-shot basis, but make sure to find out how your facility deals with this issue.

Pan and Tilt Shots

A pan or tilt shot rotates back and forth or up and down on its axis, respectively, like shaking or nodding your head.

A camera pan (short for panorama) rotates across the horizon, revealing the breadth of a scene. A tilt, as you may have guessed, rotates up and down, from the ground to the sky.

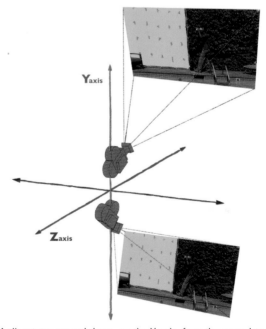

Figure 5-4 A tilt rotates up and down, on the X axis, from the ground to the sky.

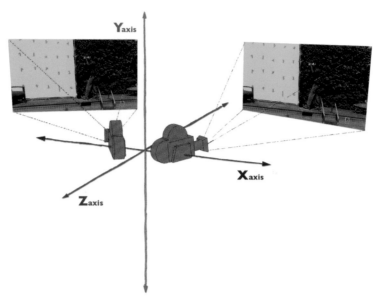

Figure 5-5 A camera pan rotates across the horizon, or the Y axis, revealing the breadth of a scene.

In theory, pan and tilt shots should have rotational movement only; they shouldn't display any **parallax**, which indicates translation.

This type of move is called a **nodal move**. In practice, a special camera mount is required for a nodal camera move. To see why, consider Figure 5-12.

As you can see, with a camera on a standard mount, the offset between the pivot point of the tripod and the optical center, or nodal point, of the lens introduces translation as well as rotation into the move – more difficult to solve than a pure nodal move, which has no translation. The **nodal mount** transfers the pivot point of the camera to the nodal point, eliminating the parallax, and creating a purely rotational move.

As you get more experience, you'll be able to recognize nodal pan and tilt shots and solve them accordingly. In general, once you have a good first frame lineup with your model, you will only need to track one 2D feature from which to derive your camera move – assuming that your shot has a good 2D feature in view at all times – one that is on the frame the entire duration of the shot, isn't blocked by the action in the shot, doesn't get too blurry or dark, and so on (see Chapter 9, "How Do I Pick Good Features for My 2D Tracks?" for more information).

Of course, if your camera wasn't on a nodal mount, *technically* you won't be able to solve your move that way. In practice, however, I often solve a "pretty close but not quite" nodal move

Parallax

The amount of perspective, or depth, in a scene based on the relationship between the motion of foreground vs. background objects. If you've ever driven down the highway and seen telephone poles by the side of the road whip by while mountains in the distance seem to stand still, you've seen parallax in action.

Nodal Mount

A camera mount that allows rotation around the nodal point of the camera.

Figure 5-6, 5-7 These two images illustrate nodal rotation, about the nodal point of the lens. When overlaid (Figure 5-8), we can see that there is no parallax shift in the relationship between the front and back elements, indicating a nodal pan.

as having just rotation only. It's a fairly common practice, but make sure to ask your lead or Sup first. At any rate, you'll be able to tell fairly quickly whether this solution will work; your camera simply won't fit your virtual set properly over the duration of the shot if there is enough translation to make a difference in your solution. And of course it will depend on the needs of the particular shot. If you're replacing the entire background from edge to edge, it most likely won't work, but if you have a smaller

Figure 5-8 (Continued)

Nodal Point

The point at which light focused by the lens in a camera converges, also called the optical center of the lens. When the camera rotates around the nodal point of the lens, the resulting image sequence won't exhibit any parallax.

Figure 5-9 Camera rotation off the nodal axis. The parallax change, indicating translation in the camera, is readily apparent in the overlapping image (Figure 5-9) and in the individual comparisons (Figures 5-10, 5-11).

character in the center of the screen and he's not moving around very much, you'll probably be fine, depending on factors like the length of the lens, how far the camera is from the subject, and so on. But I find that it's almost always worth a try.

Figure 5-10, 5-11 The change in parallax is evident, especially near the spout of the pitcher.

Locked Channel

In 3D graphics, restricting the motion (or other attribute) of an object by "locking" that value. For example, locking the Y axis translation of a camera would prevent it from moving up and down, though it would still be able to move in any other direction.

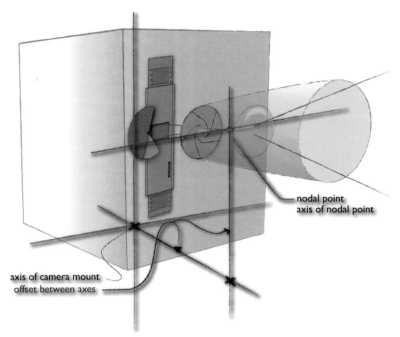

nodal point
axis of nodal point

axis of camera mount
offset between axes

Figure 5-12 The offset between the rotational axis of the camera mount and the axis of the nodal point of the camera causes problems when solving pan and tilt shots. The solution is to offset the camera on the mount in order to rotate around the nodal point, using a special nodal mount, moving the axis of rotation of the camera in line with the nodal point.

One other thing to keep in mind when solving a pan and tilt move is to solve for X and Y rotation *only*. Make sure to **lock** out all your translational channels, and Z rotation as well. It's really rare to have Z rotation of any significance in any kind of shot, really. You'll definitely want to lock it off in a pan and tilt, as the physical camera is restrained in that axis by the camera mount.

True Tales of Matchmove: Nodal Move CONFUSION!

One time, I was working on a simple pan shot. It should have taken half a day to do — nothing really was happening in the frame, we already knew the model for this particular set fit really well, there were nice, big fat tracking dots for the 2D track. . .piece of cake.

Wrong.

The next morning, I was still messing around with it, because it just wasn't working for some reason. I'd moved some set pieces around on the CG set, no good; triple-checked the lens, no good; talked to the on-set guys about it again, nothing to report — and I was starting to go nuts. Was I actually going crazy?

My lead came over and she was kind of mildly mystified too. Finally, I said, "Well. . .maybe. . .they moved the camera?" She looked at me, I looked at her, and we decided that it was so crazy, it might just work.

And it did. Crash turns out, what we assumed was a nodal pan was not! Why that particular shot had to be solved with translation and rotation as opposed to other "close but not quite" nodal rotations, I don't exactly know, but I suspect it was because (1) it used a pretty short lens (17 mm), and (2) it had a lot of CG interaction around the edges, where problems with fit due to parallax and lens distortion are more likely to show up. At any rate, I think it really shows how spoiled we were, getting good, nodal shots most of the time!

Whip Pans

A subset of this category is the whip pan. A whip pan is simply a very fast pan — it "whips" by.

Figure 5-13 A whip pan (colored pencils in a drinking glass seen in Figures 5-15 and 5-16).

Track Point Handoff

The point in a sequence when one 2D feature moves out of frame, but another suitable feature remains or appears. At this point, the work of the first 2D track is said to be "handed off" to the second one, much like the second runner in a relay race.

Obviously, a whip pan will be problematic in the 2D tracking stage, due not only to motion blur, but also because you will most likely need to have a few 2D tracking points, and do a

Tip: Planning Your 2D Track Attack

 Some artists like to start their shot with 2D tracking, but I personally like to get a first and last frame lineup (a rough, one-frame camera solution) for long shots, especially if more than one handoff is required. This helps in two ways: I'll know right at the beginning of the shot if there are major problems with the set model, camera information, or anything else unexpected before I spend potentially a couple days tracking 2D features and *then* finding out about potentially huge issues. Also, I'll know what 2D features are the really good ones to track in 2D for that particular shot. Nothing's worse than spending a long time tracking a 2D feature that ends up not helping your camera solution at all. Some Sups ask you to show them a first and last frame lineup of your shot before you do anything else for this very reason, and it's a good habit to get into.

track point handoff during the shot. It's very important to consider which features to track in 2D, and to make sure you know what they correspond to in your set survey, when solving a whip pan (see Chapter 9, "How Do I Pick Good Features for My 2D Tracks?").

Fortunately, whip pans are very forgiving, due to motion blur. When tracking your features in 2D and solving in 3D, though, make sure you know which edge of the blur you match your geometry to. The setting for rendering motion blur is chosen at the show level; the shutter angle defined in that setting determines which edge you should match. Be sure to ask your lead or supervisor for this information, because where you choose to place your edges makes a difference in the look of the final comp (see Chapter 2 for more details)!

Dolly (Truck) and Tracking Shots

A shot in which the camera is mounted on a moving platform to move smoothly toward or away from the scene is referred to as a dolly or truck shot. A shot that moves laterally along with the action is called a tracking or follow shot.

Both of these types of shots will involve X and Z translation, and almost always Y translation as well, because no matter how hard you try, you can never get a perfectly level ground for your dolly to roll over, so your camera will move up and down a little no matter what.

It's also very rare for a dolly shot to have no rotation at all; generally, the camera operator will tilt and pan the camera during the move to follow the action in the scene.

When setting up to solve a dolly shot, just as with a whip pan or other shot that covers more than one **field of view**, it's important to think about what 2D features you will track, and any handoffs that might come up.

Crane Shots

A crane shot takes the camera swooping up and over the scene, or dips down from on high to reveal the action down below. As you might guess, the camera is attached to a crane, jib, or some other type of arm that lifts it into the sky, like the cherry pickers you've seen utility workers use on telephone poles.

In general, crane shots are much like dolly shots, except, of course, that they move much more in the Y axis than on the ground plane. In general they encompass a few fields of view, and will require track point handoffs. As with other moving shots, careful study of the move and your set model is needed

before any 2D tracking is done, to plan out the best method of attack for those handoffs.

Steadicam and Handheld Shots

In this type of shot, the camera operator carries the camera either by hand or with the assistance of a special rig called a SteadiCam, and the resulting shot is less smooth than one shot on a dolly, crane, or other type of camera mount. Steadicam shots can be very smooth, and might even look like dolly shots; handheld shots can be very jittery and jumpy.

As you can imagine, these types of shots can be very challenging to solve. Handheld shots often have a lot of motion blur, many fields of view, and good 2D track points can be hard to find. Steadicam shots are not as jittery (hence the "Steadi" in the name!), but often cover a lot of ground and also encompass many fields of view. Very long handheld or Steadicam shots might require a lot of creative tracking!

Another point to note about these shots is they are the only type that are likely to contain any significant Z rotation (roll). When a camera is mounted, it's generally restricted from rotating on the Z axis, but when it's being held by a person, of course, it's free to move in any direction.

Field of View (FOV)

Extent of the scene viewable through the lens, expressed in degrees. The FOV is very wide in short lenses (hence the term "wide-angle lens") and much narrower in long lenses (see Figure 2-2). In this context, FOV refers to how many fields of view the sequence of images covers. For example, if the lens you are using has an FOV of 15°, and the camera pans 45°, then the shot has covered three fields of view (see Figure 8-1).

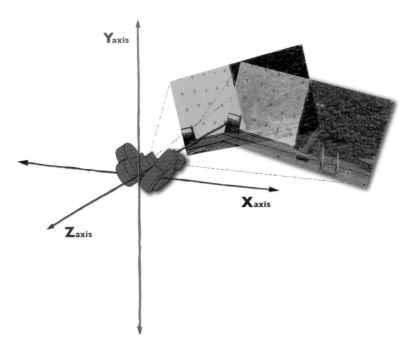

Figure 5-14 A Dutch angle, or roll, is rare in visual effects, but they do come along. They are mainly used to heighten the drama or horror in a scene.

Focus Pulls and Zooms

Though focus pulls (also called rack focus or follow focus) are fairly common, I don't see them very much in VFX shots. They can be tricky, but not impossible, to solve. You've seen focus pulls many times: the focus in a scene sharply moves from the object in the foreground to the one in the background, to emphasize a story point.

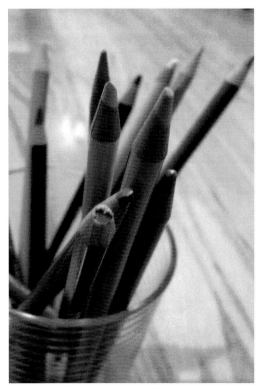 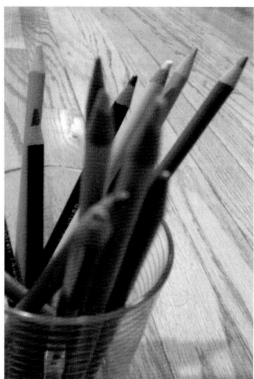

Figure 5-15, 5-16 A rack focus, or focus pull, draws your attention quickly from one area of the image to another. Here, the focus shifts from the front pencils to behind the back pencils.

The way to solve a focal change is to unlock the focus channel on your CG camera and let the software calculate for it in the solution. Generally, this channel is left locked, because you would ideally have the focal length information from the camera report to input. But for a rack, unlock the focus channel, lock the rest of the channels (assuming this is a lockoff shot — racks usually are), and then solve for the lens.

The most important step in solving a focus pull is *recognizing it in the first place*. I've seen many frustrated camera artists

trying to solve rack focus as Z translation. When you evaluate your shot prior to starting your 2D track, pay attention to focus. Does it change? Watch the areas where-+ your action takes place closely. If you see a change in focus, make sure to take it into account when solving your camera. See Chapter 7 for more information.

Zooms are the bane of a matchmover's existence. Yes, a focus pull is technically a tiny zoom, but that's not what I'm talking about here. If you have any control over what's being shot, for example, if it's your shoot, or you're advising for the shoot, make sure not to use a **zoom lens**. Dolly in, walk in, attach the camera to a squirrel, *do whatever you have to do* not to use a zoom lens for an effects shot. In fact, if you can make sure the camera package has nothing but **prime lenses** in it, so much the better! Of course, if you're just one of the VFX crew, say nothing and bite the bullet.

A lockoff with a zoom isn't so bad; you would just solve it as a really big rack focus. But a moving camera with a zoom creates all kinds of problems, because it's generally not clear which motion is resultant from the camera move, and which is from the zoom. This creates a compound move that's very difficult to untangle. It's not impossible, but it's not ideal. It's definitely a shot for the more experienced tracker. And if you're really lucky, you'll get a zoom . . . shot from a helicopter!

Zoom Lens

A lens with variable focal lengths.

Prime Lens

A lens with a fixed focal length.

But All of this Sounds Crazy Complicated — How Do I Even Start?

I know it can be a little intimidating when you first start out, and even a seasoned matchmover knows that sinking feeling when assigned a particularly challenging shot. However, there is a generally straightforward methodology for tackling any shot, which makes your job much easier:

- Determine what needs to be done.
 - Find out what's happening in the shot!
- Review your information.
- Set up your shot.
 - Color-correct your plates.
 - Model your set.
 - Create the camera.
 - First frame lineup.
- 2D track.
- Survey constraints.
- 3D solve.
- Does it make sense?

If you follow this sequence, you'll find your work much more organized, linear, and easier. Of course, sometimes you'll need to go out of order for any number of reasons, or you may have to backtrack, or do a few iterations. But this is a great place to start.

Let's see how to apply this sequence of steps on some real-life shots!

REAL-LIFE SHOT: LOCKOFF CAMERA

Let's look at a real life shot and put some of this theory into practice! To get started, we'll take our trusty matchmove checklist and see what's what with our new shot.

Determine What Needs to Be Done

The first thing to do, of course, is to determine what happens in the shot. Watch the entire sequence to which your shot belongs, if at all possible. Get a feel for what's happening in the sequence. Is it an action sequence? What happens in the shots before and after yours? Are there other shots similar – or exactly like – yours? Is there anything completely unique about your shot – something that makes it a **one-off**? These are all good things to know, and might bring up important questions or issues that need to be discussed with your lead – and those are always better discussed *before* you spend a lot of time on your shot rather than after!

So let's look at our shot:

> **One-Off**
>
> A shot or other task that requires a unique solution that can't be applied to any other task, because there are no other shots resembling it.

Figure 6-1 Your new shot.

DOI: 10.1016/B978-0-240-81230-4.00006-3

In this lockoff shot, a small CG character will hop from the green container to the counter and into the hand that comes into frame later in the shot, and then is lifted up and out of frame. Notice that the tiles and container are very reflective and shiny; we'll need to include geometry for those so that artists farther along the pipeline can generate reflections and shadows, in addition to giving the character animators surfaces to work with. The blue tape dot is the mark the character will hit; it's very important to lock that area down.

Review Your Information

Now is the time to study all the notes taken on set, and to review any photos, measurements, and whatever other nuggets of information there may be available to you. Double-check the lens information and read the camera report. Double-checking this information takes only a minute or two, and can save you hours of frustration in the long run.

Also notice that this plate was shot on video with a 16:9 aspect ratio. This will throw a few more variables into our process than

Figure 6-3 Camera reference from set.

Figure 6-2 Reference photos from set.

if it had been shot on 35 mm film, but it's nothing we can't handle. For more information, see Chapter 4.

What kind of information is there from the set? We have a few photographs, some sketches of measurements, and information about the camera model.

As you can see, the notes are a little sketchy, but they have plenty of good information from which to derive a good set model. Though the height of the counter wasn't recorded, I know from experience, and you can find from a quick internet search, that bathroom counters are generally 30−32 inches high − about hip height. We don't know exactly where the camera is, but if you really had to, you could make an educated guess as to how many tiles there are on the floor from the base of the counter to the camera man to get a rough estimate of that measurement. We can also make an educated guess as to his height and the height at which he's holding the camera − though we don't know which take this photo represents, so I wouldn't take those measurements as gospel, just as a starting point.

Figure 6-4 There are several closeups of the container and counter similar to this one with a measuring tape for scale.

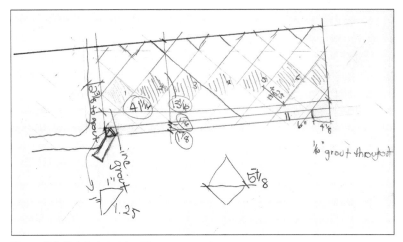

Figure 6-5 Detailed sketch with measurements.

The camera is reported as a Sony HVR-Z1U HDV, and it's easy enough to look up the chip size and other information for that camera on the web − see Chapter 4 for much more detailed information!

Set Up Your Shot

Color-Correct Your Plates

You'll most likely get raw scans of you plates – in other words, they haven't been color-corrected in any way. Most of the time, you'll find it much easier to track your markers and other prominent features if you do some color-correction in a compositing package before you even go into your matchmoving software.

In general, boosting the contrast and slightly blurring the plate does wonders for the 2D trackability of your plate. Of course, every plate is different; see the section "Color Correcting Your Plates: A How-To Guide" for more detail.

For this plate, I took some contrast out of the shadows, blurred the overall plate by half a pixel, and then boosted the contrast. Though you can see the results are a bit clipped, that's fine in this case – the shot is locked off, and I'm really doing this correction to better see the hand later on when I rotomate it. Then, I render out both full and half resolution sequences of my shot for use in my matchmove software.

Color Correcting Your Plates: A How-To Guide

Let's take a look at color correcting your plates in more detail.

Knowing how to color-correct your own plates is crucial to getting good, solid 2D track points. Depending on your shot, you might need to make more than one set of color-corrected plates for your purposes. For example, there might be a drastic change in lighting in your shot, or it may go from static to fast-moving. Different color settings are sometimes better for different situations.

Some matchmove software packages allow you to color-correct your plates in the software itself, which is nice; other times, you have to use a 2D package for the job, which gives you more control. Either way is fine, as long as you get the results you need!

When determining how to color-correct your plates, consider your source material. For plates shot on 35 mm film, the blue channel will always be the grainiest, and it's sometimes best to leave it out altogether. In plates shot on video, I find the reds to be the noisiest.

In my experience, the best general procedure to follow for prepping plates for 2D track goes like this:
- Determine which is the noisiest channel and get rid of it
- Blur the result 1 to 3 pixels

- Adjust the gamma of the blurred plate
- Adjust the contrast on the gamma correction
- Desaturate the result
- Adjust as necessary.

Of course, there is a lot of room to play around, but generally, this method works pretty well for me.

Let's look at some examples in action.

Single-Channel Plates

The first thing you'll want to do is to check whether one channel is clearly superior for 2D tracking purposes, so first, examine each channel separately to see what it looks like.

Figure 6-6 All channels, red, green, and blue (RGB) displayed.

Figure 6-7 The red channel. It's very noisy.

Figure 6-8 The green channel. It's nice and clean, and has good contrast. Definitely a good channel to track!

Figure 6-9 The blue channel. Though it has nice contrast, it's really noisy. Not a good candidate.

Figure 6-10 There are many choices when it comes to color-correction methods, but you'll find a couple of favorites you come back to again and again.

Already, there is a good candidate to track — the green channel by itself. You could bump the contrast up a little on it, render it out, and call it a day.

What if it weren't so cut and dry though? Let's look at some other options.

Color-Correction Filters

Most of the time, even if you do extract one channel, like the green channel in the previous example, you'll still want to modify it a bit further.

Let's take a basic example first. I'm going to adjust the overall plate, rather than fool around with single channels for right now. There are many, many color-correction filters to choose from, and many matchmovers get a bit overwhelmed by the sheer number in the list and tend to shy away from this step altogether for that reason.

Don't be afraid. There are really only three filters you need:

- Levels
- Hue/Saturation/Brightness (HSB)
- Swap channel (called different things, but don't worry — you'll find it)

Add Gaussian Blur to the list, and that's it. Four filters are all you'll ever need! I've never used anything else to color-correct a plate for matchmove. And I used to actually do it from the command line!

The very first thing I do after checking all the channels is to apply *Levels* to my image. Levels is the perfect, do-everything, all around, go-to tool. You could actually do everything with Levels, But HSB makes certain procedures a little more intuitive, so I use it too.

One you have Levels applied, you see a histogram, which is a graphic representation of the light to dark values in the frame displayed (Figure 6-11), which is a representation of our original plate (Figure 6-6).

Figure 6-11 My go-to of all go-to color-correction methods: Levels.

Figure 6-12 The plate with levels crushed. The original plate is shown frame right for comparison.

Figure 6-13 Lower gamma — too washed out for this plate, but it might work for a different shot.

Figure 6-14 Higher gamma — much better for this plate.

Figure 6-15 Levels: here, adjusting the red channel — note how much it's clipping.

Figure 6-16 The next most important filter for me: Hue/ Saturation/Brightness (HSB).

You can see that it's washed out — the whites aren't very white, and the blacks aren't very black. By moving the white and black values closer together (called "crushing the levels"; see Figure 6-12), you increase the contrast in the plate dramatically.

Already, that's much improved. But adjusting the gamma level — the midrange values in the plate — has an even bigger effect on contrast. If you move the midpoint toward the blacks, you lighten the plate — you make all the values to the right of the gamma indicator lighter (Figure 6-13).

If you move the gamma up toward the higher end, making the midrange darker, you get more contrast (Figure 6-14).

This is the general kind of setting I gravitate toward when color-correcting for matchmove, but a lot of times it comes down not only to better plates for 2D tracking, but also plates that please you. I happen to like hi-con (high-contrast) color like this.

Next, we have the HSB filter (Figure 6-16). Many times, when you use Levels to crush your blacks and whites for higher contrast, you also really oversaturate your image. Sometimes that doesn't matter; sometimes it causes clipping and noise in your image that will hurt your 2D track; and sometimes it's just *painful to look at*. Whatever the reason, pulling down the master saturation of your image is usually something you'll want to do.

Figure 6-17 The plate is completely desaturated.

Figure 6-18 Levels is turned off to see what the plate looks like with just desaturation applied. Not great, it turns out.

Figure 6-19 Adjust Saturation and Levels.

Last, you'll almost always want to blur your plate just a bit — no more than 3 pixels. This helps even out grain and smoothes your tracks out. I use Gaussian Blur for this.

Figure 6-20 Add Gaussian Blur to the mix.

Which Comes First?

I bet this sounds pretty straightforward, and you're ready to go and color-correct your plates right now. Not so fast, cowboy — let's talk about what order you apply the filters first!

But why? What difference could it make? Turns out that it can make a huge difference, depending on your plate. Blur before Levels usually gives a much different result than Levels before Blur, especially if your raw plate is blown out (has a lot

Figure 6-21 Changing the order of the filters — often it's more effective to blur the plate before color-correcting.

of very bright highlights). Desaturating before Levels is completely different than the other way around. So make sure that while you're experimenting with your settings, you also experiment with the order in which you apply your filters.

Figure 6-22 Further experimentation: more blur, less contrast, turn off desaturation.

Getting Fancy: Swapping Channels

Remember at the beginning we saw that the red channel in this plate was really noisy and ugly? There are *ways of dealing with this kind of problem*.

Every 2D package has a filter that swaps the channels in an image around. For some reason, it's called something different in every package – or so it seems! But you'll find it – it looks like the panel in Figure 6-23. It lists the available channels in the image, and lets you assign a value from a list to that channel. So, if you want to get rid of the red channel, and you know your green channel is very nice, you would set the red channel to come from the green channel. For film plates, I often use the setting RGG – in other words, the noisy blue channel is replaced by the green channel, removing a lot of grain in one operation (Figure 6-23).

There are many variations you can assign, so experiment and find one that gives you a result you like for your 2D track. Don't forget to experiment with the order you introduce the Swap Channel filter into the Levels, HSB, and Blur filter mix!

Once you've hit upon the right combination – and over time, you'll develop your own "preset" for yourself, a place you always start and will pretty much always work for you – render

Figure 6-23 Getting fancy: Shift Channels (sometimes called Swap Channels). Substituting the nice, clean green channel for the noisy red channel. It looks strange, but it will track much better than with the original red channel. Your plates can always be displayed as luminance only (black and white in your tracking software) if the look of the channel swap bothers you.

Figure 6-24 Blue, Green, Green Swap Channels.

out your plates and ***don't forget*** to check and make sure you're not stomping on anyone's plates! And, when your shot is finalled, don't forget to follow your facility's procedure for deleting your color-corrected plates, freeing up space and making your producers and production services techs very happy!

Figure 6-25 All green channels.

Figure 6-26 The green channel with Levels and Blur applied. The noise in the flat areas of the tiles comes from crushing the levels; depending on what you're tracking, it might be fine, or you might want to adjust.

Hopefully, I've shown you that you need not be intimidated by the myriad choices of color-correction filters, which scare away many a matchmover from 2D software. Don't forget, you *need only four filters,* and can ignore everything else — unless you're curious, that is!

Model Your Set

You'll need to make sure that you have a model for your set, and that it looks reasonably accurate based on what you already know from looking at the notes. You also want to make sure that you know *where* in the model your shot takes place. Sometimes, in a really large set model, that can be hard to tell! This is another reason for looking at the whole sequence you're working in – it will give you clues as to where you are working on your set.

If you work in a shop that breaks up different pipeline tasks and distributes them among different artists, you'll most likely receive a completed model for your set, especially if it's a location that gets used a lot. If you're in a smaller shop, or this location isn't used much, or if the modeling department just hasn't gotten to it yet because they're swamped, or for any number of other reasons, though, you might have to model it yourself. I'm not a great modeler, I will tell you up front. However, for many, many matchmove tasks, you won't need to be a great modeler – boxes, planes, generic humans , and the like will do just fine. As long as it can be seen properly to be evaluated, and passed down the pipeline well enough for others to use it, it's good enough. You don't want to spend hours on a beautifully detailed model you won't even see in your shot.

It's important to gauge what level of detail you need when you're building your own model. You don't want to waste a lot of time you don't need to, as I said, but you also don't want to leave out important details that will make your task much easier. Ask yourself, "What can I get away with in this shot?" Do you really need every single window on that building? Or will just the bottom floor do? Do you need the accurate profile of the window, including the sash, shutters, and so on, or can you get away with just the general outline? Do you even need the windows at all? Maybe just a cube to represent the entire building is all you need. Obviously, the answers to these questions depend on your shot. How close is it to the subject? How fast is it moving? What's happening in the shot? How much motion blur is there? If you have a small, mouse-sized character sitting on a windowsill, you'll need a different level of detail than if you have a long shot of a building with a lot of motion blur.

With that in mind, and based on the measurements and photographs from set, I created this model:

I went to the trouble of including this level of detail because I'm going to be using those tiles to solve for my lens, so I want to be sure they are accurate. Otherwise, I might have just created a plane for the counter and tile wall. Also, I want to make sure the

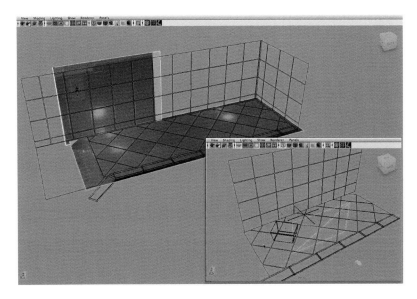

Figure 6-27 Virtual bathroom built using information gathered from set.

container is the right height. Later, I'll need to make sure my generic human hand is a decent fit for my actor's hand.

Create the Camera

Now we'll move on to the camera. As I mentioned, the camera used was a Sony HVR-Z1U HDV. After a lot of research and experimentation, detailed in Chapter 4, I set the film back to 0.189 inches × 0.142 inches, and then adjust the image plane to display the squeezed plates correctly.

Figure 6-28 Creating the camera.

As I mention in Chapter 4, this particular set of plates is a bit unusual. Usually you'll get either 35 mm full aperture or academy aperture plates, and you'll not need to worry much about this step. Ninety-nine percent of the time there will be a preset in your software for your plate.

So, we load our squeezed plates, both full and half resolution, and then adjust the image plane as mentioned previously to display it properly, and we're set to go!

First Frame Lineup

Some people like to go ahead with the 2D tracking portion of the process at this point, but I prefer to get a rough lineup with my set model first. This helps me make sure that I'm roughly in the right place, and that there aren't any huge, obvious problems with the model before I spend a lot of time doing 2D tracks. One reason for this is that if a big problem with the set

Tip: Don't Move!

IMPORTANT: Because the CG set model was most likely created for use by several artists, and they will probably share different animation and lighting rigs that all relate to the set model as built (in its original position) don't ever move the model unless specifically told to.

is identified *before* I start 2D tracking, it can (hopefully) be fixed *while* I'm tracking. Efficient!

Because this is a video plate, I really don't know what the lens is. I'm going to guess it's relatively short, because:

- That bathroom is really small so a wider angle lens will be required to capture the framing needed.
- I know that this camera's lens will be shorter than an equivalent 35 mm camera's due to its smaller filmback size.

Maya defaults to 35 mm, which is on the shorter side for 35 mm cameras. I'll take it down to 20 mm to start. Next, I'll import the bathroom model.

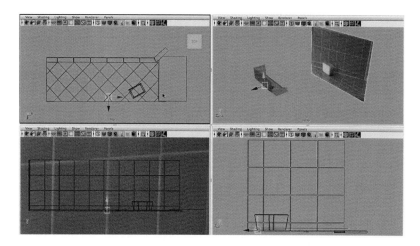

Figure 6-29 Importing the set into the matchmove software.

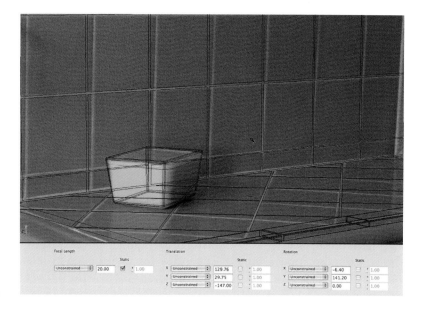

Figure 6-30 First frame lineup.

The camera is created, by default, at 0,0,0 and the bathroom model is imported exactly as the modeling department (or you) created it.

So we will move the camera around in space until it's in roughly the right spot to start.

We can see from the plate that the camera is above and to the left of the green container, so that's where I'll start. From there, it's a matter of manipulating the camera in different viewports until you come up with something you're happy with.

To get to this view, I moved around in the shotCamera1 viewport until the container was about the right size, and then lined up the tiles fairly closely. It looks like my 20 mm lens guestimate is pretty close!

2D Track

Obviously, because this shot is a lockoff, we don't need to track points in motion. We do want to lock the camera to the set, however, and more importantly, we want to get a good, tight fit to help the software determine a focal length for our lens. So we will need to "track" a few points.

Whenever a lens is in question, it's best to track points around the edge of the frame, along with at least one in the center. This gives the software a good field of information to work with. Also, lens distortion, if any, manifests itself more intensely around the edges of an image, so if that affects your shot, it will also be taken into account (see "Lens Distortion," in Chapter 2, for more details).

We have a really nice grid here. I chose the following points to track:

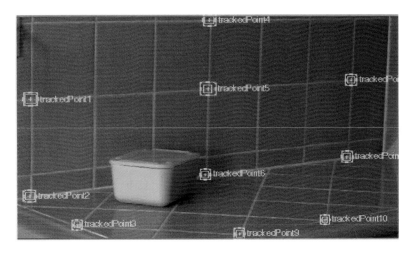

Figure 6-31 Features chosen to track in 2D, which correspond to 3D points on the virtual set.

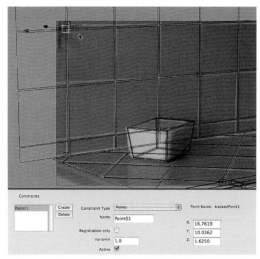

Figure 6-32 This point on the plate is right here on the virtual set . . . you do the math, I'm going for coffee.

Survey Constraints

 Restrictions imposed on the matchmove software based on the relationship between survey points in 3D space and tracked features on the 2D plate. The solver is restricted to matching that particular point in 3D space to the corresponding 2D point on the live action plate, helping to create a more accurate camera solution.

These represent a nice balance over the frame, and they are all on the actual model itself, so are easy to constrain to the model.

Survey Constraints

Because I have a really nice, accurate model to work with, I'm going to create **survey constraints** right away so that I can lock down the location of this camera and, more importantly, get a good, accurate number for the focal length.

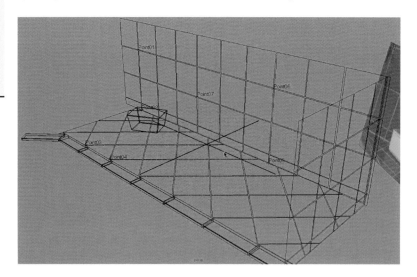

Figure 6-33 Make sure that all constraint locators are correctly placed — in all views!

In this software, we set point constraints by choosing the 2D track point and creating a survey constraint, then moving the resulting locator to the proper location on the CG set. This tells the software, "This point in the plate is right here on the set." Though every matchmove package I've worked with gets to that instruction a little bit differently, that's how they all work — by matching a point in 3D space with a point on the plate. The more points you can give it in advance, the better.

In that manner, I create a point constraint for each 2D tracked point I created, then move it to the correct spot on the CG set (snap to points is a great tool here). For good organization, name your constraint locators to match the 2D track points with which they are paired — trust me, that saves a lot of trouble later!

Once all the constraints have been created, double-check that they're all in the right place — in all views. I can't tell you how many times a simple lockoff has been foiled because the artist failed to notice one of his constraints was in the wrong place, 10 feet from where it was supposed to be! You can't see those mistakes in the camera view, but they're immediately obvious in the perspective view, so make sure to check, and check frequently!

3D Solve

Finally! bet you never thought we'd actually get here! Camera matching isn't easy, you know. The more careful preparation, the better your result. Here we go!

Tip: Software Isn't Everything

 You've no doubt noticed that so far I've been giving generic directions with regard to actual matchmove software, though of course you can most likely tell that I'm using Maya Live for this particular example. That's because I don't think matchmoving is about matchmoving software, per se; I didn't learn a certain popular package, in fact, until I needed it for a freelance job recently! No, to be a good matchmover, you need to know how to *matchmove*. You need to know how to think in the right way, to get information and clues from your plate. When you're a matchmover, you can learn any matchmove software — it's just what button to push. The trick is in knowing *which* button you're looking for in the first place!

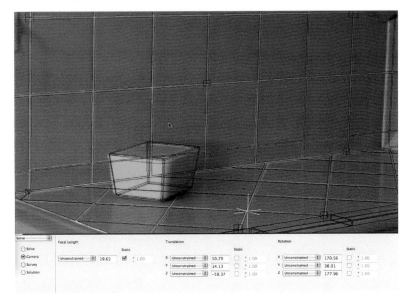

Figure 6-34 First-pass solve.

Tip: Name That Track!

A lot of artists I know name their 2D tracks very specifically, indicating where and when in the frame they occur, and it works very well for them. For example:

Right_frame_23_35
Left_upper_89_end

I personally find that really clutters up your scene, however — and you forget what you name things, and it all gets kind of crazy if you have a really long shot, and if you have to hand off the shot to someone else, it's a nightmare! So I prefer to name tracks and constraints simply, like this:

Track_001
Track_002

And then I keep a list or sketch separately, if necessary, to remember where they are in frame. It's a personal preference, so whatever works for you is the right answer.

Because we are solving for the lens, leave that channel unlocked. As this is our first test, I'm going to leave all the channels unlocked, and let the chips fall where they may.

Now, you click "solve", hold your breath, and see what the computer gives you.

Not bad! The lens solves to 19.62, very close to my original educated guess. Look how well everything lines up. The container matches up nicely — it's the right size, and though it's not exactly the right slope at the bottom, that's more to do with my lack of modeling ability than anything. When I look in the perspective view, the camera is in a reasonably correct location. Looking good!

However, if you look very closely, you can see that a couple of the grout lines to the right of the green container are a bit off. If those were near the edge of the frame, I'd write it off to lens distortion and call it a day, but these are closer to the center, and more importantly, one is near the mark for the CG character. So I'm going to try to lock that down a little more.

Now, it's weird to me that everything else lines up so well except for those two grout lines — almost too weird. I happen to know that this plate was shot in a 55-year-old building in Los Angeles — which means that in addition to the normal settling over time, it's been in a lot of earthquakes. I also know that consistent 1/16″ grout lines aren't easy to keep even — especially in a rushed construction job, which I'm guessing this building was (due to the explosive growth of postwar Los Angeles — see, all knowledge is good knowledge). So, actually, it's entirely possible those might be a little off. But I'm still going to try to lock this camera down a little better.

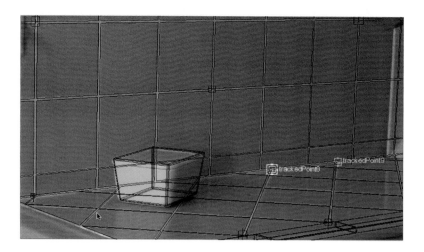

Figure 6-35 Add a few more 2D track points and survey constraints for a more accurate fit.

For my second iteration, I'm going to add constraints right at those two intersections that don't line up. I create 2D track points and constrain those points to the survey.

Click Solve and see what happens!

Not much, as it turns out. The lens changes slightly, as does the position of the camera . . . and now the fit is off on a different area. I think this is a case of "perfect model meets imperfect world." In other words, my model has perfectly sized tiles spaced exactly so, and the world just isn't perfect. After a few more constraint combinations (so that I can say I did my due diligence), I go with my first solution, which looked the best.

Tip: Version It!

Save and version up your file before making big changes — like a second iteration of a camera solve!

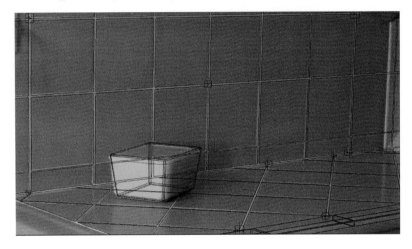

Figure 6-36 A different, but not better, fit.

Does It Make Sense?

You should be asking yourself this question all along, but it's especially important now, before you send your shot along, either for approval or to the next artist. A friend and former lead of mine calls this a "sanity check."

Figure 6-37 Checking the camera position — similar to the photo from set.

Figure 6-38 Does it make sense?

The first thing to do, of course, is to check your solve from all angles. This means going into the perspective view and orbiting around, or looking in the top, side, and front views, or in whatever combination works best for you.

Is my camera in the right spot? Are my survey constraints in the right place? Is my solution the right shape?

Really look at everything from all angles. Make sure nothing looks weird.

What's "weird"?

- Set pieces that look like they are touching in your camera view, but are five feet apart in your perspective window.
- One 3D locator that's 20 feet away from all the other locators in the solution.
- A camera right on top of an object that appears to be far away in the camera view.

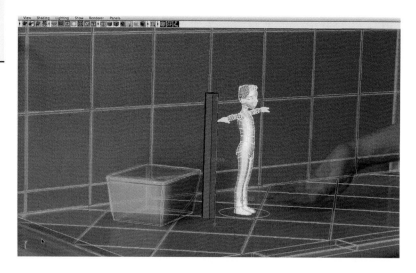

Figure 6-39 Adding characters to your shot helps evaluate your camera.

Figure 6-40 Sanity check — the human is the right height.

Tip: Thinking Ahead

It's a good thing we lined up our generic human in this frame, because we can see that her fingers are too short! If we'd waited until starting the rotomation for this shot — which will be fairly complex, due to the 27 bones in the human hand — we'd have to wait for the model to be revised, and a lot of time would be wasted. Now we can ask for the revision in advance. Yet another excellent reason for a sanity check!

Figure 6-41 Everything works from every angle.

"Weird" is completely shot-dependent, but you'll need to develop a feel for it. If something looks out of place, if it doesn't make sense, if your favorite *CSI* character would look at it askance, you need to go back and figure out what is going on.

In Figure 6-38, for example, I can see that the green container is safely in the right location — see how it's on the right tile when comparing the plate and perspective view? That's why we call it a sanity check.

Another excellent sanity check is to bring in whatever characters will be in the scene. This is a perfect way to evaluate how the camera and lens are working. Many supervisors will want to see your shot with the characters in place as a matter of course for evaluation purposes.

As we can see from these examples, our little CG friend looks good in the scene. The generic human, standing in for a 5′7″ woman, looks good next to the bathroom counter (Figure 6-40) — remember that we guesstimated how tall it was, and it looks pretty accurate. When the rig is maneuvered into position later in the shot, you can see that her hand is a fair match, and when we look in the perspective view, her position makes sense. You can see how her hand is just above the counter, and over the correct tiles, when compared to the plate.

I'm happy with this solve. All my sanity checks work, and it all makes sense. I'm ready to move on to my next task — a focus pull!

REAL-LIFE SHOT: FOCUS PULL

As I mentioned in Chapter 2, a focus rack is used in filmmaking to quickly shift attention from one area of the frame to another, underscoring an important plot point or visual detail important to the story. This move is often accompanied by *"dun dun DUN!"* music. A focus pull is generally more subtle, used simply to keep a character in focus as he or she moves through the frame (also called "follow focus"). As I've mentioned, I don't see them too frequently in VFX shots, but they do show up. Focus racks and pulls often look like Z translation to a solver, so the biggest part of the battle in solving a focus pull is knowing you have one in the first place! Let's look at how to attack a shot like this.

Determine What Needs to Be Done

This shot is similar to our lockoff shot in Chapter 6 — it's from the same sequence. In it, our character moves to pick up an object by the piece of tape on the counter, then stands up, moves closer to the green container, and examines it. The focus racks to follow his movement — that's noted in the camera report, actually, though not every focus pull is. Let's take a look:

Figure 7-1 Head of shot: the focus is on the mark near the counter.

DOI: 10.1016/B978-0-240-81230-4.00007-5

117

Figure 7-2 Tail of shot: the focus has racked to the mark on the back wall.

Looking closely, you can see that in the first frame, the camera is focused on the blue tape closest to us, and in the last frame, it's focused on the blue tape on the back wall. By stepping frame by frame through the clip, I can see that the actual transition takes place between frames 137 to 141. I also notice that the camera bounces around a little bit − I'll need to find out if the plan is to keep that bounce, or to *stabilize* the plate. I'm betting on the latter (my Sup will know for sure − be sure to ask!), and if so, I'd like to work with the stabilized plate − it will make my 2D tracking much easier.

When to Stabilize; When Not to Stabilize

Many times, you'll get a lockoff, or a shot that is stationary at the beginning or end. Even though the camera is supposed to be still, however, you'll actually be able to see some jitter or weave due to the internal workings of the camera itself, or maybe perhaps due to some technical trouble on set − may be the road was too muddy for the dolly, or something of that nature. At any rate, you have a shot that looks still at first glance, but actually isn't. What to do?

When you get a shot that falls into this category, ask your Sup immediately. Don't waste any time tracking camera jitter when your plate might be stabilized in the end! Many shows stabilize all lockoffs by default; some go on a case-by-case basis. If you see any jitter, weave, or motion at all in a shot that's supposed to be static, mention it right away.

Shots that settle or start from a stationary position are a little different. Sometimes there is a little bump (it actually will manifest as a small bump in your otherwise smooth camera curves) at the beginning or end of a

camera move, and depending on the needs of the shot and the aesthetic preferences of the Sups and the director, that bump may be smoothed out. Keep in mind that a plate can't be stabilized *too* much prior to matchmove, because just as changing the filmback changes your lens, changing the optical center of the frame throws the entire matchmove off. So if a bump is very prominent, you'll probably just have to track it.

Review Your Information

Luckily, we've already done a shot almost exactly like this one! Obviously, it's the same set, and it looks like the same place in the set — you can just see the bit of green sink over there on **screen left**. I'm willing to bet we can steal the setup from our lockoff shot for this shot, swap out the plates, and go from there, saving some time. "Willing to bet," though, and "100% positive" are two different things, so *make sure* to check the notes from set, camera notes, and the sequence cut (if available) to be sure that this is a good option.

I've determined that this shot *is* from the same sequence and was shot on the same day, but with a different lens, and it obviously has an animated focal length. I've asked my lead about the jitter in the shot, and it turns out that I was right — the shot is going to be stabilized. Generally, plates will be stabilized by the compositing department, and then published and passed back to the matchmove department for use as plates. Once I have my stabilized plates, I'm ready to go.

Screen Left, Screen Right

 Used to indicate the position of an element in the frame. Screen left indicates the left portion of the frame as you are looking at it, and screen right refers to the right portion of the frame as you are looking at it.

Color-Correct Your Plates

In this shot, 2D tracking is going to be crucial because the movement caused by a focal change is so slight; the track has to be dead on to get an accurate 3D solve. The plates as they are now are fairly washed out; they'll most likely be fairly hard to track automatically with 2D tracking software. This is an instance where color-correcting your plates before you track will be very important.

After fiddling around with my plates for about 20 minutes, I came up with a much more useful image for my purposes. I desaturated the red channel, bumped up the overall contrast, and used a degrain filter. For more information on color-correcting your plates, see "Color Correction: A How-To Guide," in Chapter 6.

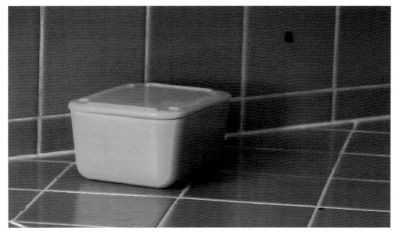

Figure 7-3 Color-corrected plate — compare to Figure 7-1.

Figure 7-4 Color-correction settings for my plate.

Set Up the Scene

Fortunately, I've determined that I can use an existing setup for this shot, so I can skip all the modelling, camera creation, and initial lineup steps I would normally take at this point. All I have to do is copy the original scene file into my new shot file structure, rename it, and open it up.

From there, I swap my plates out. Of course, my first frame lineup will no longer match exactly, but it will be close. I'll adjust it slightly to make sure everything is in working order, get something I'm happy with, and move on to my 2D track!

Figure 7-5 Imported camera with new plates. I'll adjust the camera position to line up with the new plates, then move on to 2D tracking. When copying an existing setup, **BE VERY CAREFUL** not to save over someone else's work!

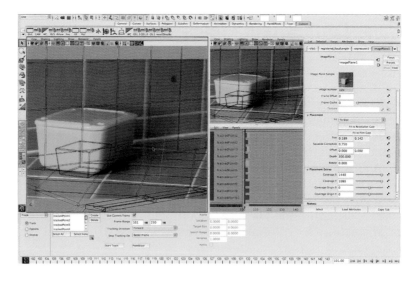

2D Track

The 2D track will be crucial to this shot, as I mentioned. The 2D motion created by a focus pull is very subtle; an automated tracker may or may not pick it up. It will also be necessary to track several points; I'll want to give the camera solver as much information as possible for this shot.

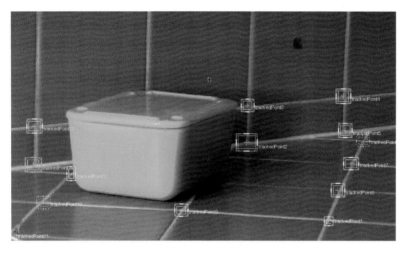

2D Hand Tracking

 Creating or adjusting 2D tracking curves manually rather than with automated software. This is necessary when there is too much motion blur in a plate, when there is not enough contrast, if a point goes in and out of different lighting situations, and occasionally for no good reason at all. This is done by moving the 2D track box or manipulating curves in the graph editor to the correct feature being tracked, frame by frame, by hand.

Figure 7-6 First set of 2D track points.

I'm lucky in that I have a nice grid for this shot, with lots of good, contrasting features to track. The more information I can give the solver for this shot, and, importantly, the more I can spread that information over the frame, the better. So, for a first pass, I choose the tile edges to track.

You might be asking yourself why I don't also track the very obvious blue tape markers – they've obviously been put there to help me, right? Well, the thing is, I don't know exactly where that tape is – it wasn't surveyed. If this were a long, moving shot, or if I didn't have a whole lot of survey data, I might very well use those marks it straight out of the gate. However, in this instance, I have a really nice model that I already know works very well, and I'd like to get a good initial solve before I start placing unsurveyed points.

Because the move is so subtle, you'll have to get in close when evaluating your tracked points. You may even have to do a little **2D hand tracking**. This isn't fun, but it does have to be done from time to time. Remember, I've determined that the move happens from frames 136–141, so that's the range I'll track. Since the plate has been stabilized, I won't need to track outside that range - though of course I'll make sure the camera is good for all frames before passing the camera along!

You can see from the graph editor in Figure 7-7 that the automatic track is pretty jumpy, even after my color-correction,

Tip: What to Track?

For more tips on choosing good 2D points to track, see "How Do I Pick Good Features to Track?" in Chapter 9.

Tip: Guestimate Geometry

For more tips on placing reference geometry for unsurveyed 2D features, see Chapter 8.

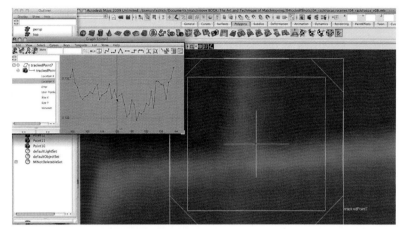

Figure 7-7 Zooming in on a tracked feature. The 2D curve for this feature is very noisy and will have to be smoothed by hand.

degrain, and slight blur. Focusing in on each track, and looking at the graph editor at the same time, I can fine-tune my 2D tracks by hand feeding much more accurate data into the solver.

It may seem overly time-consuming to spend a lot of time fine-tuning 2D tracks when you could simply fine-tune your camera move later as I often do; one set of curves to manipulate versus several is much more simple, right? In some cases, that's true. For example, in fast moving shots, where there is a lot of motion blur, and you're not really sure what features you're tracking in 2D in the first place, I wouldn't spend a ton of time fiddling with the 2D tracks down to the pixel, unless something were horribly awry with them – this isn't to say I don't try to get accurate tracks, just that when you don't have a ton of information to begin with, you can't *add* accuracy to 2D tracks by spending extra time messing with them when the necessary information isn't there in the plate in the first place. However, this is such a precise move, and the result will be so obvious on screen, that I want to do every single thing I possibly can to get the detail needed to solve this shot.

Survey Constraints

Now that I have my highly accurate 2D tracks, it's time to correlate them with known 3D locations on the CG set. From my last shot, I know this model fits pretty well – it's a little off, but not terribly. I'll place point constraints at the locations correlating to each of my 2D tracks, being careful to note exactly what feature I tracked – the center of the grout line, the upper-left corner of the grout line, and so on. Again, this shot is all about the very tiny details.

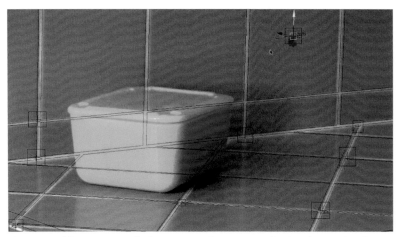

Figure 7-8 All survey constraint locators moved to corresponding locations on the 3D set.

Tip: Oh, Snap!

Want to make your life easier and your work go faster? Use the geometry snapping tools in your particular software to scoot your point constraint locators around at the speed of light!

3D Solve

With my survey points set, I hit solve and see what the software comes up with. Remember, because the move happens between 136–141, and the plate was stabilized, that's the range I solve over. When I evaluate my camera later, I'll make sure that it is good over the entire frame range, of course.

First, I'll let the software solve for all channels: XYZ rotation and translation, and the focal length. Of course, I know the translations and rotations won't be animating in the final camera, but I want to see what happens. If something goes wrong and the solution is really haywire, the information I get from solving all channels *might* be useful in telling me what's wrong. For example, if the camera pops around on one frame, particularly if it moves much closer or much farther away from the counter, it would indicate some bad 2D tracking data on that frame. Of course, solving with all channels open might not tell

Figure 7-9 Z rotation only varies by 0.1 degrees.

Figure 7-10 X translation varies less than 3 cm (around an inch) — not very significant.

me anything — but it takes only a second, and it's worth it to see what happens at any rate.

As you can see, the software solved with slight movement over all axes. Notice how small the variations are: barely 3 centimeters (about an inch) in X translation, and less than 0.1 degree in rotation. These aren't significant amounts, and are due to 2D tracking jitter. I'll choose the frame with the best overall fit, frame 138.

So I delete all the other keyframes on all channels besides the ones at frame 138; lock the rotation and translation channels, and let the software solve again, with only the focal length channel open.

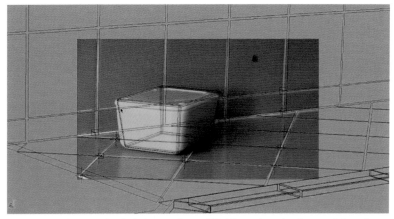

Figure 7-11 Because the fit is best at frame 138, I keep those keyframes, delete the rest, and lock all translation and rotation channels in preparation for solving the focal length.

Figure 7-12 Raw focal length solve.

With the other channels locked, all the 2D track data goes into solving for the focus. You can see that the change is very slight – from 40.561 mm to 40.582 mm – slight, but still very visible on screen. This curve is a little suspicious to me – the jump at frame 140 looks wrong (Figure 7-12). So does the much higher value at frame 137. I'll go to those frames and more closely evaluate them.

After closely examining the camera solve, I can see that the focal value at frame 137 actually gives a better fit than the values before or after. In the graph editor, I select the keyframe frame 138, and manually adjust it until the fit in the camera view is good; I flip back and forth between frames 137 and 138 to determine when I've gotten the right fit, and then move on to the next frame to make the slight focal adjustment necessary.

Figure 7-13 Fine-tuning the animated focal curve by hand. Notice the focal length values differ from Figure 7-13 — the result of experimentation with different fits on my part. Notice the focal length values differ from Figure 7-13 — the result of experimentation with different fits on my part.

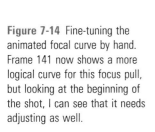

Figure 7-14 Fine-tuning the animated focal curve by hand. Frame 141 now shows a more logical curve for this focus pull, but looking at the beginning of the shot, I can see that it needs adjusting as well.

At frame 141, the final frame of the focus animation, I adjust the curve to match the fit of the previous frame. However, the curve now looks suspicious to me; it should rise steadily over the course of the shot, not shift back and forth, as this curve indicates. Obviously, I need to go back to the beginning of the move and adjust that keyframe as well.

Figure 7-15 Final focal curve, animated by hand. Again, note the difference in focal length caused by my experimenting with different fits.

After some more manipulating in the graph editor, I now have a curve for the focal length that I think is much more believable. I had to mostly animate it by hand, because again, this is a really subtle move. The software did get me 80% of the way there, though.

Now, I just have to prove it's good — to myself, and my lead.

Does It Make Sense?

In any matchmove you ever undertake, this is the most important question you can ask yourself. I've been checking all along, in the perspective view, to make sure that the software's 3D solution is jiving with my model, and it's been lining up very well. I would hate to have gotten this far (after a couple of hours of fine tuning by hand), only to look at the 3D data at this point and find out it's not even close to resembling my set! Let's see how to evaluate the 3D solution data.

Figure 7-16 Checking the positions of the 3D points created by the matchmoving software in perspective view. If they are in the same place as my point constraint locators, the solution is a success!

The camera tracking software creates locators in 3D space that correlate to the 2D points I tracked. Because I also gave the software survey constraints, the software took that data into account as well. As it computes the location and focal length of the camera based on that data, it throws 3D locators out into the scene, indicating where it "thinks" that point is in 3D space, based on the data I input. So if you see a 3D locator generated by the software that's way out of sync with your set data, you know something's gone very wrong.

In this case, though, all the 3D locators line up perfectly with the associated locations on the model. Great! That's one way to verify that your camera solution makes sense.

Evaluation

Next, you want to evaluate your camera move against the clip while it's playing, so you can judge it in real time. This is

the only real way to see if the shot really, really works; our eyes are so attuned to subtle little jumps and bumps and irregularities in real life that we often miss them when we're up close, going frame to frame, but when looking at a clip playing at speed on a screen, they're as clear as day!

There are a few ways to accomplish this task, and they tend to be facility- or show-specific, so be sure to ask your lead or supervisor how they would like to review your shots. That said, in general, there are three ways to present a shot for review:

Wireframe

A high-quality **wireframe** playblast is a great tool to test your work as you go along through the day, and to show your lead if you have any questions.

Wireframe

A display setting in 3D software showing the outlines of an object, rather than displaying it in solid form. See Figure 7-17.

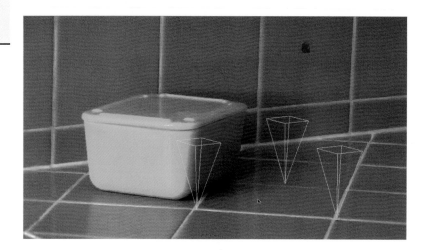

Figure 7-17 Wireframe cones rendered for evaluation. Cones are placed on the areas where the CG character will be standing.

You can show the set geometry, the characters that will be on the set (always a good idea), or markers, like the cones shown here. With their pointy tips, the cones show every little detail of your camera move. They are excellent − if frustrating − evaluation tools!

Solid

Sometimes wireframes are too hard to see, or are too aliased for proper evaluation. In such a case, it's simple to just display the same geometry − be it the set, the characters, or markers − as solids, and playblast or render.

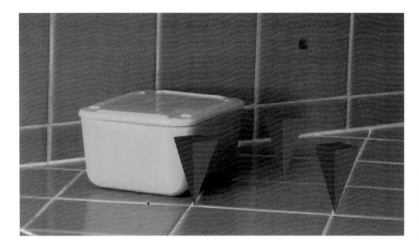

Figure 7-18 Solid cones rendered for evaluation. Ask your lead about your facility's procedures for this type of render.

Checkerboard

Figure 7-19 Checkerboard texture rendered for evaluation. Ask your lead about your facility's procedures for this type of render.

Finally, a plane or other piece of geometry with a checkerboard texture on it is a great way to evaluate your matchmove. With an entire surface covered, it's easy to see sliding that happens over a large area, especially if it's slight and over a long period of time, or around the edges of the image due to lens distortion.

How you present your shot really depends on the shot itself – how fast it is, the level of detail, and so on. Often, it's a good idea to do all three versions shown here, as each can

reveal different problems with your camera move. Some Sups will ask for all three, in fact. Be sure to ask how your lead or Sup wants to see your shot.

After evaluating my move, I'm happy with this camera. I'm ready to move on to my next shot, a tilt!

REAL-LIFE SHOT: CAMERA TILT

Here is our next shot, a tilt up. I can tell it's from the same sequence we've already been working on (though of course, I check to make sure!) That's lucky — we're already familiar with the set, the camera, and the fact that the fit on the tiles isn't 100% perfect, because we're dealing with an old building. So let's get started!

Determine What Needs to Be Done

Looking at the shot, I see it tilts up from below the bathroom counter we've been working with and settles in a position similar to all the other shots we've done so far. In the shot, our little CG friend will be hanging over the edge of the counter, looking at something below, and will then jump up and stand over by the green container. That's a bit of a relief, as there isn't any geometry or survey for anything under the counter. We don't need to be totally spot on

Figure 8-1 First frame of the shot.

DOI: 10.1016/B978-0-240-81230-4.00008-7

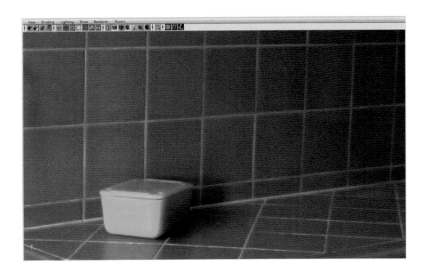

Figure 8-2 Last frame (FOV) of shot.

at the beginning of the shot, but still pretty accurate, because we don't actually know exactly where Character Animation will be positioning the character. We'll still need to build some "guestimate" geometry to get a good camera solution, as we'll see.

Also, the camera move encompasses a little over two fields of view (Figure 8-3), so we'll be dealing with 2D track handoffs as well.

Figure 8-3 Overlapping FOVs showing the zones with potential 2D handoff tracks (center region).

Review Your Information

So, I've confirmed that this shot is from the same sequence we've been working in, and in fact is the first shot in the sequence. Reading the camera report, I see that it's the same lens and setup as the lockoff we did, so I'm going to steal the camera from that shot to start out with and save some time.

Interestingly, the notes say this shot is reversed – it was originally shot starting from the tile wall and counter, and tilted down, but was reversed so that now it's a tilt up. This doesn't really mean much to us – we can track either forward or backward in time in both 2D and 3D software. It's just something to keep in mind in case it comes up for some reason.

Nothing else of note came up in reviewing the notes – though I do see in the snapshots from set that the camera is on a standard, not nodal, mount. With that in mind, let's set up the shot!

Set Up Your Shot

Set Up the Scene

As I mentioned, I imported an already final camera from another shot from this sequence, and got a first frame lineup based on the lockoff camera I imported. Hold on, though – don't forget this plate has been reversed! So that's actually the *last* frame lineup. Again, this isn't really a big deal for us. Our 2D and match-move software tracks forward and backward in time. We're really just tracking the camera "in reverse," because that's how the rest of the pipeline will see it – as a tilt up rather than the original tilt down. For all intents and purposes, it *is* a tilt up. So, let's forget it ever was reversed, agreed?

So, we have a **last** *frame lineup*. Since we have the most reliable, solid geometry lining up with the last frame of the shot, that's where we will begin our attack. When you need to place guestimate geometry in a shot, you want to work from an area of most certainty to an area of less certainty. Makes sense, right? Just like skating on thin ice – you want to start from the most solid, stable area and test a little bit as you go carefully along.

I color-corrected the plates using essentially the same settings as I have on previous shots in this sequence (for more information on color-correction, see Chapter 6, "Color-Correcting Your Plates"). We're ready to roll!

2D Track

We've had a little bit of luck, in that the character interacts mostly with the counter where the good geometry is, so I won't have to be super accurate below there, but it still has to be a good track. For one thing, you never really know where that character will go, plus, he'll cast shadows, and there are technical issues with motion blur, cloth and hair, and other effects animation that make it necessary to have an accurate camera track through the entire shot, even if the character isn't in every single frame. For more details, see "When can I get away with NOT tracking the camera?" later in this chapter.

Find the Handoff Areas

After studying the shot a little more, I see I'll actually need two sets of handoff tracks. Looking at Figure 8-3, note the highlighted areas. That's where separate fields of view overlap, and the areas on the plate and the CG set where we will really need good, solid 2D tracks for handing off.

How did I find that overlap? I noted the field of view – what you actually see in the frame – for the first and last frames.

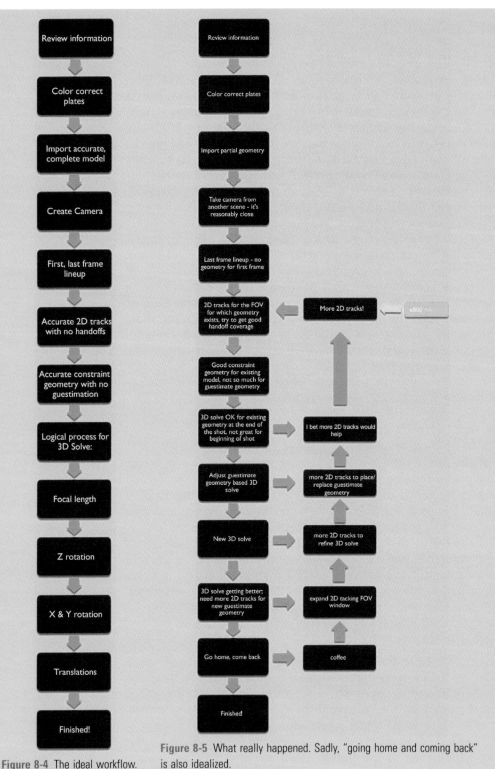

Figure 8-4 The ideal workflow.

Figure 8-5 What really happened. Sadly, "going home and coming back" is also idealized.

The Ideal Workflow vs. REAL LIFE!

As I have mentioned, one needs to be a pretty fluid thinker when it comes to matchmoving, because although there *is* an established workflow to follow that works really well, a lot of shots — maybe most shots, depending on the show — will diverge from the ideal to some degree. Sometimes this is just going back and adding more 2D tracks to your camera solution, no big deal, sometimes you might go back and adjust your model a little, no problem ... and sometimes you might have to perform major surgery: *ouch.*

This is one of the shots that, if not requiring actual surgery, certainly needed a couple of visits to the ER (mostly due to lack of set information/wacky building the shoot was in). I'd like to show you how this shot actually went as I worked through it, versus the idealized workflow presented in the chapter.

most, but don't quite, overlap in the middle. If they did, we'd need only one set of handoff tracks, but now we technically need two. Because the band in between the overlap is so narrow, though, I bet there are enough 2D features that are in frame for a long enough time to cover both handoff zones. That would be very lucky! Of course, complicating the whole procedure is the fact that we don't have half the geometry in the shot and will be placing it as we go.

So which points exactly is this image telling me to track?

I absolutely want to track points on the counter that come into view as soon as possible and last until the end of the shot. I already know for sure that those features fit well with the geometry I have, so they are ideal for 2D tracking. Next, I want to track features falling in that middle zone, in the handoff area: the edge of the counter (for which I have geometry), especially the broken tile screen left, the inner corner of the counter, and the edge of the sink. Once I have created a camera solution based on those 2D tracks, I'll be able to extrapolate some of the cabinet geometry below with a combination of the camera solution itself – and some common sense.

I'll bet you're wondering why I haven't mentioned that really obvious drawer and drawer handle – not only do they look highly trackable, but they also overlap in the handoff zone for a long time, and, they must be standardized, right? Yes to all, actually. However, I don't want to throw too much guestimate geometry into my shot at once – that makes it difficult to tell which part is throwing everything off later. I like to add a little bit at a time, test it, make sure it's solid, then add a bit more, and repeat. So we shall get to that very attractive drawer and handle in good time – don't worry.

2D points that don't overlap each other in time a great deal, or just don't last a long time in general, aren't very helpful to

Tip: How Long is Long Enough for a 2D Handoff Track?

It depends on your shot, of course.

Let's say you have a 40-frame shot, and a handoff that happens from frames 25–35. Ideally, a 2D track from the A side of the handoff would be 20 frames long and encompass ¾ of the handoff zone, and a track from the B side would be 20 frames long and also encompass ¾ of the handoff zone, so the two tracks would overlap for half of the time of the handoff. So you can see, "how long" depends on your clip, how long the handoff lasts, and what you have to work with, but ideally, you would have tracks that overlap each other in time for at least half of the handoff, and extend at least one quarter of their length beyond their respective sides of the handoff.

most camera tracks, but sometimes are necessary for giving some stabilization to the head or tail of a shot – like needing the corners of the frame at the very end to keep the camera stable. Sometimes you can't help a 10-frame handoff, especially if the shot is moving really fast. However, longer lasting and overlapping tracks are the goal.

I start 2D tracking with points on the lovely counter grid that I've determined last the longest in terms of overlap with the next FOV.

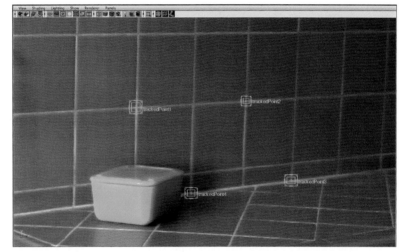

Figure 8-6 First set of 2D tracks, in the field of view where good, accurate set geometry exists.

A couple don't track very well at first, but I can go back and adjust them later, by hand if I need to.

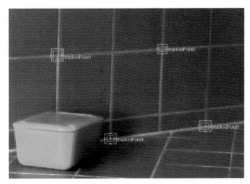

Figure 8-7 2D tracks in the frame range visible. They will have to be hand-adjusted a bit later, but it's best to see if we even need them first.

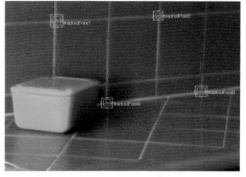

Figure 8-8 The same tracks, midway through the time they are visible in the shot. The tracks' trajectories indicate that the camera move is fairly linear at this point.

I track these initial points for the entire time range they're in view, and then look for my next likely candidates. Don't forget that you want to get good coverage over the whole frame to give a good "spread" of information to the 3D solver to work with.

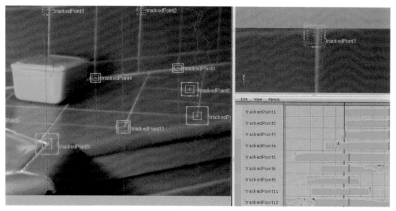

Figure 8-9 Some 2D tracks need a lot of help! The green bars represent the time range of each individual 2D track, showing the overlap of the handoff areas.

Obviously, the screen right tracks will have to be addressed. For some reason, those nice, hi-con grout lines that track so nicely on screen left just won't track on screen right! Instead of

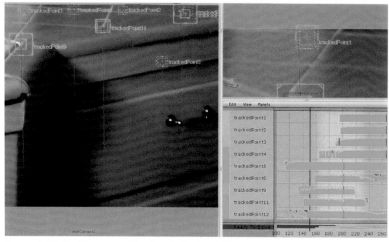

Figure 8-10 Tracking more 2D points in the handoff zone.

When Can I Get Away with NOT Tracking the Camera?

 Sometimes you'll get a shot where there won't be any CG work for the first 150 frames, the last 25 frames, or something like that. So that means you can just start your camera at that first frame and ignore everything else, right?

Wrong. As I've mentioned, you'll need *accurate camera* data both before and after any CG elements appear in frame for motion blur rendering, hair, cloth, and other dynamic simulations, and, most importantly, *because your Sup told you so.*

I can't tell you how many times I've seen novice matchmovers *actually arguing* with leads or supervisors about when they will or won't start a camera track or rotomation in a shot that doesn't need the full extent tracked. My advice? *Don't do that!* If your Sup says to start the camera move at frame 50, then *start the camera track at frame 50 and do not argue.* Period.

Sometimes though ... well, there are technical problems. This particular shot isn't actually bad, but sometimes you just don't have anything to track until your character is in frame, and as I say, you never really know where they're going to block that CG character in Character

wasting too much time on trying to figure out why (computers, they are magic), I'll go into the graph editor and adjust them by hand, which is easier and less time-consuming for me personally, than banging my head against the wall with a shot that just doesn't want to behave. See the section "When 'It Should WORK!' *Doesn't*," Chapter 3.

That issue aside, you can see the handoff overlap area starting to build up in the graph with the green bars, which

Figure 8-11 Be careful what track points you choose! Round things and highlights are definitely to be avoided.

represent the timeline of each individual 2D track (Figure 8-12). The end of the shot has good coverage, but the beginning needs more features tracked.

Now I'll move into the beginning, and less-sure part, of the shot. I do know I have geometry for the edge of the counter and the sink, so I'll track those to get handoff coverage.

Don't forget that our CG character will be hanging over the edge of that counter, so it will need to be solid.

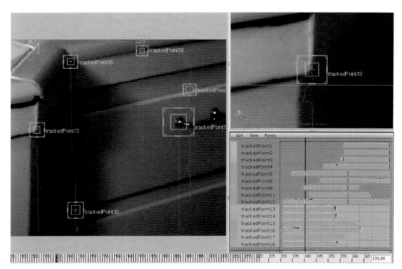

Figure 8-12 Getting more handoff coverage at the beginning of the shot. (Do as I say, not as I do ... I'll track that highlight and use it only if it's absolutely necessary. If you can weight your 2D tracks in your software, this would be the perfect case to use that option.)

Be careful which features you choose to track! Some features will jump right out at you and beg to be tracked – like the highlight on the drawer handle there. But we don't really know where that drawer is, much less the handle, and further, one should never track rounded profiles (see Chapters 5 and 8), and *never, ever track highlights*, because they aren't fixed – they move as the camera moves. There are some nice spots on the cabinet, but they sit out from the plane of the geometry we're certain of, and that corner on the right is going to be a very educated guess when placed. We're venturing into guestimate territory!

With this set of 2D tracks, we have pretty good coverage through the whole shot. It's the bare minimum of tracks needed to generate a camera solution, but it's a good place to start. When we get our initial camera solve and evaluate what its strengths and weaknesses are, we'll know where we need more 2D tracks and where we don't need to bother. So I'll clean these tracks up by retracking them if possible, hand tracking, or manipulating them in the curve editor, and move on to setting survey constraints.

Animation. And when you ask, they are a little vague, because character animation is pretty fluid.

What to do? It's okay to ask your lead or Sup about this issue; it's *not* cool to argue or refuse to do what they ask you to do once you've brought the issue up. So if you come up against a shot that you just can't seem to lock down until the character is fully in frame, ask your lead. See if he or she can find out more specifically when or where the character is going to appear (often, a lead going through channels gets much better intel). Sometimes you might have access to an animatic, (a sort of "rough draft" animation of the shot) which can tell you what you need to know. Doing a test render with the character in the shot and showing it to someone in Character Animation might be helpful, if it goes through channels. Occasionally, if the character animator is working on the shot concurrently with you, you can have him or her test the performance with your camera and see how it looks.

I always try to solve the entire shot, if possible. It's just easier in the long run, because nine times out of ten, if you track or rotomate only part of a shot, they'll need the rest of it later anyway – Murphy's Law! If it's just not possible, I track as much as possible, and then try to make the camera curves follow logical paths for the unsolvable parts (see Chapter 9).

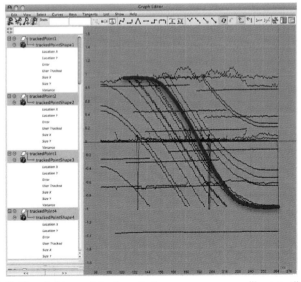

Figure 8-13 Though this won't be the actual curve your camera will eventually take, you will be able to guess how it will eventually be shaped from the average of your 2D tracks (in red). Here, you can clearly see the camera will start off slow, have a smooth move, then decelerate smoothly to a stop. If your final solve doesn't resemble this, be suspicious.

I almost always start out with as few 2D tracks as I think I can get away with when starting out a shot. This is for a couple of reasons: first, sometimes you're surprised at how few tracks it actually takes to solve a camera, so why spend hours and hours tracking in if you don't need to? In the same vein, I find that if you start out with fewer 2D tracks, it's easier to evaluate where you need more from your camera solution rather than just guessing while you're generating 2D tracks. Sometimes, you don't need nearly as many tracks in one area as you'd think you might; sometimes you need many more in another than you'd ever imagine. So I like to start out with a "skeleton crew" of 2D tracks, and go back and add on from there as necessary — it's more efficient for me.

Looking at the curves your 2D tracks generate will give you hints about what your camera track will eventually look like — it's good information to keep in mind!

Figure 8-14 Always version up!

Survey Constraints

Let's see how our camera solution looks with the minimal 2D tracks I've created, and then add new 2D tracks where it looks like we need them. Once we get a solid-looking camera move into the guestimate geometry zone, we will begin adding some new geometry, then create new 2D tracks for that geometry, then re-solve based on this new information, and so on, until we finish the shot.

Creating the survey constraints for the wall and the counter is easy — we've done these before in our other shots. Because I took this camera from another, similar shot, I already have the last frame lineup, so once I set up my constraints, I click solve, and see what I get:

Figure 8-15 Last frame lineup, version 1.

Not bad, but the lineup could use a little adjustment. I skootch the camera down on the Y axis a little, and rotate up on the X axis to compensate:

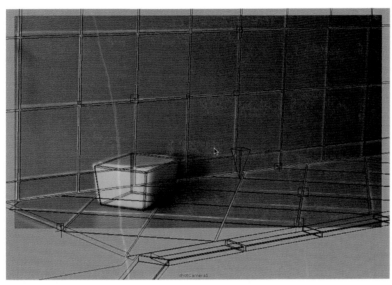

Figure 8-16 Move down on the Y axis, rotate up on the X axis . . .

Almost there — rotate a bit on the Y axis, rotate a touch more up on the X axis to match perspective:

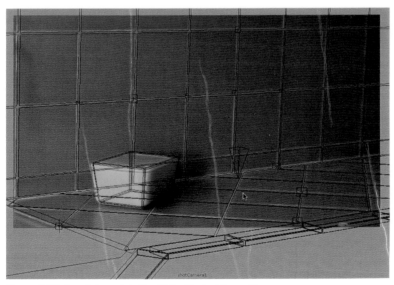

Figure 8-17 Done! A much better fit for the last frame lineup.

Done! You can see the wall tiles are a little off — remember, this is an old building. I might move the wall tiles over to the left a little to compensate for that — I'll make sure to mention it to my lead, as well. If it's a consistent problem, it might even go back to the modeling department to be revised, but with a change this small, each artist will most likely just massage the model a little if needed. Remember, *consistency of fit* over the length of the shot is more important than absolute accuracy of fit.

3D Solve

So, how is our 3D solution looking so far?

Figure 8-18 First-pass 3D solution: everything looks good.

It looks good! All the 3D locators generated by the camera solver are in the correct place. Moving on.

My plan from here is to solve the camera until these points go out of frame — around 197 — then get a good lineup there on which to base the next section of my solve. This next section of the camera solution correlates to the handoff band in Figure 8-3.

If you remember, I noticed from set photos that this camera wasn't on a nodal mount (reviewing *all information* — crucial!). Therefore, *technically*, we can't solve this camera move as a pure tilt, but with translation as well (for more information, see "Pan and Tilt Shots," Chapter 5). However, as I mention in Chapter 5, sometimes a non-nodal move can be solved nodally, depending on a variety of factors. So, I'm going to try it that way first. We'll find out soon enough if it won't work — the camera simply won't fit over the length of the shot.

Moving to frame 197 and rotating the camera manually only in X, it looks like we might get lucky (Figure 8-19):

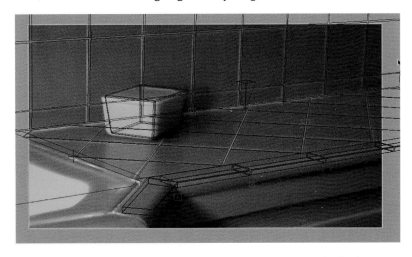

Figure 8-19 Lineup on frame 197, after rotating only in X. We might be able to solve this camera nodally after all!

That's a pretty good lineup, for just having eyeballed it. So I'm going to try solving this move nodally, by running the solver from this point to the end of the shot with the translations locked — only the rotational channels will the solving.

How does that look (Figure 8-20)? Well, it's not horrible, but it's not ready for the big time, either.

Figure 8-20 X rotation after initial nodal solve from frame 197 through the end. A little haywire at first, but settles down in the end, where the most solid set geometry is found.

Except for a few pops, which can be fixed by hand, the very end of the shot looks great. However, you can see that it's a little haywire there at the head — this indicates a lack of data. The solver doesn't have enough good information in that frame range to give back a good solution. There just isn't enough 2D data for the solver to calculate 3D locators and extract the camera move.

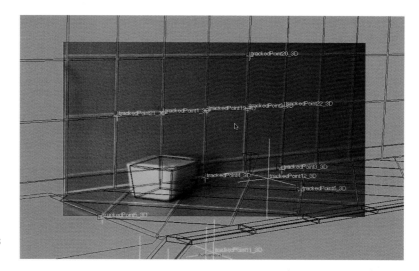

Figure 8-21 Several 3D locators are in the wrong position.

Another indication of a problem with the solve is that the 3D locator there in the front is not being solved in the correct location by the software. More information — via more 2D tracks — is needed!

The Basic Camera Solver Workflow

Many years ago, I learned a system for solving camera moves channel by channel that works really well, and I use it for practically every shot. You narrow down open channels one by one until you are solving for only one at the end. Starting from having all channels open, you would then lock down, in order:

- Focal length
- Z rotation
- X and Y rotation
- Translations
- One-point solve

So what does this actually entail? Say you have a shot with a focal pull, translations, and rotations. First, you would create your 2D tracks and survey constraints as usual, then generate a camera solution with all channels open (save focus — we'll get to that).

Now, examine the Z rotation graph. As I've mentioned, it's very rare for there to be much — if any — Z rotation on a camera that's on a mount. Even a handheld camera will tend to have very little Z rotation, believe it or not. If the Z rotation looks like it's actually zero and you're tracking film grain or camera jitter (this will show up as very, very tiny increments in the change of Z rotation value — +/− 0.001 degree or so), delete all the animation except for the frame with the best fit, and lock it. If there does happen to be some Z rotation in your solution, address it first. Adjust, smooth, and heal handoff pops (see Chapter 9 for examples of curve manipulations) in Z rotation, then lock it.

After you lock the Z rotation channel, run the solver again. The solution will be slightly different, because you are feeding it new and better information. Next, you'll address the X and Y rotations. Which one should go next? Generally, I pick the one that looks the nicest — the most accurate — let's say it's the Y rotation, in this example. Smooth it, fix any handoff pops, adjust where needed, lock it, and run the solver again.

Follow this procedure for the X rotation next. Once the rotations are solved, choose the best looking translation curve, smooth and repair, lock it, run the solver again, and so on for each channel, until you're done.

In the case of a focal pull, you have two options. If your shot is a lockoff, get a solve for your first frame lineup, then lock all the channels but the focus and solve for that. If it's not a lockoff, it gets tricky. Focus pulls can look like Z translation (like a dolly in) to the solver if it doesn't have a lot of 2D information to go on, so you might have to do a little back and forth between the translations and the focal channel. *Always* do Z rotation first, then the other rotations, the translations, the focal, and see how it goes. You may have to solve your Z translation, lock it, then solve the focal channel, lock it, and back and forth a bit a few times before it's perfect.

Finally, a good way to eliminate high-frequency jitter at the very end of the process is to choose one good, solid 2D track that encompasses the entire frame range (if possible), and solve only for X and Y rotations using only that single 2D track as the input. This is a great technique for a final, refining pass that really brings everything together in just about any shot, and is a very standard technique. Sometimes it's called a *one-point solve*, as in "Your shot looks good, but it's a little jumpy — try a one-point solve and see if that smoothes it out."

A final note: some software I've worked with allows you to lock individual rotation channels while using a 3D solver, but other packages don't. If you are lucky enough to have the option to lock the Z rotation out individually, by all means, take advantage. If not, don't worry too much. Because there is usually so little Z rotation in the first place, it comes out in the wash when you have good, solid X and Y rotational curves.

Figure 8-22 Repair and lock out the Z rotation first!

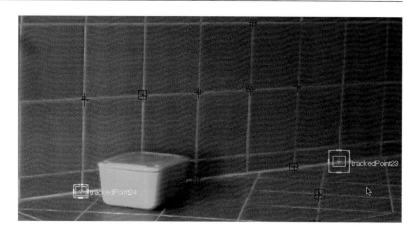

Figure 8-23 Adding two 2D tracks at the far edges of the frame helps the solve substantially.

Adding two more 2D tracks at the edges of the frame helps substantially with the solve. This is clear when looking at the 3D locators created by the camera solver (Figure 8-23) and when examining the camera curves (Figures 8-24, 8-25, and 8-26).

Let's look at the new curves:

Figure 8-24 X rotation.

Figure 8-25 Y rotation.

Figure 8-26 Z rotation.

We can see that the X rotation (tilt) is pretty believable – it has the same steady move and leveling off the 2D tracks have, so that seems trustworthy to me.

The Y rotation obviously looks a little wonky, but look at the scale on the graph: the change in value is only from 38.233° to 38.200°, which isn't really significant. I'm not going to be very concerned about it. I suspect as we go through the iterations needed for this shot, it will end up more or less flat.

The same is true of the X rotation – 177.62° to 178.246°. It most likely will end up being flat as well.

> **Tip: XYZ=RGB**
>
> Don't forget that the X, Y, and Z channels are always displayed in Red, Green, and Blue, respectively!

Handoff

To start the next section of our solve, I'll get a quick lineup for frame 101 to see where we are (Figure 8-27). Why frame

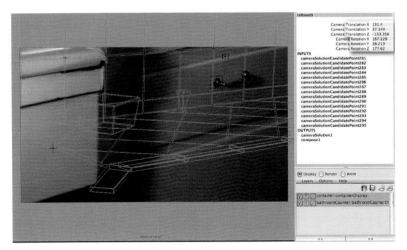

Figure 8-27 Frame 101, before adjusting camera curves.

101? Frame 101 is the first frame where known geometry shows up in frame, so that makes it a great place to evaluate how our camera move is going.

I'm going to use a nifty trick here and hope it works: I'll extend each camera rotation channel in the trend already established by the solver, and informed by what I know about the move already — that it settles at the end and starts out slow at the beginning. Once I've created those curve extensions, I'll see how my set geometry lines up.

Figure 8-28 Extending the X rotation (tilt).

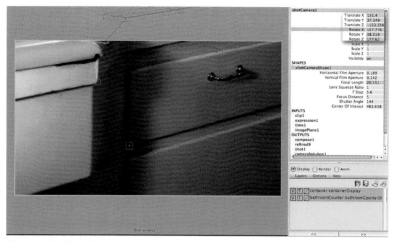

Figure 8-29 The existing set geometry (in grey, upper left) fits well with the extended camera curves!

This turns out to be a really good lineup, actually. You can see the 2D curves also resemble the ease in and out of the move indicated by the 2D track curves (Figure 8-13). Let's refine and see what key points we want to track in 2D and create guestimate geometry for.

First, at frame 197, I see that the model is off around the counter edge, so I tweak it, and make a note to mention it to my lead later. Normally I wouldn't care about this minor discrepancy, but as I'm going to be building guestimate geometry based on the accuracy of the geometry above it, I want these tiles to fit as closely as possible.

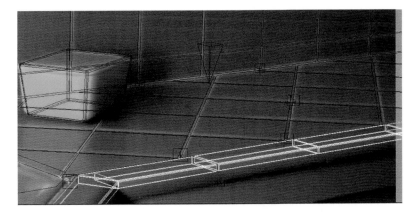

Figure 8-30 The edge tiles don't fit.

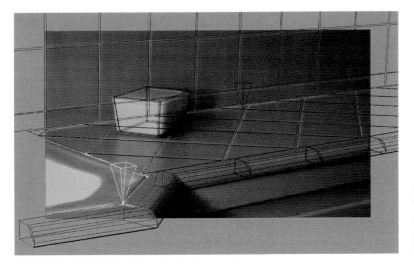

Figure 8-31 Rebuilt edge tiles. The fit is now much more accurate, helping to accurately place guestimate geometry below.

Ah, that's better. Figure 8-31 represents the final version of my tile revision — it actually went through many phases, which can be seen in the illustrations as we move ahead.

Now, I'm going to add a new layer for my new geometry. This is a Maya feature, so don't worry if you don't have this capability — it just makes things easier to hide and display (Figure 8-26).

Next, I'm going to add survey constraints for the edge tiles. So my first foray into guestimate geometry isn't actually too far out there, but that's the point — you want to take little baby steps, building the next little step on a strong, proven foundation.

I'll add a cone to my set (Figure 8-32) and lock it to the edge of the tiles, moving it over to the edge of the counter to the edge of the sink. Although I don't have actual survey for the sink, I have a pretty good idea where that point it — I definitely know what plane it's on (it's level with the counter) and I'm pretty confident about my new edge tiles. Once I place that cone, I create a point constraint for it, version up, and run the camera solver again.

At first glance, it looks great (Figure 8-32)!

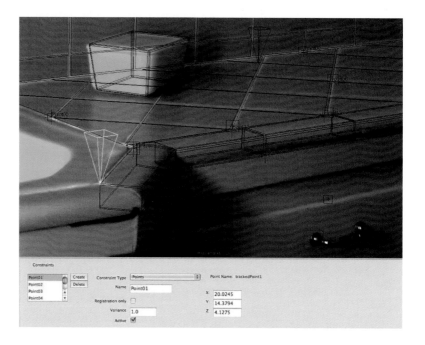

Figure 8-32 New solve with edge tile constraints added.

All the 3D locators created by the solver line up nicely with my geometry. But when looked at in perspective (Figures 8-33 and 8-34), you can see that although the 3D placement for the new points on the counter is really good, the solution for points on the lower cabinet (under the counter) is way off. Back to 2D tracking for more information!

Figure 8-34 ... are way out of line.

Figure 8-33 The 3D locators that should line up on the cabinetry ...

Adding Guestimate Geometry

This shot is dependent on creating new, accurate geometry based on an already existing set. This might sound intimidating, but actually it's fairly straightforward and logical. Let's look at some fast and accurate ways to place completely new guestimate geometry, in the context of this shot.

As I go through iterations and get more feedback from the 3D solver, I fine-tune my model as I go. Now, it's time to place a completely new point based on these refinements – I'm going to go for the edge of the cabinet below the broken tile and the handle on the drawer.

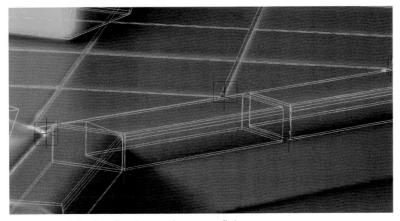

Figure 8-35 Adjusting tile edges as the camera fit becomes more accurate.

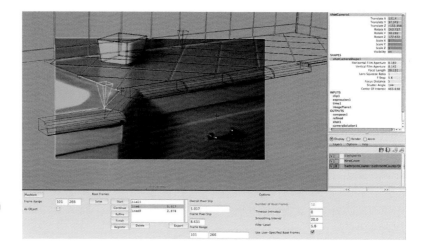

Figure 8-36 Every new solution gives us better information to extend our set.

To place the new geometry for the cabinet below the broken tile on the sink, create a cone, and place it at a solid point on your set – ideally, a point you have survey for, at a frame with a solid camera fit (Figure 8-37).

Figure 8-37 Snap the cone to the edge of the new tiles.

In this case, I start at the edge of the sink. Using "snap to curves" (or whatever snapping tools your software may have), I move my cone to the edge of the new tiles I've created. I'm pretty confident about those tiles, so this isn't a huge, crazy step for me.

But that point I've tracked in 2D is recessed from the edge of the tile, right? I can't just move my cone straight down and

expect it to work. What I do is this: once the cone is level with the bottom of the tile, I push it straight back along the cut line of the tile (looking in the Top View helps with this) until it lines up with the edge of the cabinet (Figure 8-38). Now I know it's in the position directly above the point I've tracked in 2D (or reasonably so — that cabinet doesn't exactly look square to me, but it will do).

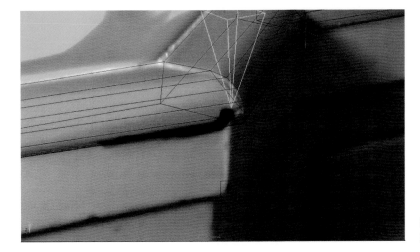

Figure 8-38 Push the cone in to meet the recess of the cabinet.

Now, move the cone straight down until it lines up with the center of the 2D tracking marker (Figure 8-39). Make sure to confirm that it makes sense in the perspective view (Figure 8-40)!

Figure 8-39 Slide the cone down the edge of the cabinet and into place.

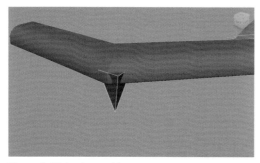

Figure 8-40 Looks good in perspective.

Excellent! I've just established the height and depth of that portion of cabinetry. Now that that point is in place, I can start putting in a lot of new geometry based on that one point. Don't forget that this is an old building, so some of it will have to be massaged, and keep confirming that it makes sense in all views, but this is the basic technique for placing new geometry when you don't have survey.

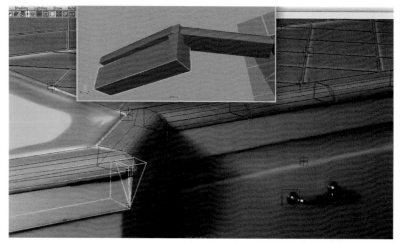

Figure 8-41 Adding simple shapes to represent cabinetry. The position of the previously placed cone determines the placement of new geometry.

Figure 8-42 Expanding the simple cabinetry.

Now that I've placed that new geometry, I'm going to use it to add new survey constraints and run the camera solver again. Once that iteration is complete, I'll again evaluate the camera solution and the 3D locators it's created, checking to see which ones are in line with my geometry, which ones are off, and then I'll repeat the procedure.

After the current solve, much of the 3D solution is in line with my new geometry, but there are still some pesky 3D locators not lining up (Figure 8-43). I'm not sure why — I'm considering dropping those points altogether to see whether it will help, in fact. Anything that far off, when most other data is working fairly well, has to have something wrong with it, regardless of whether I can tell what it is or not. Listen to your gut!

Figure 8-44 Slide the locator to the edge of the drawer front.

Figure 8-45 Pull the locator out level with the plane of the drawer front.

Figure 8-43 Some 3D locators are still not lining up.

For the next iteration of guestimate geometry, I'll place the drawer and handle in the same way as I placed the cabinet previously. I've already created geometry for the lower cabinets, so I snap a locator to the lower cabinet geometry and slide it to the edge of the drawer (Figure 8-44).

Next, I carefully push the locator out from the plane of the cabinet until it's level with the top of the drawer (Figure 8-45).

Finally, I scoot the locator over to line up with the 2D tracking marker for the drawer handle (Figure 8-46).

In this way, you can locate all kinds of points you'd never get survey for, but are really great for 2D tracks, like dirt patches, stains on walls, patterns on rugs, and the like. Just make sure that they always work in all views, and make sure to do the intricate placements on frames when you have really good camera solutions so that your points will be in the most accurate position possible. Don't forget: you'll never be certain as to the

Figure 8-46 Scoot the locator over to line up with the 2D track marker.

exact location of these points, but you'll know that you did a careful, precise job placing them.

Evaluation

All of this effort and iterations pays off! Finally, after a lot of back and forth and adjusting my geometry, I get a good camera solve. My camera curves look good, and the 3D locators generated by the solver all make sense.

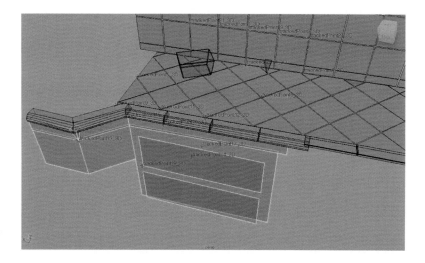

Figure 8-47 3D locators line up well with my geometry.

The X rotation curve (tilt) is pretty much what I've been expecting. It just needs to be evaluated with our character in the scene and refined at this point.

Figure 8-48 The X rotation looks as I expected it would.

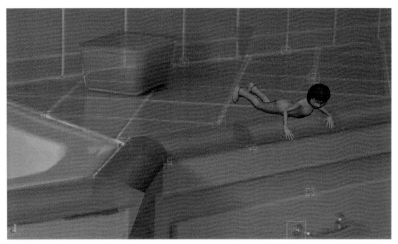

Figure 8-49 Evaluation with our character in the scene.

Once I playblast my shot with the character, wireframe, and some solid cones, I do see that some minor adjustments are needed. Mostly, some smoothing in the handoff zone is required. I apply a one-point track (see "The Basic Camera Solver Workflow" earlier in this chapter) to the affected zone, using a 2D track of the broken tile at camera left to smooth and lock down that section of the camera curves. That gives me the result I need, and I'm off to my next shot — a very challenging handheld shot!

REAL-LIFE SHOT: HANDHELD CAMERA

Let's look at a real-life, crazy handheld shot. This one has our camera operator walking backward on a residential sidewalk, following our pal as he walks by.

Figure 9-1, 9-2 The first and last frames of our new shot. That's a lot of motion blur — and a really dramatic change in lighting!

DOI: 10.1016/B978-0-240-81230-4.00009-9

On closer inspection, you can tell that he's most likely holding the camera on his shoulder (because the lens is level with our actor's face), and it's pretty shaky — no steadying methods were used in this shot. So right off the bat I know the curves on this shot might be pretty spiky.

Determine What Needs to Be Done

Fortunately, the shot is about rotomating the actor. That's good news, because this shot is going to be a tough solve. This isn't to say that I can slack off and not get a good solution for this camera; far from it. As always, a final, locked camera is essential to any successful rotomation. But our friend here is going to be on fire, so having a pixel-perfect fit for the far, far background isn't as crucial as it would be if we had to, say, replace all the buildings with smoking ruins, for example. That would be much harder.

━━━ How Do I Pick Good Features for My 2D Tracks? ━━━

With any moving camera, there will be features in your scene that don't appear in frame for the entire duration of your shot. Whether your shot just drifts a little and settles, or has a dramatic and lengthy move, you will always need to be able to determine which 2D features will be the best ones to choose for a successful camera track.

Figure 9-3 This frame is from a shot with slow pan.

In a gentle pan-and-tilt move like the one in Figure 9-3, which simply pans with the actor as he walks calmly from screen right and sits in the chair, there will always be at least one feature that you'll be able to lock onto to get your camera rotation — unless there is a lot of crazy action going on in the foreground, and all the good, trackable features are obscured at some point or another. What then?

In a shot with more movement, like a pan across a vast horizon, a long dolly in a complicated Steadicam, or one with a lot of action in the foreground, there will most likely be no single feature in frame for the entire shot. How does one get a good camera track when you can't even get consistent 2D tracks from which to derive it? Help!

The trick is to:

- Be able to identify the best features in the shot for your needs
- Be able to identify, of those points, which will overlap the most over the duration of the shot

So how does one identify these magical points in a 400-frame handheld shot panning wildly 180° down a residential street? Don't panic!

Consider our handheld sequence:

Figure 9-4 Tracking targets in a handheld frame.

Look at the scene in terms of its geometry, and more specifically, in terms of geometry that you already have built in CG or are confident that you can build yourself. Several features in this scene present themselves:

- Sidewalk
- Far and near buildings
- Low wall
- Doors

To start with, I'll need a couple of 2D points each for each piece of geometry. After I get a bare minimum of 2D tracks I'll test my model and camera. Think of this as a "rough draft" solve. Then I'll go back and make more 2D tracks to give the solver more information for a more accurate solve.

Try to choose features that are as spread out from each other as possible. Choose features that are as close to actual geometry you might have as possible — for example,

the corner of a building is better than a spot on a building (unless you have survey for that spot, of course). Choose features that are as high contrast as possible — or make them high contrast in your color-corrected plates.

Do *not* choose features that might be moving — for example, leaves, branches, water, anything blowing in the wind, the *shadows* of anything that might be blowing in the wind, and *especially never* choose a highlight as a tracking feature. These kinds of features are undesirable, because they have independent motion unrelated to the camera move, and introduce inaccurate data into the solution, giving inaccurate results.

Highlights are *particularly* undesirable because they always change position relative to the camera as it moves: if you have a shiny ball with a light reflecting in it, that reflection will track with the camera as it moves around the ball. Avoid highlights *at all costs*.

Similarly, the profiles of anything round should be avoided, as the shape will never change with respect to the camera, no matter where the camera moves.

Study your shot and choose features that are visible in frame for a long time — as long as possible. The longer a feature is unobscured and solidly tracked, the less "choppy" your solution will be. If you find features that last a long time except for a few frames here or there where they're obscured, track them anyway, deleting keyframes when the feature is momentarily obscured; a few long tracks with a couple of frames of missing data are much more desirable than lots of shorter, choppier tracks.

Let's pick some features to track on this sidewalk:

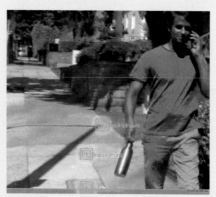

Figure 9-5 Good features to pick on the sidewalk.

You can see in Figure 9-5 that I've already broken my own rule and have put a track point right smack dab on a shadow — but since the shadow is from a lamp post, and there don't seem to be hurricane-force winds in the shot, I think it's okay. You also might wonder why I didn't pick the dark patch on the sidewalk near the top of screen left; that *would* be a great feature to track, as it's far away and would give some nice stability to the solve because it's so far away. It's only in the shot for about six frames, though, and the pop in the curves it would produce isn't really worth the trouble. And I can always come back and track it later!

Review the Information

As it turns out, no one measured anything at this location. I do know that the same camera we've been working with until now was used, though, and we know how tall our actor is. I also know the address of the shoot, so hopefully I can glean some good information from the Web, if we need it later. And, of course, there are a few standardized items in the shot — the door, steps, an air-conditioning unit. We should be okay.

I'm going to try an automated tracker first for this shot to see what I get, as I don't have any data from set. Let's give it a whirl!

Figure 9-6 Setting up the camera in the automated tracker.

Set Up the Shot

In this software, you set the camera up at the very beginning. Because I've determined that this shot was definitely handheld, I set the camera motion setting to free motion, so the camera won't be restricted in any way. It will be free to move and rotate on any axis in the solver's computations. I set the focal length to constant, as there doesn't seem to be any change in focus for the shot.

Figure 9-7 Color-correction tools available in the tracking software.

Color-Correct the Plates

In this particular piece of software, you can color-correct your plates from within the software itself, which is pretty handy. There are settings for saturation, contrast, brightness, noise elimination, and blur, along with a more sophisticated curve interface to color-correct channel by channel. You can display each channel individually, or a combination of two channels. You can also render out a temp version of your correction right from the interface – handy! For more information on color-correcting your plates, see Chapter 6.

As far as our matchmove workflow goes, we would next model the set, create the camera, and get a first frame lineup for our camera. But since there isn't a set, and the camera has already been created, we're moving on to the next step: 2D tracking.

2D Tracking

2D tracking is automated in this software; potentially, all you have to do is click a button and it will track hundreds of points, analyze them, and give you a perfect camera solution while you go to the gym over lunch. Of course, it's never *quite* that easy.

Figure 9-8 With the click of a button, the tracking software starts to generate hundreds of 2D tracks.

One thing to keep in mind is that the software doesn't create tracks that last a long time – in fact, when you look at the tracking parameters, you'll find that they often last around five frames! The software makes up for that lack of *specific* data with

overwhelming volume of data — hundreds of short tracks as opposed to a few longer tracks.

Figure 9-9 Judging by the shape of the 2D track paths, our camera solution is going to be bumpy!

Figure 9-10 The 2D track paths indicate that the camera motion has steadied somewhat at this point in the clip.

Occasionally you'll see that the tracks last for a longer time, but they don't necessarily have to. Minimum frame length can be balanced with the number and spacing of features in order to get the right balance of 2D tracks that you need for a good camera solution (see Figure 9-11).

Another way to improve your 2D tracks is to mask out any movement that you don't want to figure into your camera solution. In this case, I've noticed that in some versions of my color-corrected plates, the 2D tracker wants to track

Figure 9-11 Adjusting 2D tracking parameters.

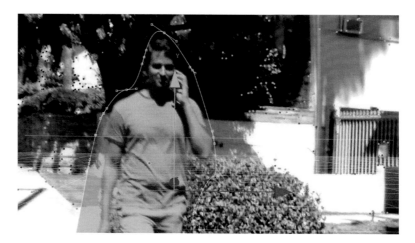

Figure 9-12 Masking the actor before creating new 2D tracks.

features on the actor's face and around his edges, which would throw the camera solution off, because he is moving independently of the camera. In other words, when the solver is using the 2D tracks to triangulate the camera position, the actor's movements, which are not created by the camera move alone, will add a certain amount of error into the solution. So, we will mask him out.

The masking tool in this and other automated trackers is similar to spline-based rotoscoping tools, and is relatively easy to work with. Simply outline your actor — or other independently moving object — fairly closely (you don't have to be exact) and make shape keyframes every four or eight frames, depending on his movement. Then, run the 2D tracker again, and your results should improve.

In this clip, our actor moves from a zone of bright sunlight into a zone of shade, and the 2D tracker has trouble finding features to track in the shady areas with the particular

Figure 9-13 As the camera starts to turn toward the building, the tracking software starts to lose 2D features.

color-correction that works for the sunny portion of the shot. The camera starts to turn toward the building as the actor passes by at this point as well, so motion blur becomes an issue. As a result, many fewer 2D tracks are generated, and the camera solution suffers at this point.

Figure 9-14 The motion blur causes trouble for the automated 2D tracker. Many fewer 2D tracks are generated.

To overcome this issue, modify the color-correction and blur settings of your plates. Try some very dramatic color-corrections (see Figure 9-15), and some subtle ones. Because you can render color-corrections right out of this particular interface, you can try many variations really quickly, and that's by far one of the best ways to get the number and quality of 2D tracks you need for a good camera solution.

Figure 9-15 A change in color-correction — boosting the contrast — substantially increases the number of features the software is able to track.

3D Solve

Figure 9-16 Click "solve motion" to start the camera solver once you're happy with your 2D tracks.

Now that we've generated 2D tracks from various color-corrected plates and track settings, we're ready to solve the camera. So . . . I click "Solve Motion," and see what I get.

Of course, as we don't have a model (right now), there aren't any survey constraints to set up as we normally do.

Keep in mind that you *can* set up some kinds of constraints in most automated trackers. But as we don't have any information from the location, I'm just going to see what the software gives me first.

Once the solution is generated, let's examine it. Already I can see that the tilt of the camera seems accurate (though I'll need

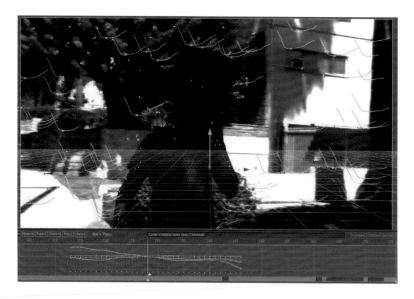

Figure 9-17 The initial camera solution.

to change the orientation of the scene if I want the grid to line up with the sidewalk). Looking at the camera curves, I can see that they're a bit more jittery that I would have expected, and when I look at the camera path itself (Figure 9-18), though it generally seems to be going in the right direction, it's all over the place, which is normal for a first pass.

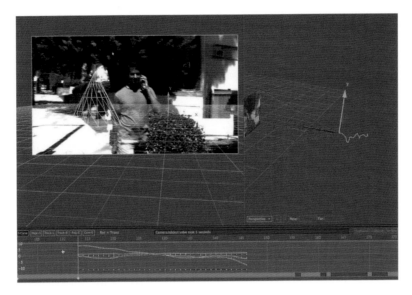

Figure 9-18 Creating a cone to evaluate the camera solution. Note the path of the camera in the right viewport — generally right, but kind of crazy!

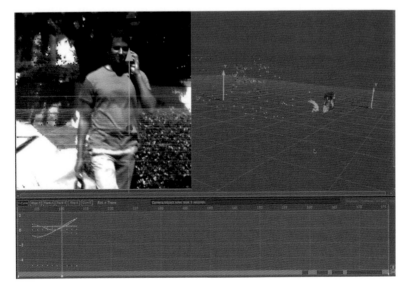

Figure 9-19 Examining the curves and point cloud created by the camera solver.

Looking at the point cloud generated by the solver, the shrub screen right shows up very well, but the background locators

are a bit more shapeless. I can definitely see a bunch of copla-nar locators that most likely represent the sidewalk and drive-way — I'll check those a little more closely.

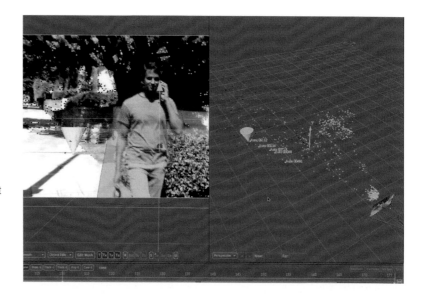

Figure 9-20 Assessing the point cloud. The highlighted locators look to be next to each other in the camera view, but actually aren't when seen in the perspective view, indicating an inaccurate camera solution.

As you can see in Figure 9-20, when I select a group of 3D locators correlated with 2D track points of the same feature (the high-contrast shadow of the light pole next to the cone), they seem to all be in the same location, as they should. However, when looked at in the perspective view, those locators that look to be in the exact same place are actually spread out along the sidewalk. This is a clear indication of a bad camera solution. To fix this issue, I'll need to go back and generate more 2D tracks — perhaps modified to last more frames.

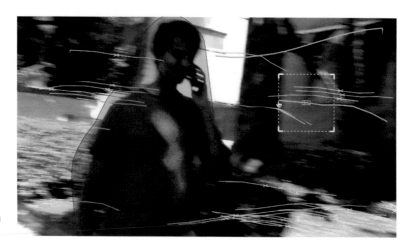

Figure 9-21 Widening the search area on a hand-tracked feature.

In some cases, I end up hand-tracking a few key points, like architectural features, that the automated tracker doesn't pick up. It turns out that the search areas on the 2D tracking boxes have to be so wide, to accommodate the speed of the camera move, that the software just can't keep up with all the features. In other words, the features move so far from frame to frame (in terms of pixels) because the camera is moving so fast (sometimes almost half the field of view), the tracker just can't find the feature in the next frame, and the track fails. Hand tracking a few key features, especially in the handoff area where the camera starts to turn, and giving priority to those tracks, helps solve this problem in the camera solution settings.

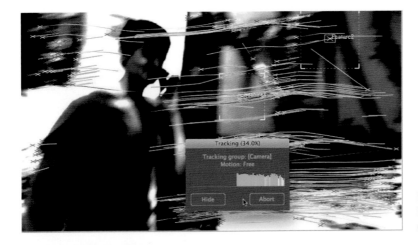

Figure 9-22 Dramatically increasing the blur and contrast generates many more 2D tracks.

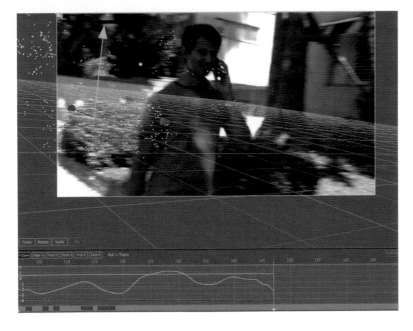

Figure 9-23 New, improved camera solution.

Dramatic color-corrections also generate many more 2D tracks.

After creating these new 2D tracks, my camera solution is much improved (Figure 9-23). The curves are much smoother, and the point cloud makes much more sense than before.

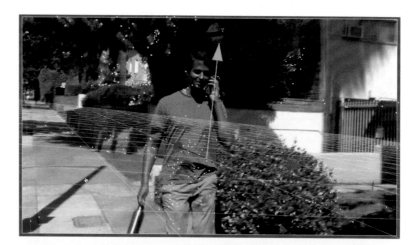

Figure 9-24 After I adjust the lineup of the sidewalk, the perspective and horizon line fit much better than in the previous solution.

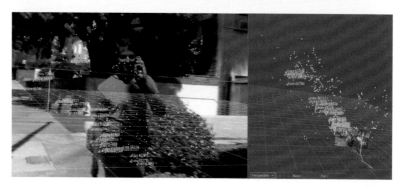

Figure 9-25 Examining the much improved point cloud: locators make sense in the camera *and* perspective views in this new solution.

As you can see, the distribution, or "shape," of the point cloud is now more logical and better represents the location than previously. The camera path, too, is much more on target.

After examining this solution more carefully, I decide that all it needs is a few tweaks and a little massaging, and it'll be ready to go. Nice work, automated solver!

Refining the Solution Channels

Z Rotation

Now we get into the fine tuning of the camera solution by massaging each channel, locking it, resolving the camera, and so on, until we are done. For more information on refining and

Figure 9-26 Closer examination of Z rotation (called "roll" in this software).

narrowing down your channels, see "The Basic Solver Workflow," Chapter 8.

Examining the Z rotation channel in Figure 9-26, it looks like a slightly bigger motion than I would expect – though interestingly, I see it's on an eight-frame cycle, give or take – about average for an adult walking normally (see Chapter 12, Breaking Down the Clip, for more details), so that's completely believable. The cameraman is rocking back and forth slightly as he walks.

To refine this curve, I'll create a smooth Bezier curve that reflects the general curve but with a bit less amplitude.

Figure 9-27 Smoothing amplitude of Z rotation.

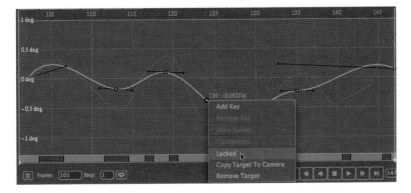

Figure 9-28 Locking Z rotation. . .

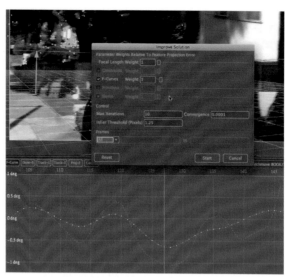

Figure 9-29 . . . and running the solver again.

With my smoothed Z rotation curve locked, I solve for the camera again. In this software, you can give priority to user modified curves when running the solver — a nice feature. Be sure to look for these kinds of features in any software you end up using.

Figure 9-30 Pops in X and Y rotation (called "pitch" and "yaw" in this software).

Refining X and Y Rotation

After the Z rotation is locked and the solver finishes, I see a couple of huge pops in the X and Y rotation curves. Not sure where that came from! Those keyframes are so obviously wrong, I just delete them. If that makes you really uncomfortable, just save up a new version, and *then* delete them. Don't worry — I delete keyframes *all the time*; you can always just go back a

version, or run the solver again. It's no big deal… but those keys are *wrong*, I'm telling you. Get rid of them!

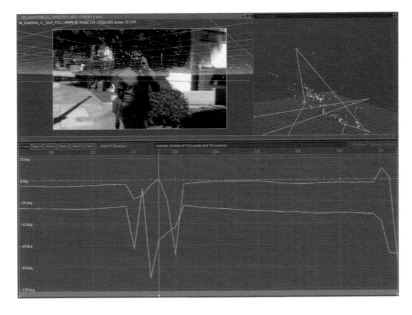

Figure 9-31 The pops put us way out of alignment with the grid — they aren't just minor variations from the solver.

Figure 9-32 The X rotation curve after deleting the obviously incorrect keyframes (the pops) and smoothing.

After I delete the *obviously* wrong keyframes, the true form of the curve is revealed. Again, note the eight-frame cycle (give or take) — this curve follows the cameraman's natural gait. Remember that X rotation is tilt, so this indicates the camera rotating up and down — reacting to him walking. It's always in the negative range, indicating the camera tilting down slightly — which makes sense when we look at the plate. This curve is perfectly logical, looks good in the camera view, and again, the point cloud looks good. I smooth it just a little, lock it, and run the solver again. Once that solution comes back, I do the same with the Y rotation.

Well, yes and no. If you remember, I said way back at the beginning, there are two kinds of matchmovers: one more exacting and technical, and one more, let's say, free-wheeling. A more technically-minded matchmover would probably look into the issues causing the trouble with the solve, fix it, and get a perfect solution straight out of the solver. That sounds like *a lot* of work to me. I can tell, in this case, this solution is mostly good; I can massage the inaccurate parts of the curves to work too. To me, that seems much, *much* easier. To a more technically-minded matchmover, it probably sounds insane. Either way is the right way, if it works for you and you get the results needed. My personal opinion is: who cares, as long as the shot comes in final, on time, under budget, and while you're having fun?

Figure 9-33 Pops in X translation. The general trajectory of the curve is believable, but the frames at 104, 111, 112, 113, 125, 138, 144, and 145 are obviously wrong. Delete!

Refining the Translations

After I smooth and lock my rotations, I check my translation curves. They all look pretty good, about what I expected, except that they all have really obvious pops at around the same frames. I honestly don't know what's up with those frames — some bad 2D tracks, or not enough 2D tracks, maybe — but to be honest, I don't really care. It's much easier just to fix the camera curves than worry about why they're wrong!

Figure 9-34 Pops in Z translation. As before, the general trajectory is good, but there are obviously wrong keyframes.

I choose to deal with the pops in Z translation first, because they're so obvious and distinctive. Sometimes it's a little hard to tell where a pop ends and some jerky but legitimate motion starts, but in this case, the problem frames are clear as day. I just go ahead and delete them, and then smooth the overall curve a tad, just to compensate for high-frequency jitter due to film grain, or, in this case, video noise. Then I lock the channel and re-run the solver.

Next, I look at the Y axis. I choose Y because the actual over-all change in distance is so little — a millimeter or so in height

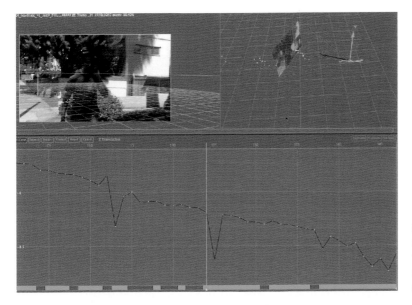

Figure 9-35 and 9-36 The difference the pop between frames 124 and 125 makes in the camera view (note the grid on the sidewalk near the driveway).

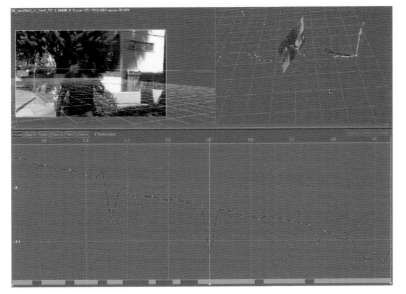

Figure 9-36 (Continued)

Figure 9-37 Correcting the pops in Z translation before locking and running the solver again.

Figure 9-38 Pop in Y axis.

over the entire clip. That's one steady cameraman! Don't forget, what you don't see in Y translation (bouncing up and down), you do see in X rotation (nodding up and down).

Aside from overall smoothing, I want to fix the dip towards the end of the clip – I don't think the cameraman stepped in a hole! To do that, I simply select the two points in question in the graph editor, and move them up to be in line with the points around them – they fit perfectly (Figure 9-39).

Figure 9-39 Adjusting the Y axis curve to determine the best fit. Here, the difference is negligible. Look at the axis: this curve differs by only 0.1 cm over time.

I also pull the last keyframe up to continue the same curve trajectory (or slope, in fancy math terms). When I go to the frames in question and check how the changes affect the fit, it's hardly visible – remember, it's less than a centimeter's difference.

One I've repaired that pop, I smooth out some of the rough edges on this curve by eye (Figure 9-40), lock it, and rerun the solver.

Figure 9-40 Smoothing the Y axis before locking it and running the solver again.

Figure 9-41 The X axis after the new solution. Compare to Figure 9-33 — see the difference the smoothing, locking, and re-solving each channel has made?

Finally, we come to the X translation, which seemed like the worst off to me at the beginning. Look at the change from Figure 9-33 to now (Figure 9-41)! So you see, the repairing, smoothing, locking, and resolving process works very well. The X channel is *much* more believable now.

The X translation indicates the cameraman's position relative to the width of the sidewalk and the face of the buildings; he

Figure 9-42 Smoothing the end of the X translation.

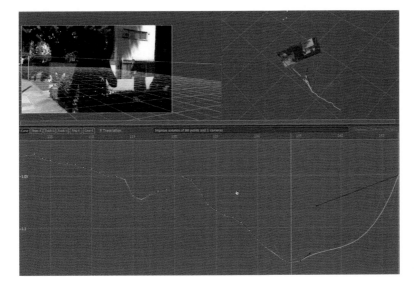

Figure 9-43 Matching the new smoothed curve to the general trajectory of the camera solution.

maintains a fairly steady distance from the edge of the sidewalk, to accommodate the actor walking by. The only translation channel to see significant change over time in this shot is Z translation, or movement down the sidewalk, which we've already looked at, and definitely reflects that change over time.

There is still some really spiky action in the X translation towards the end of the clip, which doesn't really reflect the way people move (I doubt he suddenly stepped in the actor's path), so I'm going to smooth that out and then check the new curve to make sure it's accurate.

X Translation Drift

Once I've smoothed the X translation — and I smoothed it rather radically — I step through those frames to check the fit. As you can see from Figures 9-44 and 9-45, there is a drift in the X position that needs to be fixed. In other words, the X translation is correct at the beginning of the shot; but as time goes on, it starts to drift away from the correct position, though the relative shape of the curve overall remains accurate.

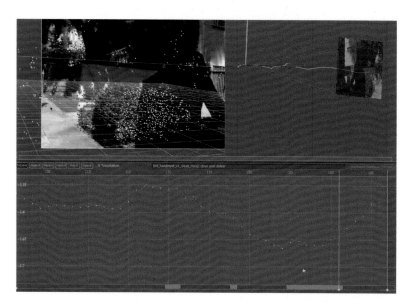

Figure 9-44 The X translation has drifted over time (seen in the ground plane next to the driveway).

Once I have found the first frame before the translation drift starts, and adjusted the camera's position in X where needed (Figure 9-45). I can repair the curve. To repair the portion between the last two values in the curve, I delete the keyframes in between and create a smooth transition between them with Bezier tools. To ease the curve from the first frame of

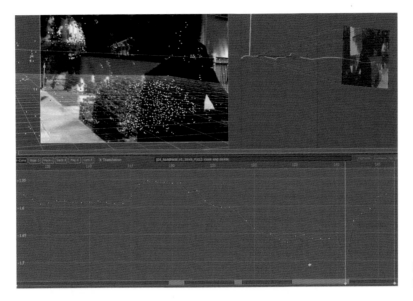

Figure 9-45 The corrected X translation value for frame 141.

Figure 9-46 The corrected X translation value for the last frame.

drift (frame 124, Figure 9-40) to the first adjusted frame (frame 141, Figure 9-45), I use a scale tool that moves each keyframe down incrementally, starting from the last good frame 124, to the target keyframe (frame 141). There are many scaling and smoothing tools available in different software packages, and most have a tool like this, with which you select the frames you want to affect, determine the frame you want to be the target, and adjust to meet. Next, I adjust the curve between frame 141 and the end of the clip in the same fashion (Figure 9-48).

Figure 9-47 Using Bezier curve tools to ease the change in the translation curve due to my adjustments.

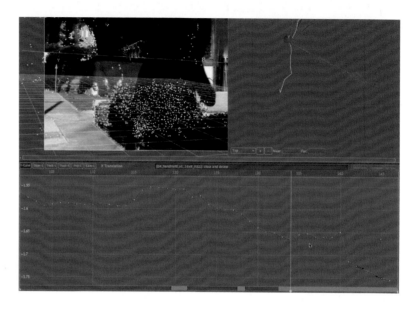

Figure 9-48 Preparing to adjust the next section of the curve, from frame 124 to 140.

Once I've made that change, I smooth the entire curve and lock it, then render a clip to evaluate my scene.

Z Translation Hitch

After I evaluate my rendered clip, I feel I've oversmoothed my Z translation: it's slipping slightly. So, I decide to solve for the Z translation again, with all the other channels locked. This isn't unusual – I did do some major surgery on the X translation, remember, and all the channels are interrelated of course!

Once my solution comes back, all looks good as I step through the frames – no more slipping. Except what's this? A big bump at frame 123!

That's actually not that weird; remember that there were pops in almost all the channels around frame 125 or so. Obviously, the 2D data around those frames is inadequate. No problem- I'll just massage the curve a bit. I'll just grab all the keyframes after this bump, pull them down to be in line with the rest of the curve, and call it a day! (Figures 9-49, 9-50)

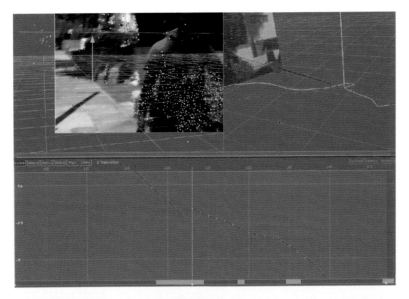

Figure 9-49 Bump in Z translation. This curve indicates that the cameraman moved forward at frame 123 and then started moving backwards again in the same trajectory already established (also seen in the camera path to the right). I *highly* doubt that happened.

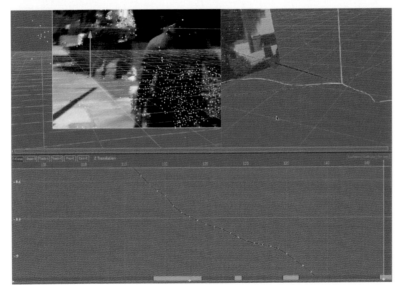

Figure 9-50 Massaging the Z translation. The keyframes after frame 123 were selected, then moved down to be in line with the overall curve.

One-Point Solve

Once I evaluate my work after repairing the Z translation, I see that the whole shot has some high-frequency jitter. It's not bad, but it needs to be taken care of. This is the perfect time to use a *one-point solve.*

Figure 9-51 A cone at the location of my one-point solve feature.

Figure 9-52 Hand-tracking the shadow feature — how crazy the track path is in the camera view (Figure 9-53)!

All you need to do for a one-point solve is find a really good, solid feature for a 2D track. Closer to the center of the frame is better, but sometimes you can't be extra choosy. I'm going to use this excellent light pole shadow — it lasts a long time, it's nice and high-contrast, and our actor never obscures it.

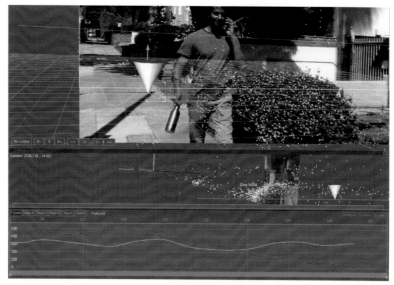

Figure 9-53 New camera generates by the 2D track. Look!

I track the feature by hand, and make extra sure the 2D track is spot on. This is the finishing touch to my shot, and I want it to be perfect!

Figure 9-54 New, improved X and Y rotation curves after the camera solver is run.

Once I finish my 2D track, I unlock the X and Y rotation channels, and run the solver again — but with *only* this 2D track as input. This way, all the filtering, smoothing, repairing, and nurturing that I've poured into these camera curves will inform the new solution for the X and Y rotation channels — bringing everything full circle.

And this final touch does the trick — my shot is finalized!

CHARACTER ROTOMATION CONSIDERED

I was sitting at my desk one day, when a co-worker wandered over to watch me work over my shoulder for a bit. I was working on the first pass of a fairly involved character matchmove, or *rotomation*. I was making my first pass at the shot, identifying the major poses, where I would set my very first keyframes, from which all other movements would flow. I started stepping through the clip frame by frame to determine where my next keyframe would be. I was zeroing in on the perfect frame, flipping back and forth between two potential frames. Finally, I decided on the former of the two, went back to my animation session, and started working on the pose. All of a sudden, my co-worker, who had been watching me silently while I was choosing my next keyframe, blurted out, "How do you pick which frame to use? *All I see is flailing arms and legs!* How do you know where to go???"

His outburst really surprised me — it seemed *really obvious* to me which was the next key pose. So I thought about it for a minute. I actually hadn't even noticed how much flailing was going on — it was a lot — because I don't focus on arms and legs during a first pass rotomation. All I look at are the actor's hips. Specifically, the zipper, if he has one, or the seams on his pants. I just step back and forth and watch that zipper, and wait for it to change direction. That's it. Then I manipulate the character rig to line up with the real-life actor in the plate, and move on to the next key pose.

When I started out rotomating, I already knew a bit about anatomy, because I had a childhood fascination with bones and all the ways to break them. When I got tossed into the rotomation deep end on *Stuart Little II*, animating hands, hands, and *more hands*, I found it useful to learn the medical terms for the bones of the hand in order to communicate more clearly with the Rigging Department. I found a $5 copy of *Gray's Anatomy* in the bargain bin and it's proved invaluable — not to mention that it looks cool on your desk. Being familiar with anatomy also helps in rotomation, because it gives you insight into the mechanics of the body — just as knowing how a camera works helps you become a better matchmover, knowing how the human body works makes you a better rotomater!

What Do You Call Character Matchmoving?

Different people — and different facilities — call character matchmoving different things. I prefer to call it "rotomation" — I suppose because that's what I originally learned. You might also hear it called matchmation, soft tracking, or just character matchmoving.

DOI: 10.1016/B978-0-240-81230-4.00010-5

I explained that to my colleague, and he pretty much looked at me like I was nuts. He did come back and ask me about it a few times, though, so I must have made an impression!

This kind of frustration and panic is not unusual when it comes to rotomation, I've found. It's more of the rule than the exception. Many matchmovers find rotomation very frustrating, but this needn't be. In this chapter, I'll look at the theory and tools you'll need to attack any rotomation with confidence — and maybe to even enjoy it!

How Did I Get to Be Good at — and Actually Enjoy — Rotomation?

During my tenure at Imageworks, I got to be a go-to rotomation person. I often got shots where other artists tracked the camera, and then handed it off to me for the rotomation! If a shot had some hairy roto in it, you can bet it would be assigned to me.

I had no idea I'd be good at rotomation before I tried it, but after my first shot — which went a little nuts (see "Crazy Dynamics!" in Chapter 12) — I really took to it and *I actually like it*. So how come I'm a natural rotomater when so many other really, really talented artists are so frustrated by it?

I've thought about that for a long time, and here's what I've come up with:

I Loved Doing Pratfalls à la Chevy Chase When I Was a Kid

Chevy was — and still is — a genius of physical comedy. I got really good at falling off, over, or otherwise upsetting things, imitating his performances on *Saturday Night Live* — much to my parent's horror. I've been known to toss myself on the floor, Chevy-style, to this day if I think it will get a laugh. So I started observing and imitating human movement at a young age.

I'm Fascinated with the Way People Move

I can't get through an entire episode of *The Colbert Report*, because I keep rewinding to watch the way Stephen Colbert uses his hands — fascinating. Clint Eastwood looks so cool, yet uses the sparest amount of effort to push himself off a wall in *The Good, The Bad, and The Ugly* — I could watch it over and over. It often takes me over an hour to watch the half-hour *Entourage* — Jeremy Piven is my new Chevy Chase, a real physical comedic genius.

People on the street fascinate me, too — I've been known to "pose" myself as if I were a CG character, imitating other people, practicing for animating later. Don't let other people catch you doing that, by the way.

I'm Not Afraid to Look Goofy or Have People Laugh at Me

In fact, I encourage it. This is key, because roto often requires you to act out the moves you're animating — and your co-workers *will* see you! Having fun and not being too stiff about life in general makes you a good matchmover anyway, so have fun!

First Off: What's Roto for?

You might be wondering why we would want to animate CG characters to match real-life actors on set in the first place. Here are some functions the rotomated character might serve.

Having Something for Full CG Characters to Look at and Interact With

When a real-life actor is talking to, doing battle with, or otherwise engaging a full CG character, the character animators need to know where in 3D space that real-life actor is. Quite often, character animators don't look at the plate very much, or at all – they only look at their scene and character performance from the perspective views in the CG environment. They depend entirely on the matchmove team to place the sets, props, and actors in the CG environment accurately for interaction with the full CG character.

FX Animation Interaction

If the real-life actor is supposed to generate or otherwise interact with dynamic simulations like fire, sand, snow, goo, water, hair, cloth, or similar effects, a CG character will need to be rotomated to drive, influence, and interact with those simulations.

Shadows, Reflections, and Other Lighting Interactions

If the real-life actor would cast shadows on, or be shadowed by, a full CG character or element, a rotomated character would be needed for those lighting simulations. The same is true for reflections, refractions, and ambient occlusion.

Face, Clothing, Body Replacements, or Additions

Perhaps the real-life actor will be digitally aged, or have half his face digitally burnt off. Or maybe he grows a third arm, or sprouts a magical cape. A rotomated character is needed as a base on which to add these effects and animations, and to render and integrate into the final plate.

Tip: What's a Rig?

A rig, in our context, is an animatable CG character. It has digital skin bound to a digital skeleton, which behaves somewhat like yours or mine. This skeleton allows the artist to manipulate the character, animating it in the way a human would move. Usually, it will have *handles* (graphic representations of animation controls) to select the different joints of the body. It might have the ability to select between FK (forward kinematics) and IK (inverse kinematics) animation (for more details on FK and IK, see Chapter 11).

Tip: Why Is It Called a Rig?

A CG character is often called a rig because, well, it's a digital skeleton with digital skin over it, *rigged* up to work like a human skeleton and skin.

"Rig" is actually a common term generally in filmmaking (including Visual Effects). Usually it refers to something – any sort of useful, ad-hoc contraption – built or cobbled together on the spot to get a job done.

Other Cases

Occasionally, practical effects or makeups on set don't work out for one reason or another, and have to be replaced digitally – the "fix it in post" phenomenon. If these interact with an actor, then of course he'll have to be rotomated to mesh with the digital replacements.

How Do You Start?

One problem with rotomating that can lead to frustration is that the show might not always be prepared for the rotomation needs of the Matchmove Department. I think this is because there is a perception that the Matchmove Department has a "store" of digital camera equipment – camera backs, lenses, and so on – that are really just software presets, but perhaps seem like actual digital assets to someone unfamiliar with the process. Therefore, it's logical to assume that we would also have a store of characters for rotomation handy as well. Actually, though, matchmove is dependent on the show to provide rigs for rotomation – which makes sense if you think about it, since every show has different actors and pipeline needs.

So sometimes you have to do a little detective work to find your own CG character, or rig done on set.

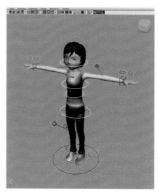

Figure 10-1 Andy, our rigged CG human character.

Where Does My Rig Come From?

Hopefully, you're on a show that has dedicated rigs for each character needing rotomation. Sometimes you'll even get rigs that have been scanned from the actors themselves; other times, the Modeling Department creates virtual doubles from meticulous photographic studies done on set.

If you don't have a rig available right away, find out if there will be one. Is one in the pipe? If so, see if you can get the current working version to at least get you started on your shot. This situation isn't unusual, especially at the beginning of the show. Also, rigs are constantly updated throughout the course of a show; make sure that you have the right version of your rig whenever you start a new shot.

In other cases, your might have some good, generic humans that can be adjusted to fit a variety of different body types and situations. Sometimes there are just GenericMale and GenericFemale; other times, there may be more varieties – business man, casual guy, kids, shopping lady.

Sometimes, you'll have to go hunting for a rig yourself. This is when it really pays off to know – and be able to ask favors of – the production staff at your facility – a good reason to make friends outside your own department!

Ask if another show in the facility right now has a rig that will work for you. Maybe you can use that rig. If not, you'll need to do a little data mining. Has there been another show at your facility that had a rig that might work? This is when it pays off to know what kind of information your facility backs up, how it's stored, if it's on-site or off, or at least how to quickly find that out. If you can't get a rig that way, your next step is to send a request up the ladder through your lead or Sup.

What Should I Do If I Can't Find a Rig?

Before you start sending requests up the chain of command, gather a little more information. Just as in any other shot, *determine what needs to be done.* Is this a loose roto needed only for a full CG character to talk to, and really only the eyeline is important? Or does it have to be extremely accurate, because the actor's arms are going to be replaced? Or is it somewhere in between? This information will tell you right away what kind of rig you need – or can get away with.

Next, review the information you have. If you don't have a rig to use right now, ask your lead some questions:

- Is there a rig being developed for your character?
- If not, would it be possible to get a rig started for this character?
- Would it be possible to get a generic human?

Sometimes production doesn't realize that it's hard to find character rigs to work with, so make sure to ask your lead or Sup these kinds of questions so the requests can move up the ladder and get in the pipeline. It's okay to check up on progress every couple of days with your lead or Sup *only.*

If you don't need a really close fit, ask if a simple shape like a sphere or cylinder can be used. Sometimes that's all that's needed for eyelines, FX interactions, and shadows.

If you do have a rig, make sure to ask some questions about it before you start working with it. For example, you'll want to know if it's really heavy (a very dense, detailed model, which is therefore slow to manipulate), and if so, is there a lighter version for matchmove? Also make sure to ask whether there is

go on every day. Many publishing and other import interfaces linked to these scripts refer simply to "char," and substituting whichever character you are working with. Most facilities refer to individual characters with a three-letter prefix; if I had a digital double, it might be ejh. Scripts might then refer to me as *showName_char_ejh_v01.* Going further, if you were to select my left hand to animate, it would be called something like *showName_char_ejh_v01_lf_ikHand_Cntrl_lf.* Don't worry – you get used to it after a while. For more about Character Rigs, see Chapter 11.

Tip: Wait, What Are We Talking About Again?

Rotomation is often shortened to "roto." Rotoscoping, the art of creating articulated mattes for use in compositing, is also shortened to "roto." Roto is used as a noun and a verb.

Don't let it confuse you – you'll almost always know which one you're talking about from context, especially if you aren't a rotoscope artist in addition to being a matchmove artist! Usually, if you're talking about both disciplines in the same conversation (rare), the full terms will be used.

Tip: Status: No rig!

If you have to file daily status reports, or keep a coordinator up to date on your status, make sure to mention every single time that you need a character rig for such-and-such shot before you can start it. Status reports do get read! Don't be complainy; just note something like, "Shot 101 IP (in progress), Shot 102 IP, Shot 103 OH (on hold) waiting for character rig." On-hold shots definitely get noticed.

anything special about the rig you need to know. Most character rigs are at least partially show-specific, and so have certain unique conventions and procedures you'll need to know about before you get started. For more details, see Chapter 11.

Great, I Got a Rig. And I'm Scared

Don't be scared! Roto is fun, *I promise.*

The first thing to do is make *doubly sure* you are working with a final, approved camera. The camera in your scene absolutely has to be final before you can start any rotomation, because if the camera changes, obviously the lineup of your character will change, and all your work will be for nothing. So confirm that your camera is a final, and then *lock it*. Most likely, you'll have tracked your own camera, and if that's the case, *do not* start rotomating until your camera has been approved.

Miniature Land and Your Rig

I've mentioned a couple of times to check the scale of your rig first when you import it, and that's really important on every show — you absolutely want to make sure your CG character is the right height and overall size for the shot you're working on. Sometimes, though, scale is even more crucial than others, especially when your work is going to FX Animation.

FX Animation is very complex, as you might imagine. Dynamic simulation of feathers, fur, water, smoke, crowds, or any number of other fantastic elements that respond realistically to the forces of gravity, wind, air pressure, and other laws of physics is extremely computationally demanding. Sometimes, it's too demanding, and the simulations either fail completely, or come back with undesirable — though often amusing — results (see "True Tales of Matchmove: Crazy Dynamics!" in Chapter 12).

FX Animations tend to go haywire in a couple of different situations: the larger they are in scale, and the farther they are from the origin of the scene (the 3D location 0,0,0). To solve this problem, many shows I've been on simply change the scale of the entire CG environment to 1/10 scale. In other words, where I am 170 cm tall in a 1:1 scale CG environment, I would be 17 cm tall in a 1/10, or 1:10 environment. I've even worked on a 1:100 show. These scale changes help FX Animation go more smoothly, but they do affect matchmove in a couple of different ways.

First of all, when working in Miniature Land, judging your translational camera curves by the relative scale of change over the length of a shot is completely different. Whereas an oscillation of +/− 2 mm in Y Translation in a 1:1 scale environment is negligible and can be ignored, it's quite significant in a 1:100 environment — the equivalent of 20 cm (0.2 cm × 100 = 20 cm). That's important to keep in mind (see Chapter 9 "Refining the Solution", Figures 7-9 and 7-10 for details).

Second, checking the scale of your CG character is more important than *ever,* especially if you hide your set geometry before importing your character rig (which I advise against in *any* situation, but it happens, especially if your set is really heavy). If you start your character or object tracking work at the wrong scale by an order of magnitude, it's often not savable by simply scaling down the character and animation curves. I've found that when the scale difference is that great, you just have to start over. That's pretty bad news if you've spent a week on a really detailed rotomation!

To avoid this sort of mini-disaster, I advise two important steps:

- *Never* start tracking or rotomating without placing your prop or character in the CG set and checking it from all angles.

You should be checking your work from all angles periodically anyway, but working in very complex sets can be cumbersome, slow, and hindering, so often you have to hide the set. But you must *absolutely and without question* check your object or character in the proper location in the CG environment immediately on import to avoid any costly mistakes down the line. This is a must. As a (difficult, but good for fun stories) client of mine used to say, "I'm not asking you, I'm telling you!" *Good times.*

- Make doubly sure that you're in the right scale environment. Ask if in doubt!

If this somehow doesn't happen, or you pick up a shot from another artist, if you're new on the show, or for any other reason, the second you get a new shot, ask your lead or Sup if the show CG world is at 1:1 scale or something different, and how that is handled within the show — through an automated script, by you or some other way? Most likely, this information will be communicated to you immediately, but it never hurts to ask. It also makes it look like you're on the ball!

Publishing a scene at the wrong scale not only eventually gets it sent back to you to fix, which can be a pain, but also wastes valuable artist time, render time, and coordinator time (in figuring out where to send it back). Because it's so easy to check — just make sure to judge the scale of your characters and props to the set, and make sure to know if your shot is 1:1 or in Miniature Land — go ahead and save time, money, and hassle in a two-minute sanity check (see Chapter 3, "Sanity Checks Will Save You!")!

Rotomation First Pass: Animating Large to Small

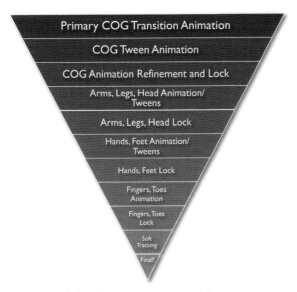

Tip: LOCK the Camera!

I can't tell you how many times I've accidentally messed up a final camera by panning or zooming in the shotCamera view with keyboard shortcuts — which mess up the shotCamera! Ooops! So one of the first things on my rotomation checklist is to make sure that I lock all the camera channels before I do anything else. It saves a lot of heartbreak!

Figure 10-2 Always work from large movements to small.

Analyze the Clip

Once you've secured your rig, checked your scene scale, determined what needs to be done in the shot, and reviewed the notes from set (if you haven't already), you're ready for the first pass at rotomating your shot!

Get yourself in the right mental space to watch the clip. Watch it through a few times. Now, start watching only the actor's hips. Ignore everything else and really focus on his hips.

Why his hips? If you've ever taken a Pilates class, danced, skated, or played just about any other sport, you know that all motion is centered around your core — your hips and abdomen. This is your center of gravity — or COG — and your extremities work very hard to stay in balance with it.

CG characters are also built this way — the root of most skeletons is in the hips, with all the other bones radiating from there. With some exceptions, which are noted in Chapter 11, most CG skeletons are built so that when the COG is moved, the rest of the body follows it, then the extremities farther up the skeletal chain are animated as they relate to the COG.

So you can see that the most important thing to get right the first time is the placement of the COG, because everything else in your rotomation depends on it.

How to Watch Your Shot

When you've started to really zero in on watching your actor's COG, you're probably wondering how you're supposed to tell which way it's moving in the first place! How do I find this elusive major change in direction, or *key pose* (see sidebar)?

Keyframes, Old-School

No doubt you've seen TV shows or websites about the Golden Age of cel animation — Disney features like *Snow White* and the classic Warner Bros. cartoons, for example. So you've seen how a senior artist will create the key poses for a sequence — the major points of action — and a junior artist will then fill in the frames in between. This is where the terms "keyframe" and "in-between" or just "tween" come from. The major key poses — or keyframes, from now on — I'm referring to in this first pass are the equivalent of the senior artist's key drawings — the most important points of the shot, with everything else flowing from it.

Once you've watched the clip through a few times to get familiar with it, start watching the actor's hips. Find a good

reference to see which way they are turning. Good features that indicate hip orientation and motion are:

- Zippers
- Seams on pants or costumes
- Buttons
- The edge of a T-shirt
- Waistband
- Beltloops
- Pockets

Or anything else around the actor's waist or hips that's pretty well fitted, doesn't move around too much on his body, and is visible enough to be able to be followed easily.

When choosing a feature like this, make sure not to choose one too far up or down the body; a cummerbund, for example, is a good indicator for spinal movement, not COG movement. Shirt buttons are no good either — unless the shirt is snugly tucked in and you follow only the lowest one or two next to the waistband. Anything below the pockets or zipper is too far away from the COG as well.

Step through the clip frame by frame and watch for major changes in motion. Consider these three frames:

Our actor is transitioning from walking to the chair to lowering himself into it. It's a pretty big change — if you compare the first frame to the last frame, you can see he's changed directions, from still arriving at the chair to starting to bend over to sit in it. But how did I pick the exact frame to set a *keyframe* (Figure 10-4)? Take a look at the next series of frames:

Figure 10-3 Watching the hips.

Figure 10-4 Looking for changes in hip direction.

Figure 10-5 A clear change in hip direction.

When I start to watch for the major poses in a clip, this is what I see — hip position and orientation exclusively. The hip transition here is very obvious. From Figure 10-6 to 10-7, look at the change in perspective: the diagram indicating the actor's pelvis is short and long in the first frame, and much taller in the second. He's tilting his hips up, and his whole upper body is moving with him — watch the shadow on his shirt. As he leans forward, it gets longer.

Figure 10-6 Hip orientation represented by the yellow diagram.

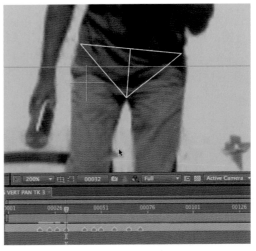

Figure 10-7 The change is evident when comparing diagrams.

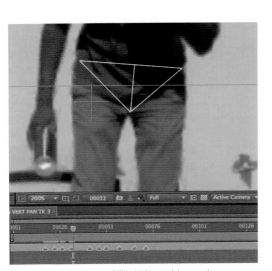

Figure 10-8 Diagram of final hip position and orientation.

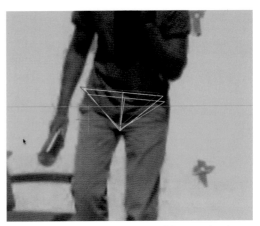

Figure 10-9 When overlapping, the hip diagrams clearly show the way the hip direction changes.

From Figure 10-7 to 10-8 the perspective changes again, but in a different way. Rather than tilting his hips up, he's turning them to the side — pivoting on his screen right leg in anticipation of sitting down.

Looking at the three diagrams overlaying each other, the change over the three frames is dramatic. The first frame (blue) to the second (yellow) clearly shows a change in tilt, while the change from the second to the third frame is very clearly a pivot. See Chapter 12 for a more detailed breakdown of this transition.

Once you get the hang of knowing what you're looking for, breaking down a shot like this is a breeze. You can see this shot is over 300 frames, but I broke it down to 18 key poses in about 10 minutes.

So, your first pass on any rotomation is simply watching the actor's hips, looking for changes in their direction, posing your CG character at the frames where the major changes occur, and then moving on to the next major change. See? It's easy!

When You Can't See the COG

Not every shot shows the actor's entire body. What happens when you can't see his hips? How can you tell what frames to choose for your first pass rotomation?

Remember the **Large to Small Principle**. If you can't see your actor's hips, but you can see his lower abdomen, then watch his lower abdomen for changes in direction. If you can only see above his upper chest, then watch his upper chest, and so on. The idea is to watch the part of the body that's closest to your actor's COG, and let your keyframes stem from that movement.

Of course, you'll be watching your progress in all windows, and checking your position within the set, constantly and vigilantly. The first pass is so important because if your keyframes on this pass don't work, none of your successive passes will work. If you accidentally animate your CG character through a wall he's not supposed to go through, you're going to have to do some major surgery on your shot at some point. So make sure to always keep checking!

Rotomating Dos and Donts

Don't Break Your Character

One very, very important lesson about rotomating I learned early on (thankfully) is this: never, *ever* move your CG character in a way that would break your own bones.

But why would it matter – it's not a real-life guy, right? No, but don't forget that we *are* simulating the real world. If you break your CG character, you'll probably break something else in the pipe as well (see "Crazy Dynamics!" in Chapter 12).

A lot of times it's tempting to pose a character's body quickly rather than anatomically correctly. For example, it might be faster to pose your character's hand by rotating it in a way that would break your own arm. The same thing can happen with heads, elbows, knees, and feet very easily (for more details, see Chapter 11) – sometimes it's just easier to rotate them the wrong way around. No matter how much time you think you're

saving, though, if it would break your body, *don't do it!* Your animation curves will go all out of whack, motion blur will go crazy, and FX Animation will not like you very much.

The bottom line is, if you (or a stuntman) couldn't make your own arm/leg/neck go that way, don't move your CG character's body that way, either, even if it's just temporary. It might get keyframed like that by accident, and then it's broken for good.

Don't Do Anything Crazy

What's "crazy"? Well, I've seen a few crazy things over the years:

- Animating the scale of arms or legs rather than manipulating them properly to line up with the plate is crazy.
- Moving the character three feet back from the camera between two consecutive frames to force a fit is crazy.
- Floating your character five feet in the air, even though the actor is clearly walking on the ground in the plate, because you can't get it to fit any other way is crazy.
- Forcing your character into a position or having him do anything not humanly possible when it's being done in the plate by an actual human is crazy.
- Doing any of the above and hoping no one will notice is crazy.
- Doing any of the above instead of asking for help is *really, really crazy.*

If you find yourself in a position where you have to do any of these things to make your rotomation work, make sure to *remind yourself* not to do anything crazy, and ask your lead for advice or help. That's what they're there for!

Do Act It Out

You might think this falls under things that are crazy, but not so. One of the very best ways to get your CG character into the correct, natural pose is to first mimic that pose yourself.

If you've ever danced, skated, or played any sports, you know muscle memory is a powerful thing. That's the idea behind acting out your shot. The more familiar you are with the pose you're working on, the easier it is to achieve.

Another advantage to acting out your pose is determining whether it can actually be done. Often, you can *just barely* get your character to line up with the plate, and then see that in the perspective window he looks a little. . .uncomfortable. Try out the pose and see if you can do it yourself. If you can, well, maybe it's okay. Make a note that that frame is a little weird, and move on. If you can't do that pose, but maybe someone

Tip: I'm stuck!

 Sometimes when I get stuck like this, I don't set it, move on to the next keyframe, then come back to it later. When you have the keyframe leading in to the problem pose, and the one flowing out of it, the problem keyframe usually just works itself out.

stronger or more flexible, like a stuntman, could, go ahead and move on, but remember you might have to come back to it. However, if the position requires you to bend your elbow up behind your head or dislocate a finger, then you'll have to rethink that pose.

Which Channels to Key and When to Key Them

When I first started rotomating, I didn't really have a method to follow. I consider myself really fortunate, actually, to have so spectacularly messed up my first or second rotomation (see — you guessed it — "Crazy Dynamics!" in Chapter 12), because that made me sit down and really think about how to go about rotomating in a systematic way. Even though I talk in terms of "act it out," and "just feel it," and seem a little loosey-goosey about the whole topic, I do actually have a pretty rigorous system I follow for rotomating.

The problem is that most people think it's *nuts. Do not* let that deter you! The reason is because I set a keyframe for *every* channel I'm using on *every* frame of the shot. Most people don't like that at all. They think it makes for a stiff, unadjustable animation. This isn't actually the case, though.

Let me explain what I mean. First off, a channel, as you know, is simply a keyable attribute. For example, Y rotation is a channel on a CG camera. On a character rig, there are channels for the COG, spine, neck, head, arms, elbows, hands, fingers, legs, knees, feet, and more. So that's a lot of channels. Why would I want to key all of those on every frame?

Let's say I'm doing a first-pass rotomation as in Figures 10-3 to 10-5, for example, with our actor walking into frame, sitting down, standing up again, and walking out. In the first frame, I pose him in a walking position. The channels needed for this pose are feet, legs, COG, spine, shoulders, arms, and hands.

In the next frame (Figure 10-4), where he pivots to sit down, I set keys for his COG, his right leg, and his shoulders, because that's all that changed on that frame.

In the next frame, he just sat down. Here, I key his feet, legs, COG, spine, shoulders, arms, and hands.

Now, I step back between my three key poses, to see how they are working so far. But there is a huge problem — the middle pose, where he's pivoting to sit, is wrong! It's totally different from the pose I set just five minutes ago! What happened?

This is one of the most common things I find that really frustrates folks about rotomation. Here is what happened: because you didn't set keys on all your open channels on the middle

keyframe and then set keys on those channels on a subsequent frame, the interpolation of the unkeyed channels between the first and third frames caused the pose at the middle frame to change. Because you didn't key those channels, you have changed that pose by setting new keyframes down the timeline. The inbetweening performed by the software changed the positions of everything but COG, his right leg, and his shoulders, which had keyframes set, and therefore were unaltered.

The solution is simple: *set a key for every channel you're using on every frame you have a pose.* Easy!

As I said, most artists think this is crazy and refuse to even try it. It's really unpopular. But it works, *and it works really, really well.* So indulge me, and give it a try.

To use this technique, first you must consider what channels you're going to use (see Chapter 11 for more information on character rig channels). For this shot (which is examined in detail in Chapter 12), I know for sure that I want to use:

- COG
- Spine
- Neck
- Head
- Shoulders
- Arms
- Hands
- Elbows
- Legs
- Knees
- Feet

simply because that's the bare minimum I'd need to rotomate this actor to have FX animation emanate from his body (see Chapter 12). What else might I need? Fingers? Toes? Well, he's wearing shoes, so no toes. He is holding stuff in his hands, but except for tossing the cup in the pool, he doesn't really move them. I probably won't need to animate them (ask your lead to be sure!), but I will line them up once to make it easier to line the hands up later.

To make it even easier to wrangle all these channels, I make a shelf button or small script that selects and keys all the channels I want in one step. Whenever I move to a new keyframe, I click that button immediately, and that way even if I only manipulate one hand, for example, the entire pose will be captured. I also keep the autokey option on, so that whenever I manipulate a pose, it's keyed automatically. Having to "undo" a few times because you don't like your new automatic keyframe is much better than losing several poses in a row because you forgot to set keys for them.

If I did have to add finger animation later, no problem. If all my rotomation were already done and approved, I'd just lock all the other channels and work on the fingers. If I were on an earlier pass and needed to realign the fingers only on the first and fourth keyframes, I'd make sure to first set keys for all the other frames that already have poses as well; I don't want to lose good finger poses due to inbetweening.

As you progress through your shot and make a few passes, sometimes you'll find a pose that lines up perfectly on a frame you hadn't planed on working on just then. Key it! *Key all the channels!* Any time you see a good pose, you want to capture it. Setting keys on *all* channels is the way to do that. It's not crazy; it's smart and efficient.

Evaluating the First Pass

You've made the first pass of your rotomation, set keys on all channels at every keyframe – now what? Now you evaluate your work before moving on to the next pass.

First, step or scrub through the timeline, and look at the frames in between your keyframes. If the tweens generally follow the main action of the shot, then you know your key poses are good. If something goes awry – for example, your character flips 360 degrees between two poses but the actor in the plate does not – you know you need to go back and re-evaluate. The tweens aren't going to be perfect, of course; they just need to be in the general ballpark.

Next, playblast your shot and look for the same kinds of issues at speed. You'd be surprised how many little things show up in a clip playing real time that you never notice flipping from frame to frame!

Check your animation curves as well as the perspective view to make sure that everything makes sense (for more details, see Chapter 12).

Version up your shot and get ready for the next pass: the first set of in-betweens for the major poses.

Finding the Next Set of Keyframes

I've found two good ways to find this next set of keyframes – and all the keyframes in each subsequent pass after the first.

The first is very much like the method I use to find the major keyframes in the first-pass animation. Again, I watch the hips closely, looking for changes in direction and speed. Often, once the major changes have been keyed, this method will give you two keyframes between every major pose: one coming out of the major pose, showing a change in speed toward the next

major pose, and one just before the next major pose, showing another change in speed. These frames usually are showing acceleration and deceleration in and out of the major keyframes I identified in the first pass. This is really fascinating, and I could go on and on about how you're using calculus every day and don't even know it, but actually, I've found a better way to do the next (and all subsequent) passes.

Here it is: step back and forth between your major poses, and wherever the CG character is the *least* lined up with the plate, that's your new keyframe. Basically, you're looking for the *wrongest* frames in any pass you're working on.

This method is so much easier than the first, and it works like gangbusters. Obviously it's really easy to see where your rotomation is the farthest off, and setting a keyframe there accurately adjusts the animation much faster than attacking it incrementally from two sides, as the first method does.

Once you've set this next pass of keyframes, check your work again:
- Does it make sense?
- Is the CG character going in the overall right direction?
- Does he stay on the right path?
- Is he on the ground/off the ground when he should be?
- Is he breaking any bones?
- What do the unkeyed tweens look like?
- What do the curves look like?
- Is he keyed on all frames?
- Is he smooth where he should be?
- Are there places where he's a good fit but not keyed yet? Capture that pose too.

Set, Delete, Set

Another technique I use on almost every rotomation is one I call "set, delete, set" (though technically it's delete, set, delete, set). It's also considered insane by my peers and it also works *really well* to smooth out animation and make it more lifelike and natural. Here are the steps:

After any pass at a shot (let's say first pass here):
- Version up.
- Go to the second keyframe.
- Take a deep breath (you've saved a new version, remember).
- Select and delete *all* the keys on all channels.
- Set a new keyframe on all those channels without manipulating any of them.
- Move on to the next keyframe and repeat until the second-to-last keyframe.

- Adjust the new poses as minimally as possible to line up with the plate.

I'm sure you can see how this technique really helps each pose smoothly flow into the next. This is especially true if you have a hard time with one or two of them. As I mentioned earlier, if you're having a particularly hard time with a pose or two, skip it and come back after you've set the other poses; this way of working similarly helps blend poses by smoothing rough transitions and refining them.

When you perform this step on your first pass, you'll naturally need to repose your CG character more heavily than a fourth- or fifth-pass animation, when your keyframes are only two or three frames apart. Each time you delete and reset a keyframe, you're locally smoothing the animation, and as your animation gets more refined, so do your refinements. I know I'm done with a shot when I delete a keyframe and the CG character doesn't move — the frames on either side are perfect, he lines up great, *done*.

Sometimes, I do this process only for certain channels. Some channels can get really overworked, with really choppy animation, and pop around when playing at speed. This is typical for the spine, shoulders, and elbows, though it can happen anywhere, depending on the action in your shot. If I'm happy with all the other animation, but the head and neck are popping around, I'll do a set-delete-set pass for those channels only.

Next Up

Whew, this is a lot of information to digest! In the next chapter, I want to take a detailed look at a typical character rig, and all its ins and outs. After that, we'll finally put all this theory into practice!

Now, let's look at our rig and see what it's all about.

KNOW YOUR CHARACTER RIG

Embrace Your Inner Rotomator

Rotomation needn't be the frustrating experience it seems to be for many matchmovers. When I talk to other matchmovers about rotomation, I find that most frustration stems not from difficult shots, but from a lack of familiarity with human anatomy and movement, added to a lack of familiarity with the character rig they're working with. I can see why that would be frustrating!

In this chapter, we'll take a really close look at a typical character rig, its ins and outs, and some tips and tricks for avoiding a lot of the hassles I sometimes see others struggling with. In addition, I really, *really* want to make sure to instill a sense of curiosity and willingness to play and investigate your rig every time you get a new one – that's the only way to *truly* know how to use your rig to its best advantage in your shot.

Getting to Know You

Take an hour – *at least* – to play with any new rig.

A lot of matchmovers think this is a waste of time, or that they might get in trouble for "not working." But imagine if you got a new camera rig – say, if the in-house software team created a new version of the camera plug-in you use – and you never bother to learn how it works. That sounds crazy, right? How would you track a camera if you don't even know how the camera rig works?

So it is with a character rig. If you don't bother to learn how to use it, you'll never be able to use it well. So, go ahead and take that hour. See what every single control does – really put it through its paces.

Not every rig is the same, though of course they all have similarities. Some rigs are extremely complex, with controls for hair, clothing, and weapons in addition to the basic character. Some aren't very complex at all and might lack controls for fine

DOI: 10.1016/B978-0-240-81230-4.00011-7

movement, like fingers and toes. Either of these extremes might be inappropriate for your shot, so it's best to find out immediately, *before* starting your shot, if this is the case.

Putting your rig through its paces also exposes any issues it might have. Watch your clip and make sure your rig is appropriate for your shot and the task at hand. For example, the rig you'd need for a regular guy walking down the street might be less complex than the rig for a superhero character leaping off a building from a crouching position. In the latter case, a standard rig might not be flexible enough, or have enough controls in the spine and neck to duplicate the action in the plate. Sometimes the riggers just don't realize how *extremely flexible* stuntpeople are!

True Tales: My Arms Are Too Tight!

I was working on a superhero show for which the star's stunt double was actually a gymnast. He was *really* flexible. Occasionally, I would have trouble lining his rig up with him on the plate, because the rig's shoulders, neck, and arms had limits on how far they could bend and they couldn't bend far enough for my shot. I asked a few times to have the limits changed so that I could more accurately fit my rig, and the answer came back that it wasn't possible for the rig to be too tight — it's really flexible! Finally, I had one of the riggers come over to my desk to show him the problem. He couldn't believe someone could bend his arms that far back! Well, competitive gymnasts can. So I got my request filled after that!

Figure 11-1 Andy, created by John Doublestein. Andy is short for "androgynous"; here, she's in adult female mode. All the circles, lines, and other graphic symbols around Andy are *control handles* that select different nodes, or parts of his or her skeleton, to manipulate.

Let's Meet Our Rig

Meet Andy. Andy was created by John Doublestein for students at Savannah College of Art and Design, and is available for download from many locations on the Internet. Student feedback is often implemented for Andy, so he's well-tested, stable, and great for various types of animation.

Andy has many sophisticated rigging features, but I really like Andy because he has a *great* hand rig, and that's hard to find if you're not part of a big facility.

Andy is scalable, which is a great feature, and though he has a big cartoon head, the rest of his body is proportioned like a real human. In Chapter 12, I fiddle with his head a little to better fit our actor. After many years of playing with various types of rigs, being able to scale a head like that without breaking the entire rig is very impressive! I highly recommend downloading Andy and playing with him whenever you have some free time.

Let's check Andy's rig and controls out!

IK and FK: What's It All About?

There are two ways to manipulate CG character rigs: Forward Kinematics (FK) and Inverse Kinematics (IK).

FK is the older method of the two. I remember being really excited the first time I saw a demonstration of commercially available IK — sometime around 1995, to the best of my (and my friends) recollection. It's definitely my preferred method of working. Truth be told, I refuse to work in FK if at all possible.

In FK, each bone in the skeleton can only be rotated, and every rotation affects every link in the skeleton forward in the hierarchical chain. For example, if you rotate the arm,

the elbow and hand are affected. If you rotate the spine, the neck, head, both shoulders, arms, elbows, and hands are affected. All movement goes forward through the skeletal chain, and forward only.

In IK, the opposite is the case. To move the hand, for example, you select it, move it around, and the software adjusts the positions of the arm and elbow automatically. The movement goes up the skeletal chain, the inverse of FK.

To see the advantages of IK over FK, let's look at a few situations side by side.

Arms

FK **IK**

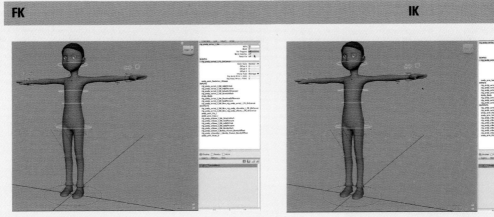

Figure 11-2 Turning off IK arms (more details in "Control: Arms," later in this chapter).

Figure 11-3 IK arms on (more details in "Control: Arms," later in this chapter).

Figure 11-4 Left FK arm on.

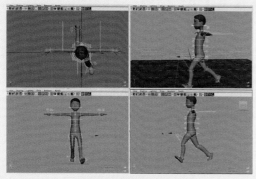

Figure 11-5 Starting on the arms.

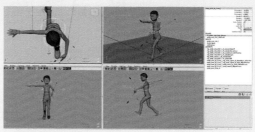

Figure 11-6 To move Andy's IK arms, just grab the IK handle — and move them wherever you like. Nothing else is disturbed, and no other movements disturb them (unless you choose, more details in "Control: Arms," later in this chapter)!

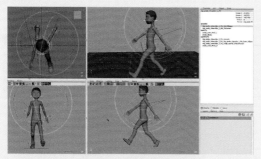

Figure 11-7 FK arms can rotate only from the shoulder down. Every rotation affects the potion of the joints below it in the skeleton chain.

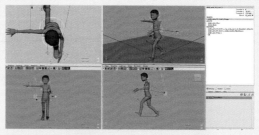

Figure 11-8 Need to move the elbow separately? There's a handy control for that!

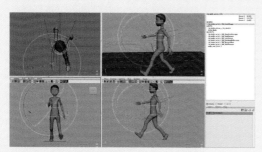

Figure 11-9 Positioning each bone in Andy's arms can be frustrating and tedious, because every movement from higher up the skeleton chain, like the shoulder, spine, or COG, alters the position of the arm joints.

"Hey, want to come to lunch with us? Oh, still working on that FK rotomation, huh… see you later, then."

Legs

FK	IK

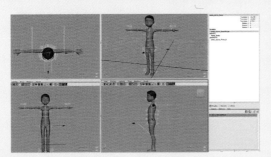

Figure 11-10 FK legs on.

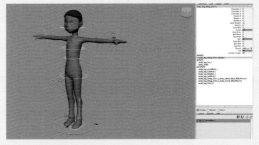

Figure 11-11 Turning the IK leg on. If a character rig has IK, usually the legs (and sometimes the arms) come in set to IK by default.

See **COG and Weight Distribution** below for details on COG manipulation in IK.

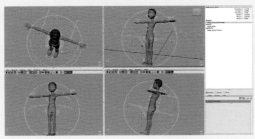

Figure 11-12 I want to lower Andy's COG to compensate for bending his knees. The COG (spine root) moves the entire rig in FK mode, so his feet go below the ground.

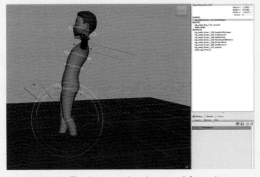

Figure 11-13 The legs need to be posed from the hips down in FK mode. They can only be rotated.

Figure 11-14 I've moved the COG back up so the feet are on the ground, and am adjusting the leg pose.

Figure 11-15 To move IK legs, just grab the feet handles and put them wherever you want! Manipulating them doesn't affect any other joints.

Figure 11-16 Adjusting the leg from the hip joint down is somewhat awkward, as every rotation affects the potion of the joints below it in the skeleton chain.

Figure 11-17 Want to only rotate or roll the foot? No problem! Just rotate it! Nothing else will be affected!

Figure 11-18 The back leg is *finally* posed.

Figure 11-19 Move the other foot the same way — wherever! No other parts of the skeleton are affected!

Figure 11-20 Adjusting the roll on the back foot is difficult in FK, as the leg above the foot remains stationary and will need to be adjusted later to compensate.

"Hey, we're going for coffee, want to come? Oh, you're still working on those FK arms ... see you later, then."

Figure 11-21 Adjusting the back leg after the COG has been altered to adjust for weight balance. Going back and forth like this is very time-consuming.

COG and Weight Distribution

FK **IK**

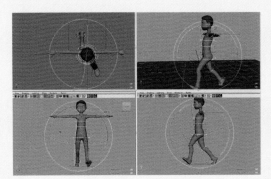

Figure 11-22 Adjusting Andy's weight distribution. His main body mass should be centered between his feet, but in the top view, you can see it's not. Adjusting the position of the COG, however, changes the position of the feet *again*, which isn't desirable.

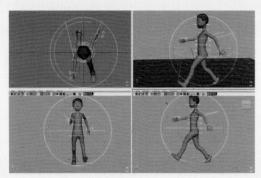

Figure 11-23 Andy is standing far too upright; I'll lean him forward with the FK spine.

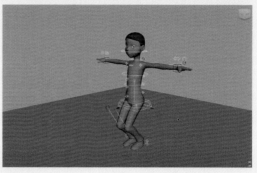

Figure 11-24 Move the COG, and it behaves like a real person would! The feet aren't affected —that's so much better than FK!

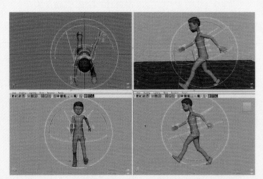

Figure 11-25 Leaning forward with the FK spine. The lower spine should be generally in line with the COG.

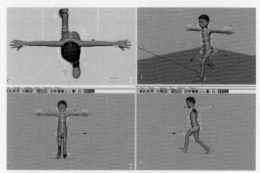

Figure 11-26 Need to lean your character forward or redistribute his weight? Just select the COG and do it! Don't worry about the feet or the arms — they won't be affected (unless you want them to be — more details below in "Control: Legs," later in this chapter)!

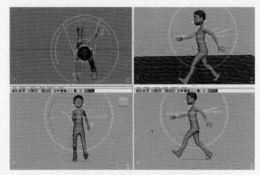

Figure 11-27 Counterbalancing the forward lean. His chest is too far out now. I'll lean his COG back slightly and adjust the spine from there.

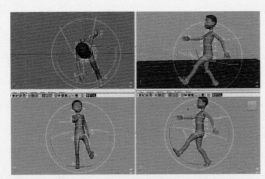

"Hey, we're going for drinks and a movie, want to come? Oh ... you're still working on that FK rotomation ... bummer. See you tomorrow then. Oh, except it's Saturday, and you're the only one who's working, since you have to finish that FK rotomation. See you Monday, then!"

Figure 11-28 *Oh, no!* When you move the COG, you move *EVERYTHING!* I'll have to start over ... !

As you can see, I'm a big proponent of IK animation, and for good reason. I can't imagine why *anyone* would want to use FK, especially for rotomation, when you already know exactly where you want your hands, feet, and so on, to be.

Sometimes, you'll get a rig with a control called *FK/IK Snap.* You might have already guessed what it does — allows you to work in both FK and IK mode, using software to create the interpolations between the two. I've never used it myself, but I know artists who have, and I've never heard any complaints. Again, I absolutely can't fathom why you'd want to use FK for anything, but if you find a reason and have that option, go ahead and try it out.

Often, when I'm called to help an artist who is stuck on a rotomation, I find that they are working in FK. That's the root of the problem, right there. *You just don't want to work in FK, ever.* It's difficult, frustrating, tedious, unintuitive, counter to the way humans move, and just plain unpleasant.

I can't stress this enough: if you're rotomating, do *NOT* use FK controls. IK is the way to go.

When I ask the artist in need of help why he chose to use FK, invariably I find it's because he didn't know how to control the elbows and knees in IK mode, and they were doing crazy stuff. That's understandable; there are a couple of ways to do it, and neither is completely obvious. So, in frustration, he turned to FK, instead of *asking about the elbows in the first place.*

This is a perfect example of when to invoke the 15-minute rule, by the way — if you're stuck on how to control elbows for more than 15 minutes, ask! Someone will know, and you'll be on your way. More details on elbows, and all IK controls, are available in the next sections.

Happy IK animating, and here's to getting out of the office at a decent hour!

Control: Master (World)

Where Is It?

The Master node is generally the largest control handle at the base of the rig's feet. Sometimes it's a circle, sometimes a four-directional arrow, and occasionally it is labeled "Master" or "World." (Figures 11-31 to 11-34)

Tip: What's *that* do?

Andy has a few controls that aren't pertinent to rotomating humans, but are great for animating more cartoony scenes. I don't go into those controls in this chapter, but I recommend very strongly that you go through Andy's rig and test *every* channel to see what it does, at least once. Some are very surprising!

What's It Do?

The Master Control does a couple of things:

- Translates and rotates the entire rig through the CG environment
- Allows for the selection of various default states for the rig

What Can It Mess Up?

Pretty much everything, especially if you animate it by accident.

Is It Good for Anything Special?

The Master node is often where many default settings are set, for example, IK or FK arms and legs (see "IK and FK: What's It All About?" in this chapter), the complexity of the model display, and in Andy's case, various settings for girl, boy, man, or woman appearances.

Tip: Off and On

To turn controls on or off in the channel box, type 1 for on or 0 for off.

Figure 11-29 Andy's World Control channel box.

Figure 11-30 Turning the Body and Face controls on.

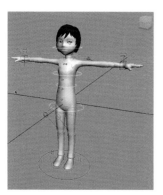

Figure 11-31 Andy with Proxy body, Woman body and hair.

Figure 11-32 Andy with boy body and hair, display smoothness 1.

Figure 11-33 Andy with girl body and hair, display smoothness 2, face sliders.

Also, if your character is not in contact with the ground – flying, riding a bike, and so on – then you might use the Master node to animate the overall translation of the move (see "Control: Body," later in this chapter).

Tell Me More!

As you can see, there are many settings in the World panel for Andy – not only rotation, but also translation and scale (a really valuable feature that is not always available, or implemented well).

Here you find many appearance attributes for Andy, as well as options for turning on and off various groups of controls, which can be very useful, as extra controls can get very dense. There is also an option for displaying Andy at full or proxy resolution, handy for fast display and interaction with the CG environment.

See Figures 11-31 to 11-34 for various combinations of Andy's World control states.

Andy also comes with a bunch of outfits to play with. Have fun!

Figure 11-34 Andy with girl body and hair, display smoothness 3, face handles.

Control: Body

Where Is It?

Usually, the Body handle is a smaller circle within the Master handle. Occasionally it's a larger handle surrounding the COG handle. Andy doesn't have a Body control – not every rig does – but it's worth considering here.

What's It Do?

The Body node also moves the entire body, but independently of the Master node. For example, if your rig is imported at the origin of the scene, and you were to use the Body node to move your rig to another part of your CG set, the Master control handle would remain at the origin.

What Can It Mess Up?

A couple of things:

- If you accidentally animate the Master node for one motion and the Body node for another, the two will fight each other and you'll have to sort that out.
- If your show requests that you animate *only* the Master or Body node, and you animate the wrong one, that will get the shot sent back to you to be fixed.

> **Tip: It's an IK World For Us**
>
>
>
> All the descriptions of functionality I'm giving are for IK rigs exclusively. I *never* use FK unless I absolutely can't avoid it. For details about the difference between IK and FK rigs, see "IK and FK: What's It All About?" in this chapter.

Is It Good for Anything Special?

I use the Body node exclusively for animating characters that are flying, on bikes, or otherwise not touching the ground, unless the show specifically stipulates to animate the Master instead of the Body.

Tell Me More!

Both the Master and Body controls can be used for situations where your character is not in contact with the ground – flying, or riding a bike, for example. However, some shows ask you not to animate the Master, and others ask you not to animate the Body control. Which one is used has to do with FX animation scripts and other pipeline issues. Andy doesn't actually have a Body control, but I wanted to mention it.

Control: COG (Center of Gravity)

Where Is It?

The COG (called *Spine Root* on Andy), is a handle right around the hips of your character. It's usually made to stand out in some way – a different color or shape, usually. Here, the COG is a trapezoidal shape, where most other handles are round, so it stands out.

What's It Do?

The COG moves the hips and all the parts of the body above it (with certain exceptions, as you'll see shortly). It moves the upper body relative to the feet and legs, without actually moving the feet (with certain exceptions, as you'll see shortly).

What Can It Mess Up?

If animated too far from the feet (or hands, in some circumstances), it will stretch the legs and arms in undesirable ways.

Is It Good for Anything Special?

The COG is the *first* control you'll animate in any shot and any frame. See Chapter 10 for more details.

Tell Me More!

As I discuss in detail in Chapter 10, all movement comes from the COG. If your body is not in balance around the COG, you'll fall down. The COG is the first control you'll

consider for all poses you set on any frame, because all the rest of the body depends on the COG for stability, balance, and control.

The only exception to this rule is if your actor is attached to wires or some other sort of rig that changes his center of gravity – say he's attached to a harness around his upper chest and rotates around that point instead of his hips. In that case, you would treat the area where the harness is attached as the COG. This is the only exception.

If you use the Master or Body to move your rig when he's supposed to be in contact with the ground or other surface, the hands and feet will slide on that surface, because they are set up to work with the COG as the IK parent. In other words, the IK arms and legs are below the Master and Body nodes in the hierarchical chain, and so when those nodes are manipulated, the IK feet and hands go with them. This is why you would use the Master or Body controls for flying – but not for walking, crawling, or anything where contact with the ground plane is needed.

When using the COG, the IK feet stay put. Rotating the COG will rotate the spine all the way up to the head, but the feet and hands will also stick, if set up that way (more details in the "Control: Arms" section). This is extremely convenient, as you can manipulate the COG however you need, and then adjust the extremities as needed on any frame.

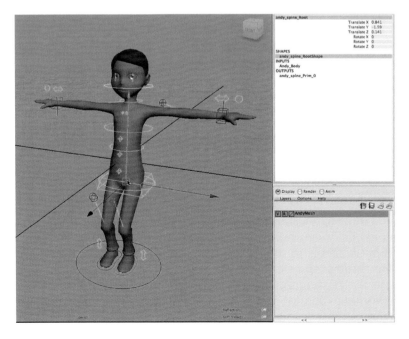

Figure 11-35 Andy's COG. The COG handle is almost always differentiated from the other control handles to make it easy to find. Notice that it's actually not called the COG on Andy, but Spine Root.

Occasionally, there are extra controls on the COG – default settings like IK/FK leg and arm states. Those IK/FK states can really be anywhere, so make sure you look at every control handle to find them!

Control: Hips

Where Is It?

The Hip Control handle generally sits right inside the COG control handle, sometimes a little lower, at mid-hip.

What's It Do?

The Hip Control manipulates the hips under the COG. In other words, the Hip Control can change the position of the hips – and the hips only – independently of the COG position.

What Can It Mess Up?

If you start animating both the hips *and* COG accidentally, they will start fighting each other, leading to a confusing mess. Another thing that often happens is to accidentally move the hip control without knowing it, and then see that all your COG positions are wrong all of a sudden – without knowing why – that can be crazy-making! Particular to Andy, the Hip Control can apply a cartoon-like squash and stretch quality to the animation – cool for cartoons, undesirable for rotomating humans.

Is It Good for Anything Special?

It can be useful if your actor is doing something really flexible with his whole spine and you need extra curvature control. Particular to Andy, it can help lengthen the torso to help proportion the character to the actor, but should be locked after that.

Tell Me More!

I once had a shot where the actor was performing a very sinuous, belly dance-like motion, and my rig didn't have enough spine controls to match all the curvature from the actor's low hip through the COG and up to the shoulders. I was forced to use the hip control and the COG in addition to all the spine controls to achieve the motion, in effect adding two extra spine controls.

Tip: Be Flexible!

As you can see, a few of Andy's controls aren't actually named the same way I'm referring to them (I'm noting the differences) – the most obvious example being the COG. I'm using the terms I see most often at facilities where I've worked so you'll be familiar with them, but there are always variations (especially in fingers, as we'll see shortly). However, just because something isn't named the way you expect it to be, doesn't mean you have the right to have a "Well, when I worked at *so-and-so*, we called it *xyz*, which is *much* better . . ." attitude about it. No one likes that. It's obnoxious and unprofessional. If it's not named what you're used to it being named, so what? *Just go with the flow.* It's not a big deal. Know what you're looking for and how to find it, and move along– a rose by any other name. . .

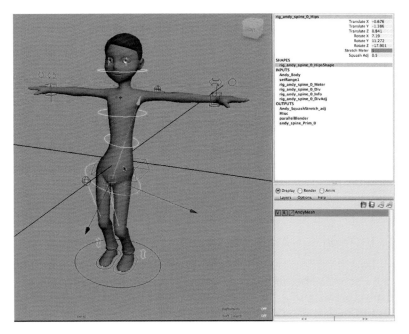

Figure 11-36 Andy's Hip Control can create a squash and stretch effect — fun for cartoon-like animation, not so great for rotomating humans.

I think that's the *only time* I've ever used the Hip Control (intentionally). I usually just lock it out, because of the issues noted — fighting the COG animation, and accidentally changing the COG position without knowing how it happened. Both have happened to me — and *will never happen again*, I assure you!

Control: Spine

Where Is It?

Spine Control handles come in many shapes and sizes, and show up in different places along the spine. In very general, broad terms, there are three spinal controls, one around the mid-lumbar area (bellybutton-ish), one right around the lumbar/thoracic transition (bottom of ribcage) and one mid-thoracic (mid chest).

That's a really, really general description. Almost every rig has some variation or difference from this description.

As you can see, Andy's controls are somewhat different and more refined. Actually, Andy has really great spinal controls!

What's It Do?

In my very general description, the spinal controls rotate the spine and everything above it (save the arms, depending

how they are set up. See "Control: Arms," later in this chapter). Most spine controls, then, are FK. Sometimes, you'll get an IK spine, which can be translated and rotated. The spine, of course, is an extension of the COG, and is the source of balance for the arms.

What Can It Mess Up?

Problems with spine animation are more often user-error-related than control related. The biggest problems come when both FK and IK controls are available at one time. See "Tell me more!" for good tips on avoiding common problems.

Is It Good for Anything Special?

IK spines can be very helpful in situations with very flexible, agile actors. The ability to translate a spine joint (which effectively rotates the joint below) *and* rotate it (affecting the joints above) makes for a very flexible system.

Tell Me More!

As you can see, Andy has two different kinds of controls going up the spine. After testing them both out – as I have with every control on his rig – I found that the yellow circle controls at the bottom of the ribcage and mid chest are IK handles – the lower control can only be translated, and mid-chest can be rotated and translated.

The purple pin-like controls going up his spine are FK handles. They rotate his spine up the chain. Both sets of controls are available at all times – you don't have to choose one or the other. That's really fantastic!

I've worked with a lot of rigs, and this is one of the best spine setups I've ever seen. For one thing, look how close the FK controls are to each other; usually, you only get one, maybe two controls in that space, diminishing flexibility. The addition of the IK control in that same area, is the cherry on top. The IK spine can be used for two things:

- It would allow for very fine refinements in position after the FK pose has been set.
- It would allow for subtle corrections to the entire spine without disturbing the neck and shoulders.

The same goes for the IK shoulder control (upper chest). It's a fantastic tool to have for refining complex spinal rotations without disturbing the head and arms and then having to counter animate as you would have to with an all FK system.

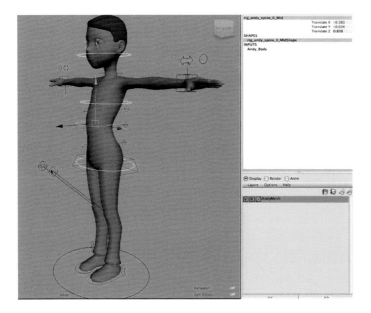

Figure 11-37 Andy's IK spine controls allow for translation and sometimes rotation.

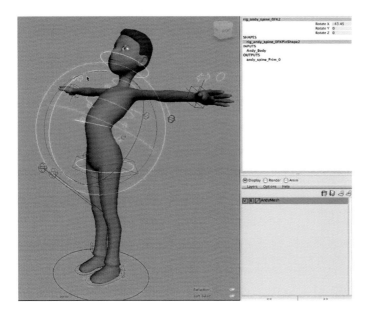

Figure 11-38 Andy's FK spine controls allow for rotations only.

These controls in combination are awesome! This is one of the things you'd need for a really flexible stunt guy, but probably not for Joe Average walking down the street. So don't get crazy. You can animate yourself into a tight corner if you overuse all of these controls at once. For example, you don't want to use the FK spine to rotate your rig all the way to the left, and then

use the IK spine to animate him in the opposite direction. Heavy counter-animation like this eventually becomes very confusing ("Wait — why is the spine doing *that?* Is that coming from the FK spine or the IK spine? *I can't tell anymore!*"), and should be avoided at all costs.

My recommendation is to use the FK spine for overall, gross movements, and the IK spine only when needed for refinement; Or, if you can get away with it, depending on your shot, use the IK spine exclusively and lock the FK channels out entirely. Decide which approach you're going to take before you start the shot, though, and *stick with it.*

More Natural Spine Manipulation

When you start to pose your rig and are at the stage where you need to bend his spine, here's a great trick: grab all the spine (including the neck) controls at once — make sure you actually pick all of them — and rotate them all at the same time (called "ganging").

This creates a much more natural motion in your animation. People bend from all 33 articulated bones in their spine, not separately from the two or three joints usually built into most character rigs (Andy being a notable exception). When you animate each of those spine controls separately, they start to become disjointed, and look as if they have no relation to each other — which is definitely not how humans move. This often happens if your shot requires a lot of spine manipulation, and each pose is achieved by moving separate spine and neck controls in different ways in relation to each other.

Allow me to demonstrate . . . with pictures:

Figure 11-39 Select all of Andy's spinal controls. Select them from the neck down; that way, you know you have them all.

Figure 11-40 Rotating all spine joints to pose the lower spine. The very top of the chain of course won't match your plate at all; we're getting there.

Figure 11-41 The next step: I've deselected the lowest control and am adjusting the mid-spine pose.

Figure 11-42 After posing the mid-spine, I deselect it and create the pose for the upper spine.

Figure 11-43 Andy's final pose at frame 1.

Figure 11-44 First rotation of the entire spine on the next key frame.

Figure 11-45 Final pose at next frame.

Figure 11-46 Extreme pose in between the first two frames. Because I set this key frame with the same spinal manipulation method I expect the interpolated frames to be smooth and natural, even though the key poses are extreme.

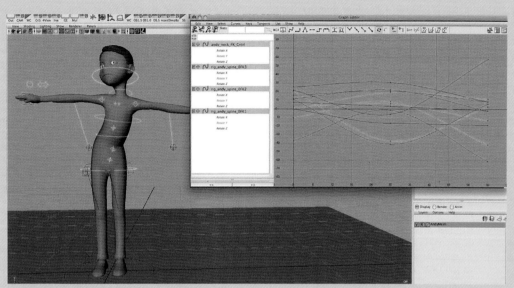

Figure 11-47 Interpolated pose. The spinal curvature is smooth and natural, as I expected.

Obviously, when you rotate all the joints at once, you're going to over-bend your character and it won't line up with your plate. Don't worry! The trick is to select the entire spine and neck, and rotate those controls together until the first joint in the chain — the lower spine — is in the correct position. Then, deselect that control, and rotate the remaining spinal joints, until the mid-spine is in the right position. Then, deselect that control, rotate the rest of the spine to pose the next joint up, and so on.

In this way, you're manipulating the rig's spine the same way you move yourself — all at once, not zone by zone, randomly, over time. This gives a much more natural movement to the spine, and a more natural flow to your entire rotomation.

Control: Neck

Where Is It?

Called Neck FK on Andy, the neck control is usually a small circle surrounding the base of the neck.

What's It Do?

Most often, the neck control is FK, and rotates the neck and head from the base of the neck where it meets the shoulders.

What Can It Mess Up?

Necks are often too long, for a couple of reasons (mentioned shortly). This can affect your shoulder, arm, and head animation as a result.

Is It Good for Anything Special?

Not really.

Tell Me More!

Your neck is super motile, and people often use their necks for all kinds of movements normally associated with facial expressions (Figures 11-48, 11-49). We tend not to realize, until we start rotomating, that a large part of your facial expression and how it's read has to do with the position of your head — and that comes from your highly flexible neck.

There are a couple of problems with character rig necks that come up time and again, and they mostly have to do with these kinds of facial expressions, in combination with posture, and, believe it or not, clothing.

Most character rig necks are way too long. I've almost never met a character rig whose neck *wasn't* too long. Why is that? I have some theories.

For one, when actors are scanned in order to create a digital double, they tend to stand up really, really straight. Then, they never, ever stand up that straight again, so their neck is just shorter than the rig's neck, because the rig has *perfect* posture. Second, actors being scanned have to wear those skin-tight Lycra body suits, and although that makes for a good 3D scan, it doesn't compensate for shoulder pads and leather jackets and scarves and whatever else might be on top of the actor's shoulders in a shot, making his shoulders look taller, essentially shortening his neck further.

If you're really lucky, you'll get a rig whose neck can be scaled. If not, first ask how important the head and neck fit are to your shot before you drive yourself crazy trying to get everything to fit. If you don't need them, hide them if you can, and don't look back.

If the head and neck are important, your rig might already have special controls for the neck. If not, you might get really lucky and have an IK head (discussed next). Failing that, it's sometimes possible to compensate by raising the shoulders — hunching them up, if you will — but that often makes the arms too short.

When all else fails, it's time to talk to your lead and put in a request for a shorter neck or a scale option. If you're on your own, investigate the possibilities of manipulating the skeleton for your needs.

Control: Head

Where Is It?

Called Neck IK on Andy; usually the Head handle is a ring around the middle of the rig's head.

What's It Do?

It rotates the head. Sometimes you get an IK head control, so it will translate the head as well. Sometimes the head also had parenting options, discussed shortly.

What Can It Mess Up?

Too much counter animating with the neck rotation can be a problem, but nothing else other than that.

Is It Good for Anything Special?

If you're lucky enough to have an IK head, all your overlong neck problems are solved!

Tell Me More!

As I mentioned earlier, people do all kinds of weird things with their necks as part of facial expressions. Take Figure 11-48,

Figure 11-48 Head back, chin tucked under: "Whatchoo talking 'bout, matchmove?"

Figure 11-49 Head thrown back, skull tucked in: "KHAAAAAAAN!!!!"

for example. Forcing your head backwards and tucking your chin under like that can be part of expressing surprise, disgust, or sarcasm. It's also a *really hard pose* to get right if you only have FK controls and an overlong neck.

In Figure 11-49, Andy's neck it forced forward, head thrown back, the base of his skull tucked in. This can be pain or screaming at the sky in anger, depending on the look on his face. It's also a very hard pose to achieve with only FK controls and a too-long neck. Any time your actor shoves his head forward or back, or hunches his shoulders up and his chin down, it's going to be tough. Having an IK head to drag the neck and base of the skull into the right position, and then rotating the head from there, is a perfect solution.

Andy also has some interesting head parenting choices. Let's see what that's about.

This controls where Andy's head points by default when you create a new pose. You can then animate Andy's head independently under that parent constraint.

When his head is parented to his neck, the neck controls the position of the head. If the neck is rotated, so is the head, as in any FK relationship. The head can then be posed independently.

When Andy's head is parented to the COG, his head follows the COG rather than the neck. Why would you want to do that?

For one thing, it's how humans move in real life. No mater what your diet today, humans are predators, and predators keep their big, stereoscopic eyes pointed where they're going, because that's where the prey is.

Figure 11-50 Parent Andy's head ("neck IK") to his neck ("neck FK").

Figure 11-51 Parent Andy's head to his COG (spine root). Parenting to the Master (world) is also an option.

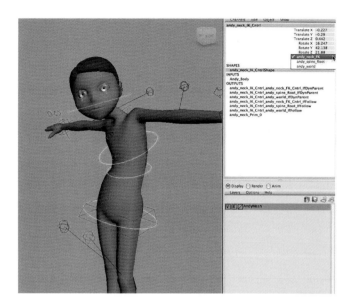

Figure 11-52 Andy's head parented to his neck. His head follows the position of the neck.

Because your center of gravity is naturally going to be pointed at where you're going (unless you're being carried, or are falling down, or something else unfortunate is happening to you), it's natural to have your head and eyes pointed that way too. Likewise, if you see something you want – prey – you'll keep your eyes locked on it until you can get to it; that is, get your COG situated in such a way as to get you moving in that direction.

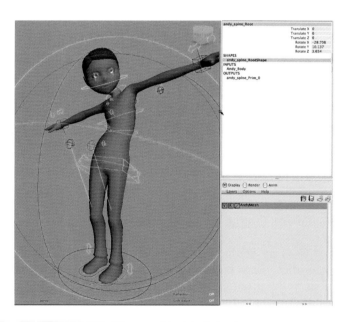

Figure 11-53 Head parented to COG. No matter what Andy is doing . . .

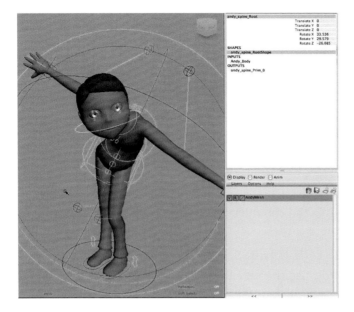

Figure 11-54 . . . he keeps his eyes and head facing where he's going . . .

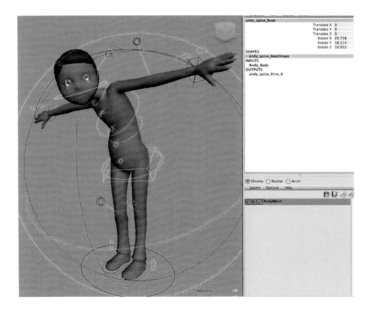

Figure 11-55 . . . or what he's stalking.

Having your rig's head follow the COG makes your life easier, because your actor is probably already behaving this way. It's a very helpful feature, and one you definitely need to investigate whenever you get a new rig.

Control: Shoulders

Where Is It?

Generally, you'll find the shoulder handles near the shoulder joint. Occasionally there will be two shoulder controls: Clavicle and Shoulder (sometimes called Shrug). Andy's FK clavicle is actually located at the base of the clavicle (right under the neck) rather than by the shoulder; his IK shoulder handle is at the shoulder joint.

What's It Do?

Moves the shoulder around.

What Can It Mess Up?

If you use the shoulders to compensate for a too-long neck, you could create problems with the arms being too short.

Is It Good for Anything Special?

Occasionally, you can use the shoulders to compensate for a too-long neck.

Tell Me More!

Shoulders make a huge difference as to how well your arms fit, and that sounds obvious, but so many people don't ever use shoulder controls, and I've never known why. So let's take a look:

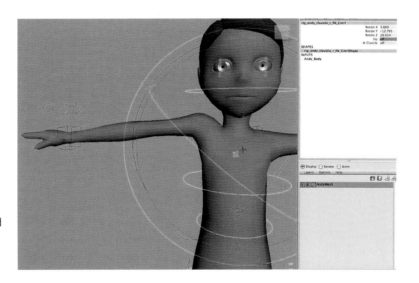

Figure 11-56 FK clavicle control. The clavicle is your collarbone and this control rotates your shoulder from pivot point at the base of the collarbone.

Most shoulders are FK clavicles, or collarbones that rotate from the upper chest. In general, that gets the job done, but Andy here has an option for IK clavicle too, so let's look at that.

Figure 11-57 IK Clavicle (green cross): shrug!

Ah, the IK control can move the shoulder in and out from the neck as well as up and down! That's more like actual human movement.

This is another instance where it's a good idea to decide which controls you want to use before you animate – IK or FK – and lock or hide the other.

Control: Arms

Where Is It?

There are generally two or three Arm Controls. One is the actual arm handle, and usually surrounds the hand. There is another for setting options for the arm: FK/IK, parenting options, and so on. Third, there is a selection handle for controlling the fingers. The finger and options handles are usually a little off to the side of the hand.

What's It Do?

Moves the hand around, and the IK adjusts the arm to the proper position between the hand and shoulder.

What Can It Mess Up?

Hand and arm animation problems are usually user-error-related.

Is It Good for Anything Special?

Hands are pretty special!

Tell Me More!

The first thing to investigate when you're looking at the arms and hands on your rig is where to set them to IK. Sometimes this option is on the Master, or World node, but more often it's on a control handle near the hand used solely for setting hand defaults (the arrow in Figure 11-58).

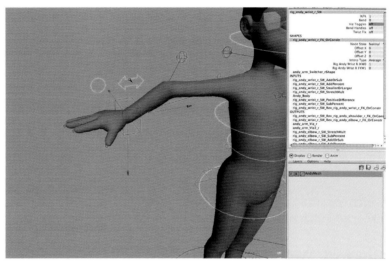

Figure 11-58 The control handles for setting IK arm options and controlling fingers (arrow and circle, respectively).

Figure 11-59 The IK/FK option control (arrow handle).

I know from experience that those two shapes offset a bit from the hand will allow me to set IK/FK, maybe hand parenting options, and control the fingers. Let's take a look:

As I expected, the arrow sets the IK or FK state of the arm — *make sure it's IK.*

Also as expected, the circle handle selects the finger controls (more details coming up).

The box around the wrist is the actual IK handle for the arm. It allows you to move the hand around while the IK rig automatically creates the correct arm pose for that hand movement.

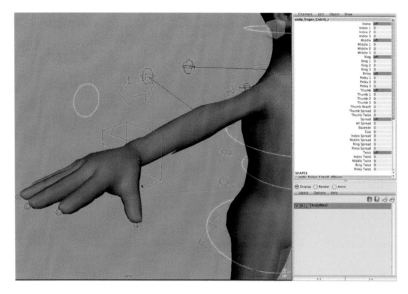

Figure 11-60 Finger controls (selected by the circle handle).

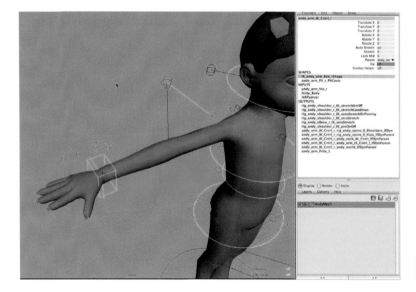

Figure 11-61 The IK arm handle is a box surrounding the wrist.

The handle also controls the rotation of the hand. Occasionally you will see an elbow control in the IK arm channel box (sometimes called "twist"), which you scrub to adjust the position of the elbow. I don't see those very often any more, though.

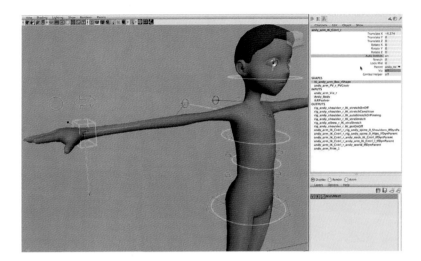

Figure 11-62 Andy can really stretch his arms!

There's a stretch control here that, while fun, isn't appropriate for rotomating humans, so I turn it off and lock it.

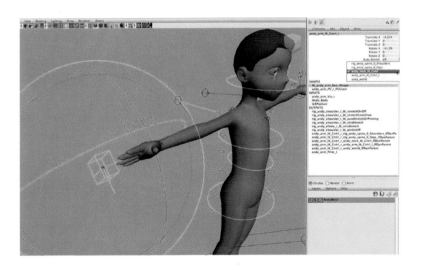

Figure 11-63 Choosing where to parent Andy's arms.

This is also where I choose how to parent Andy's arms. The choices are Shoulders, Hips (COG), Neck IK (head), or World (master).

Choosing where your arms are parented is really important to think about *before* you start your animation, and can make your life really easy, or really, really annoying.

Let's look at what each of these choices look like, and what they are good for.

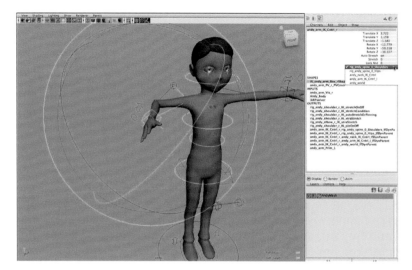

Figure 11-64 Parent to shoulder.

Parent to Shoulder

If you move the shoulder around, it won't affect the hand. However, any joint below the shoulder *will* move the hand.

When this Would Be Useful

If your actor's body is pinned beneath something and he's trying to pull himself out with one hand.

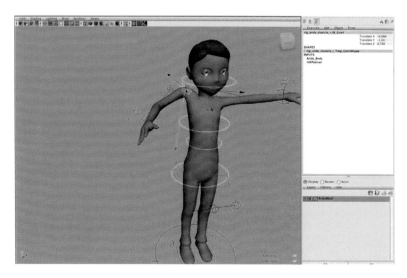

Figure 11-65 When I move the shoulder, the hand stays where it is.

Parent to COG

The hand will stick in place no matter how your rig moves for every joint above the COG. The arm will move with the COG.

When this Would Be Useful

Walking and running: because your arms come along with you when you're moving forward, it's easier to have them move with the main driver of motion – the COG. Then, additional adjustments to the arm position and be made independently.

Sticking to surfaces as long as the COG doesn't move, the rig's hands will stay planted where you place them. This is an unlikely situation, though – better to parent to the body or master if you need to plant the hands.

Parent to Head

The hands follow the head.

When this Would Be Useful

Good for a character holding his head.

Parent to Master

Only the Master node will affect the position of the hands.

When this Would Be Useful

Planting the hands on a surface and not letting go.

Walking on your hands. When you're walking on your hands, you are essentially planting your hands in one location for a length of time, then moving it to a new position and planting it again. If you parented the hands to the COG, they would slide along as the COG moved. When parented to the Master, thry'll stay put.

Control: Elbow

Where Is It?

The elbow controls are generally ball or pyramid shapes a short distance behind the arms, with a line connecting them to the elbows. Rarely, the elbow controls are on the IK Arm Control panel itself as a scrubbable channel, usually called "elbow twist" or just "twist."

What's It Do?

When manipulated, the controls adjust the position of the elbows in relation to the IK hands and shoulders.

What Can It Mess Up?

It can be easy for inexperienced rotomators to accidentally animate the elbow handles to the front of the character, causing the arm to break. I find that controlling the elbows (and the similar knee controls) is the *number one reason* rotomators become frustrated with IK rigs and make the disastrous switch to FK rigs.

Is It Good for Anything Special?

Just for animating the elbows.

Tell Me More!

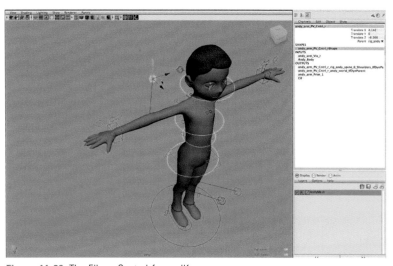

Figure 11-66 The Elbow Control for an IK arm.

As I mentioned earlier, the elbows seem to cause the most consternation amongst rotomators who don't take the time to really become familiar with their rig. When animating IK arms, if the elbow control isn't used, the elbow isn't controllable – which makes sense, right? You want to be able to control it yourself. However, it appears to many that actively posing the elbow isn't possible, because they don't take the time to discover that the ball or pyramid shape behind the rig is actually the control for the elbow. This makes it seem that IK arms perform randomly and are too frustrating to work with. This isn't the case, I assure you.

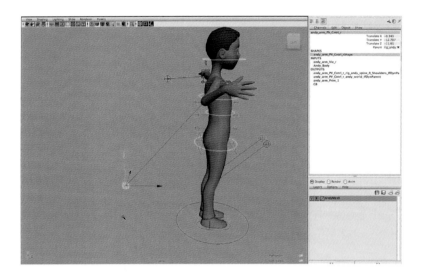

Figure 11-67 Posing the elbow downwards with the Elbow Control.

Tip: Stay Back!

In order to keep the elbow and knee controls easier to see and grab, keep them slightly farther away from your rig's body than would seem necessary — half his height or so should be fine, and won't hurt the animation in any way.

As you can see in Figures 11-67 and 11-68, the Elbow Control is quite easy to use. Once you pose the shoulders and IK arms as you like, simply grab the Elbow Control and manipulate it up or down, pulling the elbow with it, into the position you need to line the arm up with the plate. That's it! That's all there is to it.

I think a lot of confusion with the elbow handles comes from accidentally moving them in a way that isn't anatomically possible, then accidentally keying it that way (Figure 11-69). In general, you never want to pose the elbow controls in front of the body — your arms just don't move that way, unless you're having your shoulder dislocated, of course.

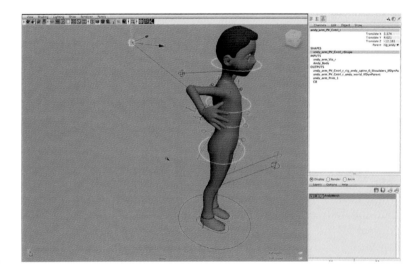

Figure 11-68 Posing the elbow upwards with the Elbow Control.

Sometimes the elbow controls move to the front of the body accidentally, due to software interpolation between two keyframes that are many frames apart. This is one of the reasons I like to key every channel at every frame I pose my rig, whether I manipulate that particular control or not – because if the pose is perfect as it is at that point in time, I want to capture it! If I don't key every channel, I might lose that pose due to interpolation between other keyframes I set later on. See "Which Channels to Key and When to Key Them" in Chapter 10 for more details.

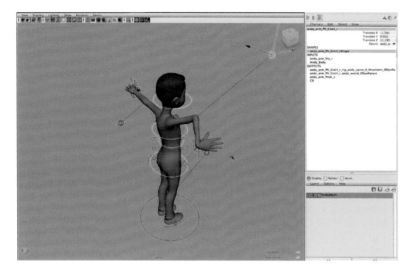

Figure 11-69 Don't animate the elbows in front of the body — unless he's getting his arm broken, in which case, go for it.

On Andy, you can also parent the elbow controls to the shoulders or the World node. Because you're not using the World node except for the situations noted previously, it's best to parent to the shoulders. That way, the relative position of the elbows are maintained from frame to frame until you manipulate them.

Keep these Elbow Control tips in mind...
• Don't move them so they break the body.
• Always keep them behind the body.
• Key them every time you set a pose.
• Parent them to the shoulders if it's an option.

... and you won't have any trouble at all with the elbows!

Control: Legs

Where Is It?

The IK leg handles are generally located at the soles of the feet.

What's It Do?

IK leg controls move the foot around, much as the IK Arm controls move the arms. When the foot is positioned, the IK rig automatically adjusts the leg to an appropriate position.

What Can It Mess Up?

If the IK handles are moved too far away from the foot geometry, it can cause undesirable stretching in the leg.

Is It Good for Anything Special?

The Leg IK channel box also has controls for posing the feet.

Tell Me More!

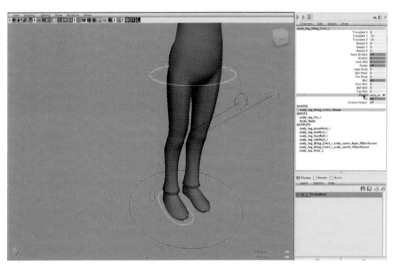

Figure 11-70 The IK leg controls. Note the Foot Posing channels under the Translation and Rotation channels.

The arrow symbol off to the side of the rig's ankle controls the FK/IK state of the controls. Most often, if a rig has IK legs, it's imported to your scene with the IK state already on, but if not, make sure to turn IK on *immediately*.

The IK Controls for the feet work essentially the same way the IK arms do. Grab the handle, move the foot around, and the leg is positioned automatically.

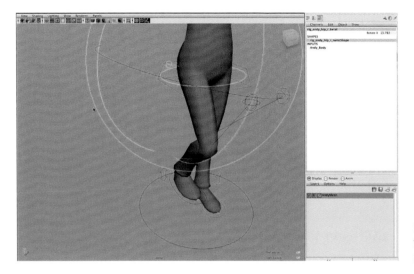

Figure 11-71 Raise Andy's foot and the leg is automatically positioned correctly.

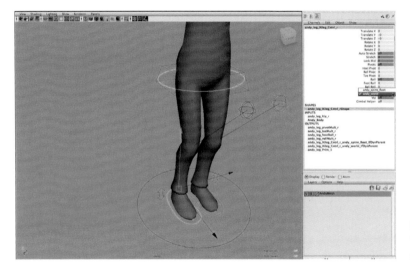

Figure 11-72 Legs parented to World, so animating a walk is easier.

Andy's legs have two parenting options: World and COG (Spine Root). If your actor is walking, running, crawling, or otherwise keeping his feet in contact with the ground plane, then you want to parent his legs to the World node. This way, his feet will stay planted on the ground, no matter how his body moves, until you reposition them.

If your rig needs to fly, jump off a building, ride a bike, or perform any other action in which his feet don't touch the ground, parent his feet to the COG. This way, his feet will come along with the rest of his body, saving you time in repositioning them on every frame.

Control: Leg, Pivot, and Roll

Where Is It?

The Foot Pivot and Roll controls can be in the IK Control channel box, or sometimes have a channel box of their own, accessed by a handle off to the side of the foot. Very rarely, you'll see handles on the mid-foot and ankle to animate these poses.

What's It Do?

These controls pose the foot in several ways.

What Can It Mess Up?

Not much.

Is It Good for Anything Special?

Nothing much, except getting fancy with foot rotomation if you need to.

Tell Me More!

Figure 11-73 Heel pivot — compare to foot rotation.

Figure 11-74 Ball pivot — compare to foot rotation.

Figure 11-75 Toe pivot — compare to foot rotation.

Why would a rig need those fancy controls, and why would I use them? Well, for one thing, they mimic the way humans actually move.

Figure 11-76 Foot rotation. Compare this pose to the poses using the pivot controls.

Figure 11-77 Pivoting the foot doesn't change the orientation of the leg, whereas rotating the leg itself does.

Pivot Control

If you want to turn on your heel, for example, you put your weight on that heel and pivot. If you want to turn on the ball of your foot, you lean to put your weight there and then pivot. Try it out yourself – I'll wait.

It's tough to animate those situations using foot rotation. When you rotate the whole foot on your rig, you're only rotating from the center of the leg – around the ankle – so to get that same foot position, you'd have to rotate the leg and reposition it. It's more desirable to leave the leg planted where it is and pivot the foot rather than to rotate and reposition it, and perhaps ending up with a pop in the foot animation. The fewer moves to get a pose, the better!

Figure 11-78 Foot roll.

Figure 11-79 Ball roll.

Figure 11-80 Toe roll.

Roll Control

Foot roll: Raises the foot up onto the ball of the foot. It's useful when a character is pushing off his back leg when walking and running, or when crouching down.

Ball roll: I've never really used this one. It might be useful if your actor is standing on the edge of a building or lying flat on a surface.

Toe roll: Not really useful on its own, but great in conjunction with foot roll to really get your rig up on his tippytoes if need be.

Control: Knees

Where Is It?

The knee controls are generally ball or pyramid shapes a short distance in front of the legs, with a line connecting them to the knees. Rarely, the knee controls are on the IK Leg Control panel itself as a scrubbable channel, usually called "knee twist" or just "twist."

What's It Do?

When manipulated, the controls adjust the position of the knee in relation to the IK leg and COG.

What Can It Mess Up?

It can be easy for inexperienced rotomators to accidentally animate the knee handles behind the character, causing the leg

to break. I find that knee control (and the similar elbow controls) is the *number one reason* rotomators become frustrated with IK rigs and make the disastrous switch to FK rigs.

Is It Good for Anything Special?

Just for animating the knees.

Tell Me More!

The knee controls work essentially the same way the elbow controls do, just for the knees. Instead of making sure they stay a little ways behind the body, you want to have them stay a little ways *in front of the body*. That's really the only difference.

Just as with the elbow controls, keep these Knee Control tips in mind...
* Don't move them so they break the body.
* Always keep them forward of the body.
* Key them every time you set a pose.
* Parent them to the COG if it's an option.
...and you won't have any trouble at all with the knees, either!

Control: Fingers

Where Is It?

The handle to select the finger controls is generally located a little bit off to the side of the hand.

What's It Do?

Controls the various movements of the fingers.

What Can It Mess Up?

Finger control problems are generally user-error-related.

Is It Good for Anything Special?

Just fingers.

Tell Me More!

Ah, fingers, my favorite.

First of all, look at your own hand and fingers. Feel and see where the bones are. Don't worry – no one's looking. Notice they don't just bend one way, but in all three axes. Notice that

Figure 11-81 **Figure 11-81** Finger Control channel box.

your thumb has a different number of joints than the rest of your fingers. Notice where the tarsals – the hand bones – seem to radiate from. Now pick something up and hold it. Look at your hand. Did you know your fingers could bend that way? Now squeeze this object really tight. How about now? Your hands are incredibly complex pieces of engineering, but luckily, most hand rigs are fairly simple and flexible.

Let's look at the controls (Figure 11-81).

Yikes! So many! What are all these controls for? The first set – index 1, 2, 3, middle 1, 2, 3 and so on – are the bend controls. In Figure 11-82, notice that I've bent all three index joints at the same time – I've ganged the channels much like I gang the spine handles. You don't move your individual finger joints, so you shouldn't animate them that way, either.

There isn't a control for "fist" on Andy, which sometimes shows up, so I make a fist by choosing all the finger channels and scrubbing them until I get a good fist pose.

When the thumb is in a good position, I deselect those controls and continue bending the rest of the fingers until I'm happy with my pose.

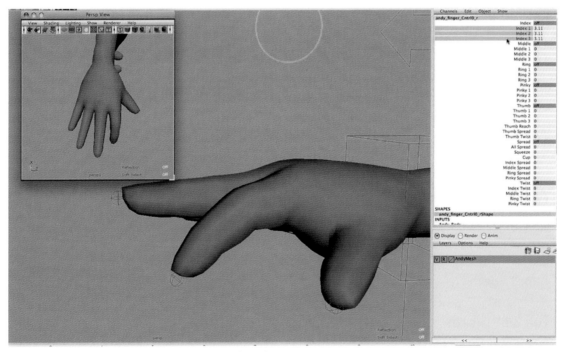

Figure 11-82 Bending the index finger with ganged channels.

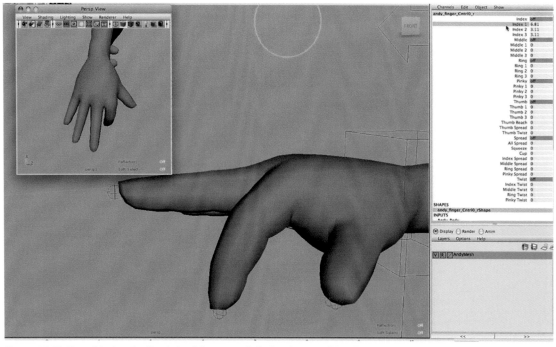

Figure 11-83 Repositioning the first index joint as needed after the overall bend.

Thumb Controls

As we all know, thumbs set us primates apart from the rest of the animal kingdom, and are a nifty bit of engineering. So they can be tricky to animate. They're also hard to model for a generic rig, as well. Most of the time, I find the location of the base of the thumb is off – no matter what you're rotomating.

So thumbs are tricky, and they have a much wider range of motion than regular fingers. Although there are separate controls for thumb rotation, reach, spread, and twist, you will always gang at least two of these controls together to get a more natural animation, just as you would for the spine and fingers.

Overall Finger Controls

Finger Spread not only spreads the fingers apart, but can mush them together as well.

Finger Squeeze is similar to negative finger spread, but comes from lower in the hand, and also gives a slight bend to the palm.

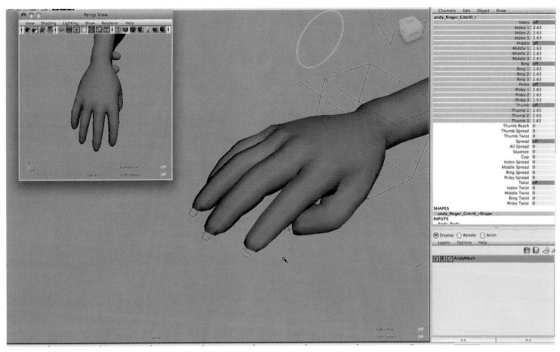

Figure 11-84 Home-made fist control.

Figure 11-85 Fingers-only bending.

Figure 11-86 The thumb in a neutral pose.

Figure 11-87 Thumb rotation pulls it into the palm.

Figure 11-88 Thumb Reach controls the range of motion from the palm to straight out from the hand.

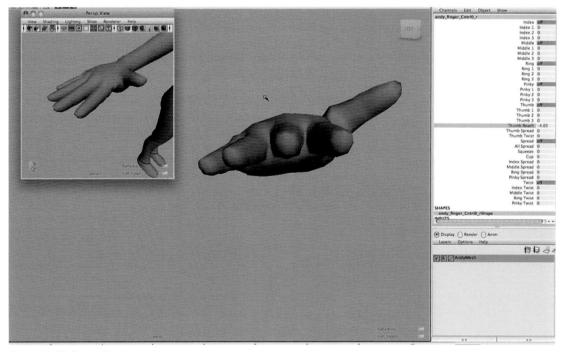

Figure 11-89 Thumb Reach.

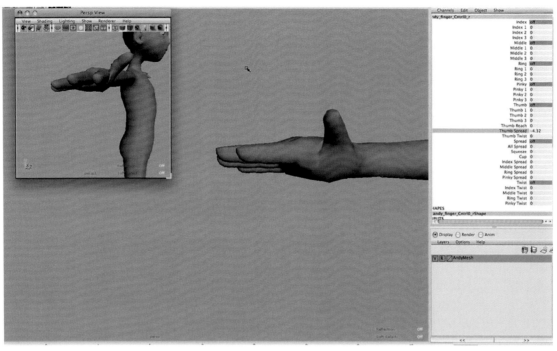

Figure 11-90 Thumb Spread controls the motion from fingers back towards the wrist.

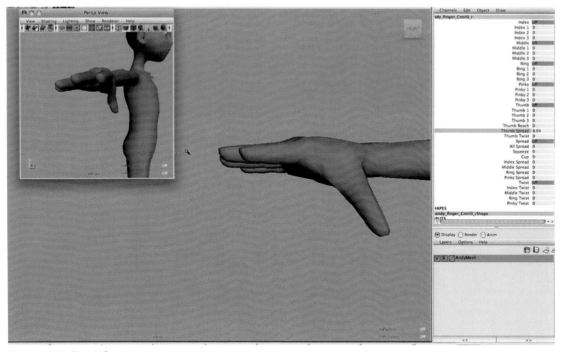

Figure 11-91 Thumb Spread.

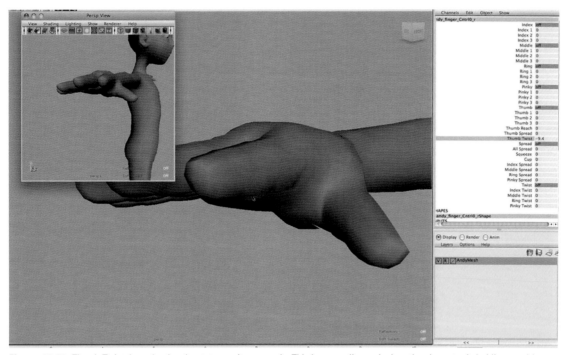

Figure 11-92 Thumb Twist: how the thumb rotates on its own axis. This is generally used when the character is holding an object.

Figure 11-93 Thumb twist.

Figure 11-94 Fingers spread in the negative direction.

Figure 11-95 Fingers spread in the positive direction.

Figure 11-96 Finger Squeeze is similar to negative Finger Spread.

Figure 11-97 Cup makes it easy to create classic Elvis gestures.

Figure 11-98 Individual spread and twist controls.

Cup Control squeezes the palm and fingers even more. It gives you the classic "I'm holding a miniature person in my hand" pose.

There are also individual spread and twist controls for each finger, which is great – you don't always get those. They are essential, especially if a character is holding or touching something.

You're Almost Ready to Start

Play around with your rig a little now – do a few poses with the hand, put him through a quick walk cycle, whatever. Make sure he'll do what you need him to do in your shot! While you're at it, start deciding now which controls you want to use and which you want to lock. Consider this list of important questions to help you decide:

- Is my guy walking/running/making contact with an object or surface that his feet need to stick to?
- Is he making contact with an object or surface that his hands need to stick to?
- Is he on wires/on a bike or other kind of vehicle/otherwise flying?

- What's he looking at? All around, like someone who's scared, running away from something and looking here, there, everywhere? Or like a predator, focused on one thing only?
- How flexible is he? Are we talking floor acrobatic or a regular guy walking around?

And don't forget the *most* important question: what's the shot about? What's important? What are the needs of the other departments? Are there any special requests from production — like don't ever touch the IK shoulders, or to animate only the World node, not the Body node? Be sure to take all these factors into account as you evaluate your new rig.

Next Up

Now that you know your rig, let's move on to using him in a real shot!

REAL-LIFE SHOT: CHARACTER AND OBJECT ROTOMATION

Here is our next shot! In it, our actor pal walks into frame while partaking of a delicious beverage and chatting on the phone. He sits in the chair at frame left, has some sort of argument with the person on the other end of the line, and tosses the cup he's holding angrily into the pool. My goodness!

Figure 12-1 Our actor holds the practical cup . . .

Figure 12-2 . . . is angered by someone on the other end of the conversation . . .

DOI: 10.1016/B978-0-240-81230-4.00012-9

Figure 12-3 . . . and throws the practical cup into the pool!

Determine What Needs to Be Done

Originally, only the cup was requested to be matched in the shot, but later the concept changed. Now, both the cup and our actor are going to have FX animation applied to them: the cup is going to be replaced with a magical goblet that reflects our friend's emotional state — transforming over the course of the shot until it bursts into sparks and flames showing his anger when he throws it. Our hero himself will have wispy, smoky effects trailing off him. They're generated, apparently, from the magic elixir he's drinking.

To achieve this effect, FX Animation needs a full character rotomation and a CG cup closely tracked to the plate. When FX Animation takes over this shot, they will use the character and cup that we animate to generate whatever smoke, spark, and fire simulations they are planning. The software they use takes the motion of the animation on the cup and CG character into consideration when calculating the dynamics of the sparks — how fast it's moving, how it rotates, when it changes direction, and so on. This information affects the movement and behavior of the dynamic simulation of the sparks, which are also affected by gravity, air pressure, the movement of the object generating them (the cup and rig), and so on. So you can see that a very accurate rotomation of both cup and actor is necessary to generating a believable dynamic simulation of sparks.

By the way, this is a pretty interesting show we're working on — little people, magical cups, retro trippy things emanating from bodies, folks bursting into flame, random keg parties in Texas . . . I'm really excited to see it!

True Tales of Matchmove: Crazy Dynamics!

I was working on *Spider-Man* when I was assigned my very first rotomation. In it, a stuntman is crouched on the ground, acts out shooting webs upward, and is pulled out of frame on wires. My job was to rotomate the stuntman so that FX Animation could create the webs.

This was my first or second rotomation *ever*, so I hadn't really nailed down a technique yet. Long story short, the shot was approved — everything looked fine. It moved on to FX and I moved on to my next shot. A few days later, the shot came back, with the note that around frame (let's say) 150 and 151, "the webs are exploding."

Interesting.

This wasn't only my first rotomation, it was actually my first matchmove job, and I'd only been there a couple of months. It took me a little while to figure out what was going on, but finally I saw that I had accidentally animated Spidey's hands 360° between frames 150 and 151. It looked fine — the hands were in the same position to our eyes, of course, because they'd made a full revolution between frames 150 and 151. But to the FX software, those hands were spinning really, really fast — covering the entire set with webs in one frame! It really did look like an explosion of webs. Once I corrected the mistake, everything was just fine.

Naturally, you can see how important accurate, realistic movement in your object and character rotomation is to dynamic simulations, and it's something to always keep in mind on these types of shots. Or something else might explode.

Part 1: Character Rotomation

Set Up the Shot

This camera is a lockoff, and in fact, one has already been done. So all of my setup steps have already been done for me — the set's been modeled, the plates are actually fine for my purposes as they are, so I don't need to color-correct them, and the camera for that shot was in fact already finalled. All I need to do is import that setup into my new scene and start setting up to rotomate!

Tip: Scale Check!

Always check the scale of your character rig the first thing when you import it! If your rig is the wrong scale, it won't line up in the correct location relative to your camera — too small, and you'll place it too close to camera. Too big, and it will be too far from camera. Check the scale *first*.

For more information on character rigs and the scale of the CG environment, see "Miniature Land and Your Rig" in Chapter 10.

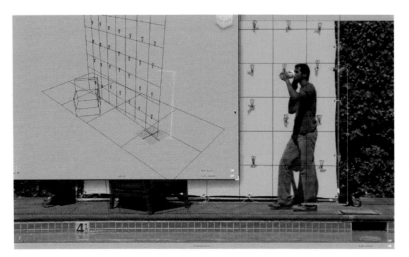

Figure 12-4 An existing shot setup is imported to my new scene.

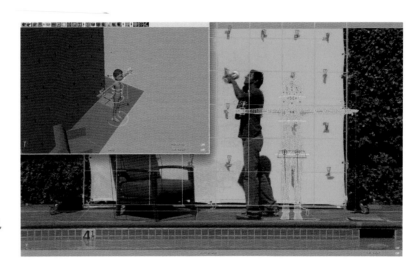

Figure 12-5 Andy is imported and immediately checked for accuracy of scale against the set, and with measuring tools in the software.

Tip: Warning!

Never, ever, **ever** bring an unvetted character rig into your facility without permission. Getting fired would be the *least* of your worries — don't do it! *Always* ask before bringing any models, rigs, plug-ins, and so on from the outside world into your facility.

I'm using Andy for this shot. You may have noticed that I've changed his proportions a bit! I poked around his skeleton for a while until I found a way to scale his head joint to make his head more human-like. Then, I used his universal scale channels (on the World node) to get him to the right height and proportions. I have to say that Andy is one heck of a rig — I can't believe I didn't break him with all this scaling! For more details, see Chapter 11.

To keep checking my animation from all angles to ensure accuracy, I'm going to set up my workspace to my typical layout for rotomating objects and characters: shotCamera view in the

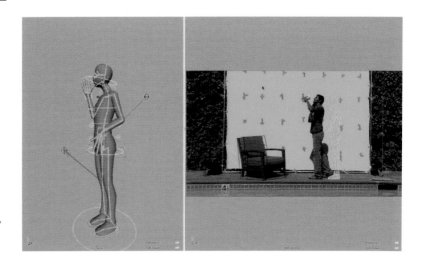

Figure 12-6 Correctly scaled rig, checked against the set for accuracy of placement and size.

main viewport, zoomed in on the Image Plane as needed, and a tear-off perspective view that I can move around and look at my scene in all angles (for more information, see Tip: Tearing Off Panels in Chapter 3).

Breaking Down the Clip

As I mentioned in Chapter 10, breaking down a shot into the all-important first-pass keyframes can be a bit of a mystery to some. So let's break the clip down together!

First, think of the general action. Our hero walks into frame, turns, and sits in the chair. "But wait," you're thinking, "he's talking on the phone, and waving the cup around, and, and, *and* . . . !"

Not in the first pass, he isn't. The first pass of any rotomation is only about the broad strokes of the action. Think of it as a one-sentence book summary.

So: our hero walks into frame, turns, and sits in the chair. Let's break this down further.

Walk Cycle

You might have heard the saying that walking is just controlled falling, and it's true. When you walk, you lean forward on one leg, start to fall toward the ground, stop the fall with the other leg, then lean forward on that leg to start the cycle all over again. If you think about it, it's pretty amazing!

We have here a simple walk cycle, which breaks down like this:
- Heel plant on first leg
- Push off on back leg
- The back leg comes level with the front leg (called "pass through")
- Heel plant on second leg
- Push off on back leg

Now you must be wondering, what about the *hips*? Why aren't we talking about *HIPS*? Good question, and I'm very glad you're paying attention! There are couple things about a regular walk cycle that make it easier to watch the feet than the hips:
- The feet and legs are reflecting what the hips are doing anyway — shifting the weight between each foot will cause the hips to change direction. It might be off by a frame here or there, but not enough to worry about.
- Every human adult walks on an eight-frame cycle — an excellent rule of thumb to keep in your back pocket.

I'm not kidding about that. Walk cycles are surprisingly — really surprisingly — regular amongst adults. I've never seen a

regular person (i.e., not in heavy costume or rigged up some-how), male or female, no matter what kind of shoes they wear, or surface they walk on (within reason), or in what kind of weather, who *didn't* walk on an eight-frame cycle. Seriously. *Everyone* walks on eights. It's kind of freaky. As you'll see, our hero here also walks on eights.

First Frame

Figure 12-7 Clip breakdown: frame 1.

Frame 1 will always be a key frame, of course — and you can see that our hero's magic cup just barely shows up in the far frame right — I'll need to remember to set my pre- and post-infinity curve behaviors appropriately when I'm done with this shot (for more details, see "Finishing Up" later in this chapter).

First Foot Plant

Here, our hero has all of his weight on his front foot and is most likely pushing off with his back foot. I can tell that his weight is fully on his front leg because his hip on that side is higher — he's swinging his other leg forward, it's heavy, and it tilts his hip down on that side.

Rule of thumb: weight fully on front leg, that hip is raised; back leg pushing off, that hip is lowered.

Figure 12-8 Clip breakdown: first foot plant.

Pass Through

Figure 12-9 Clip breakdown: first pass through.

Here is the first pass through. Sometimes it can be hard to choose the pass-through frame, because the leg passing through is usually a little ahead or behind the opposite leg. It doesn't really matter in the grand scheme of things – pick a side, forward or back, and just stick with it for the shot. Here his outside leg is actually pretty centered.

Notice his hips are also level and pointing almost completely forward. At this point, he's balanced between falling and having caught himself, and the rest of his body has lined up around his core.

Rule of thumb: hips are even at the pass through.

Second Foot Plant

Figure 12-10 Clip breakdown: second foot plant.

In Figure 12-10, our hero has his weight almost equally balanced between his two legs. I can tell this because his hips are still fairly level, and by looking at his feet; his front leg is still slightly lifted at the toe, and his back foot is still pretty firmly settled on the ball of his foot.

In the frame before this, his front heel would be barely making contact with the ground, and his back foot would be slightly pushing off. In the frame after this, his front foot will be in full contact with the ground and his back foot might be barely touching or might have just left the ground.

Any of these three frames – heel plant, weight balanced between both feet, or whole front foot plant – is good to pick. The thing is to choose which one you're going to pick and *stick with it* for the whole shot. Which one you pick just depends on the shot, the phase of the shutter vs. the phase of the action, and sometimes what kind of shoes the actor is wearing. Sometimes, one type of frame will just be easier to identify than the others, so just stick with that!

Second Pass Through

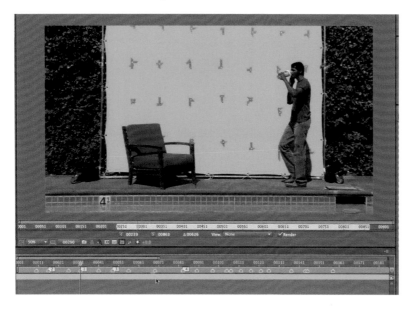

Figure 12-11 Clip breakdown: second pass through.

If the second pass through looks quite a bit different — his leg isn't as high — from the first, it's because our hero is already starting to slow down in anticipation of turning to sit in the chair. However, it's still in an established walk cycle, so I include it in this part of the breakdown.

The second pass through is the end of the cycle, which then repeats from the beginning with him planting his foot again. Though he's slowing down, he keeps walking in this cycle until he gets to the chair, for several more frames.

And, if you'll notice, there are around 16 frames, give or take, between each pass through — an eight-frame walk cycle!

Turn

Once our hero gets to the chair, around frame 100, he starts to turn to sit. He'll have to turn almost 180° to line himself up. How does he move to accomplish that?

In Figure 12-12, he's just changed direction slightly from walking straight to the chair to pivoting a bit on his heel. I watched his hips to find this pose (see "Hip Close Up" later in this chapter), but his free leg also helps, as you can see he's twisting is a bit to swing himself around.

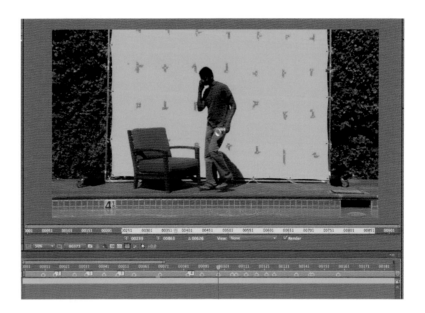

Figure 12-12 Clip breakdown: moving into the turn.

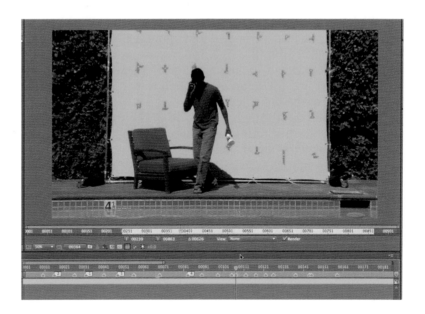

Figure 12-13 Clip breakdown: crossover step, similar to a foot plant.

Next, in Figure 12-13, he has completed the direction change by planting that free foot so that his hips are now rotated almost half the way needed for him to sit. Again, I watched the hips to find this frame, but the direction shift in the hips coincides with the shift in weight from his back leg to his front.

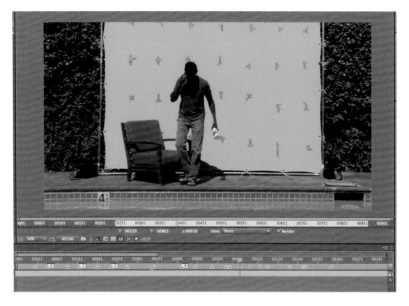

Figure 12-14 Clip breakdown: mid-pivot — similar to a pass through.

Now, in Figure 12-14, he's halfway through the next pivot he must perform in order to sit. This pose is almost like a regular pass through — it's about halfway between the time he picks up and puts down his free leg. His hips are also similarly level, as in a pass through.

Our actor makes a few more little pivots like this, and is finally lined up to sit.

Sitting Down

Though our hero hasn't completely lined himself up with the chair, he's started to lower himself into it, and this is why I'm breaking down the sitting motion — I'm not just setting a keyframe at the beginning of his sitting motion (which is . . . where, exactly?) and one once he's sitting (and how do you define sitting, exactly?). For an interesting experiment on this theme, see the section "Second Pass Rotomation" and Figures 12-41 and 12-42.

People move extraordinarily fluidly — more so than you would ever imagine, until you start rotomating. Even klutziness has an elegance to it. And so does our actor, as you can see in Figures 12-15 and 12-16.

Our hero very fluidly continues to rotate, lining himself up with the chair, even as he's lowing to sit in it. He's not even looking at the chair. That's pretty amazing, if you think about it.

This keyframe (Figure 12-16) was easy to find, actually. There's a very pronounced change in the turn of his hips from the previous frame to this one. He's actually pushing himself

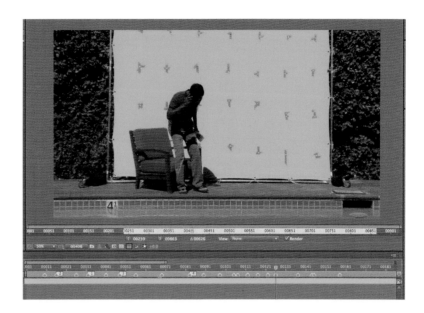

Figure 12-15 Clip breakdown: beginning to sit down.

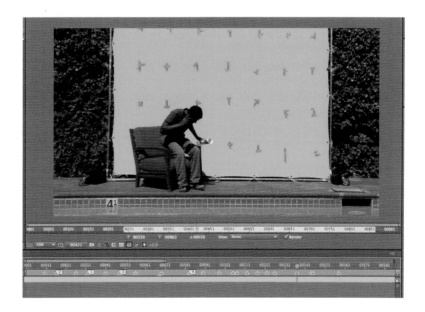

Figure 12-16 Clip breakdown: continuing to rotate on the way down.

into position with his left leg, and you can see the quads in his right leg tighten to maintain position.

From there, he lowers in the same trajectory until he's as far down as the cushion will allow, and then he leans back and settles. I could also have chosen to set a keyframe where he first touches the cushion, but he doesn't really change direction there, so much as slow down a little – I'll leave that for the next pass. The next couple of keyframes you see tagged in the

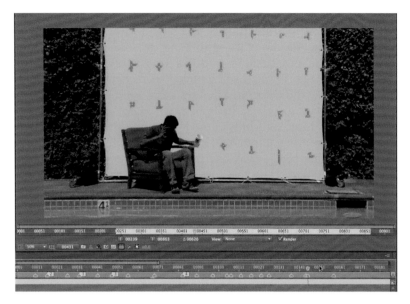

Figure 12-17 Clip breakdown: fully seated, not yet settled.

timeline (Figure 12-17) after this pose mark him settling into the chair – he pulls his knees into his chest to scoot up a bit, changing the position of his hips. However, the whole time he sits and talks on the phone, though he fidgets quite a bit, he holds his whole core completely still, so I don't mark any poses at all for the first pass in that section.

It takes a lot of practice to break a clip down like this, so if you're feeling a little overwhelmed right now, don't be! I've been doing this a long time, and I find it really fascinating. Once you get the hang of it, you'll be able to see the important poses and zero in on the right frames in no time. It only took me about 10 minutes or so to break down this clip – this end and the back end where he throws the cup!

Just remember these important tips...

- Work from large to small.
- The first pass is for the *major* moves only – like a one-sentence book summary.
- Watch the hips (but the feet can give you clues, too).
 ...and you'll be a rotomating machine in no time!

Hip Close Up

Now you're probably thinking, "Sure, it's all well and good for you to tell me I'll get the hang of breaking down clips, but *I still don't know what you're looking at! Help!*"

Don't freak out. I'm going to show you.

Here are the frames where our hero transitions from walking to the chair to lowering himself into it (Figures 12-18 to 12-20).

It's a pretty big change — if you compare the first frame to the last frame, you can see that he's changed directions, from still arriving at the chair to starting to bend over to sit in it. But how did I pick the *exact* frame to set a keyframe? Take a look at Figures 12-18 to 12-21, over which I've drawn simplified diagrams to show the position and orientation of our hero's hips.

When I start to watch for the major poses in a clip, this is what I see — hips, and only hips. Now, of course other parts of the body give clues about major changes in motion (especially the feet, in this clip, as we saw previously), and can help you if you're really stuck between two frames, but the hip transition here is very obvious.

Look at the change in perspective from Figure 12-18 to Figure 12-19: the triangle depicting the actor's pelvis is short and long in the first frame, and much taller in the second. He's tilting his hips up and forward, and his whole upper body is moving with him — watch the shadow on his shirt. As he leans forward, it gets longer.

From Figure 12-19 to Figure 12-20, the perspective changes again, but in a different way. Rather than tilting his hips up, he's turning them to the side — pivoting on his screen right leg in anticipation of sitting down. Again, to confirm this, look at the shadow on his shirt — it's moved to screen right, indicating a turn. You can also see him preparing to shift his weight to his screen left leg — it appears he's planting the ball of his foot, pivoting it in anticipation of turning into the chair.

How do I know he's pivoting on the ball of his foot? Well, mostly years and years of experience. I just know. However, you

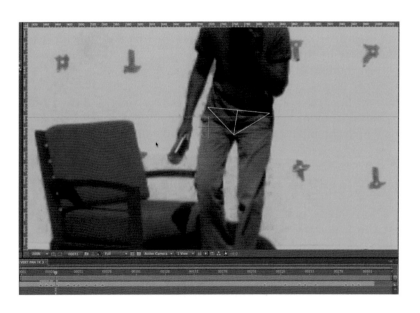

Figure 12-18 First frame.

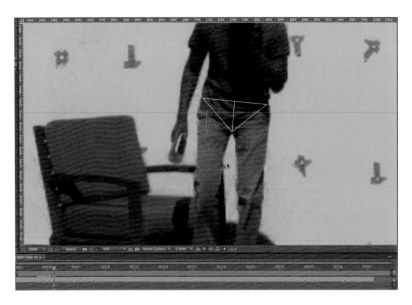

Figure 12-19 Second frame.

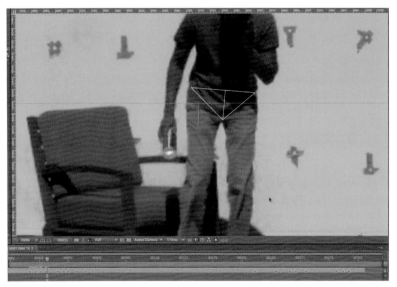

Figure 12-20 Third frame.

can see that his screen left knee is turning in slightly — it's pro-
nounced over the three frames; you can tell this because if you
look at his pants, the crease that runs down the lower part actu-
ally starts right at his patella — it's the highest part of the leg in
that position, so the crease will stem from it.

Looking at the three diagrams overlaying each other, the
change over the three frames is dramatic. The first frame (blue)
to the second frame (yellow) clearly shows a change in tilt, and
the change from the second to the third frame (red) is very
clearly a pivot.

Figure 12-21 The superimposed diagrams clearly show the change in direction of our hero's hips.

Again, it does take practice to be able to zero in on these subtle changes quickly, but once you get the hang of knowing what you're looking for, breaking down a shot like this is a breeze.

First-Pass Rotomation: Walking

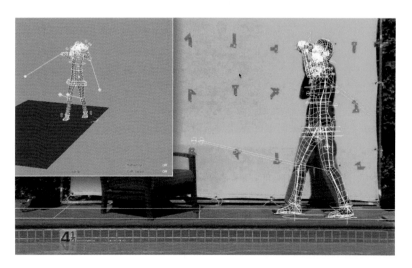

Figure 12-22 Selecting all the rig controls to make sure keys are set for all channels at this frame.

First Step

Now that I've posed our hero with his feet planted, making sure to key all the channels I want to use, I move forward to the next pass through.

The first thing I do on that frame is immediately set keyframes for *all the channels*. I know I have the autokey feature on, but I've lost one too many poses that were too hard to get because I forgot to set a key for a channel I didn't actually manipulate at that frame. Better safe than sorry!

Tip: This is Key

Remember, autokey sets a keyframe for a channel only if you *actually* manipulate it on *that frame*. If not, the channel won't be keyed, and you risk losing that pose if you don't key it yourself!

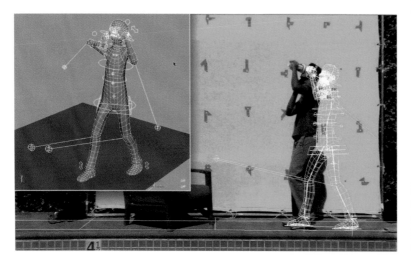

Figure 12-23 Making sure keys are set for all the channels at the new frame, even though I haven't touched anything yet. Better safe than sorry!

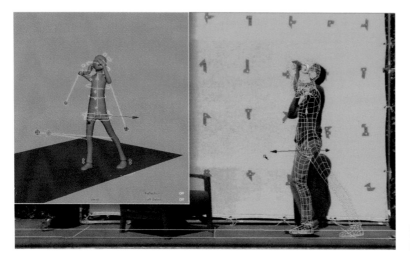

Figure 12-24 Move the COG first.

Second Step

At the next pass through frame, I move Andy's COG into position, always checking in the perspective window to make

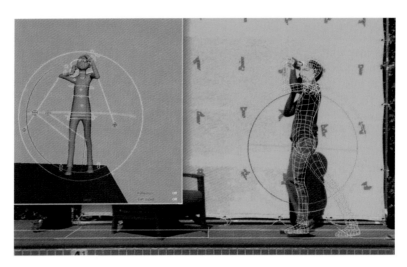

Figure 12-25 Adjusting COG rotation.

sure that everything is making sense (Figure 12-24). I know that Andy's COG is going to be fairly level and pointed fairly straight forward, as this is typical of a pass through pose. Naturally, the foot he's standing on will not move — the bonus of parenting it to the world node is that it will stay put until you move it, eliminating all chance of slipping and sliding (see Chapter 11 for more information on parenting hands and feet).

Incremental Spine Manipulation

Now that Andy's COG is in place, I rotate his spine into position. Remember that I rotate it in increments, first rotating all the spine handles at once, then the top two, then the top one, for more natural movement (see "More Natural Spine Manipulation," Chapter 11).

Figure 12-26 Rotating all spine handles at once.

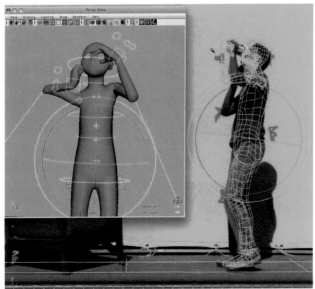

Our bodies are always twisting and counter-twisting to keep balance while we move through space. When our legs and hips move forward and rotate towards the forward motion, the rest of our body counterbalances this motion to maintain balance, and to keep our head level and our vision constant.

In the previous frame (Figure 12-22), where both Andy's feet were on the ground, you can see that his spine is twisting in the opposite direction of his hips, and as his hips are rolling forward, his

spine is arcing back – look at the curve of his back from his waist to shoulders. This position balances the weight distribution around his center, preventing him from falling.

However, on the pass through, everything is lining up again, because our hero is balanced at this point, just between catching himself and falling again. Once he starts to swing his free leg forward, his hips will start to twist one way, and his spine will start to twist the opposite way. By rotating all the spine manipulators at once, this fluid, counterbalancing motion looks much more believable.

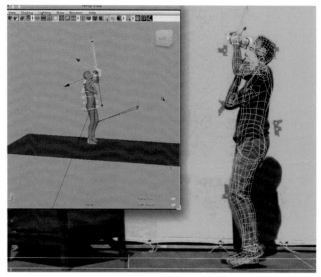

Figure 12-27 Final pose adjustments. Note how far back and down the elbow handle had to be moved. This is fine, as long as it doesn't break his body on this – or any other – frame.

First-Pass Rotomation: Turning

Once we get though animating the walk cycle, which is pretty regular, we get to the turn before our hero sits down. In the shot breakdown, I found that our hero takes many little steps in pivoting himself around and sitting down; they mostly coincide with a kind of modified walk cycle, as he's sort of stepping and turning and stepping and turning as he goes.

First things first: get Andy's COG in place and make sure that it makes sense with his foot placement in relation to the ground. It's at this point that I can see, as I've been suspecting,

Figure 12-28 Moving into the turn.

Tip: Move It!

When I need to move my rig a long way but I'm not using the World or Body nodes, a quick and dirty trick is to select the COG and both IK feet at once to easily move the whole rig at once.

Figure 12-29 Rotating the COG to match our hero's hips.

that Andy here is a little too skinny from side to side for a really consistent fit — remember that consistency of fit is better than complete accuracy. I've been turning him too far towards camera in an effort to make him as wide as our hero, when in fact he isn't. I make a note of it, pass it on to my lead to see if anything can be done about it, and carry on with this new information handy.

To help determine my fit a little better, since I'm unsure about exactly how Andy's hips match up to our hero's, I make extra

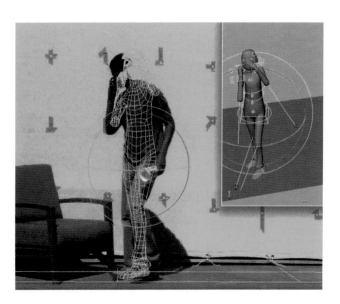

Figure 12-30 Andy is a little deceptive — it looks like he fits in camera view, but in perspective you can see that he's turned too far forward. I think it's because Andy's too skinny.

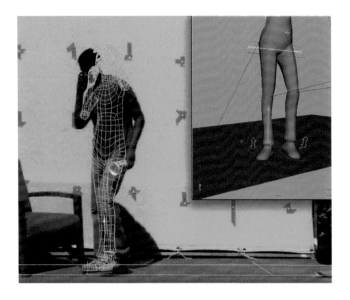

Figure 12-31 Positioning the feet, making sure they remain in contact with the ground.

sure to accurately place his feet on the ground, and use the manipulators to accurately judge which way his COG is actually pointing.

Now (Figure 12-32), with this more accurate COG fit, I can go ahead and fit the spine and other extremities.

Now that I have a better handle – no pun intended – on how Andy's COG lines up with our hero's hips, I'm better able to quickly fit him in the next few frames of the turn and sitting poses. I continue to confirm my accuracy with the feet placement, and I check with the chair's visibility on and off.

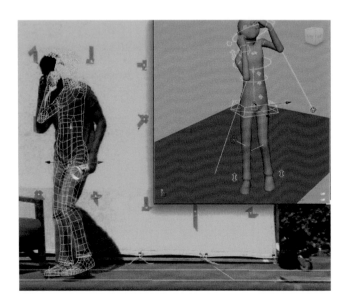

Figure 12-32 Using the manipulator to more accurately judge the orientation of the COG.

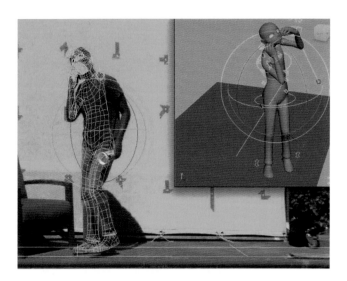

Figure 12-33 Bending the spine, all handles at once.

Everything is looking good — except Andy's spine. He's looking a little like an Edvard Munch painting (Figure 12-34).

This happens to the best of us — sometimes, the spine just gets messed around with too much and you have to reset it. It's no big deal, and I'm not really surprised, as our hero actually does some funky stuff while he's turning — he leans *waaay* back to finish his drink, then *waaay* forward to sit. That'll mess with anyone's curves.

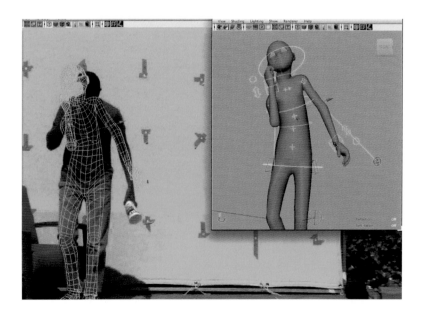

Figure 12-34 Next frame. Andy's spine is looking a little tortured.

At some point in a future pass, the Set-Delete-Set technique I outline in Chapter 10 will take care of this problem – there will be enough keyframes around this pose to delete spine keys, reset them, and so on, to smooth the pose out. However, we aren't at that point yet, so I'm just going to reboot Andy's upper body.

To do this, select all his FK spine channels and set all the rotations to 0. I select his IK head, set the rotations to 0, and move it into position so the neck isn't too crazy long. And, while we're here, I reset his IK shoulders, too.

Ah. Fresh as a daisy! From here, it's much easier to set his spine and shoulders into a more natural pose.

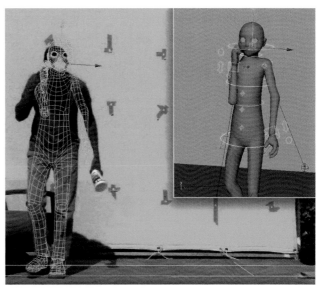

Figure 12-35 Relaxed spine.

First-Pass Rotomation: Sitting

Though I've called out more than one keyframe between Figure 12-37 and Figure 12-38, I'm going to skip them because the pose between those two frames really shows how our hero changes rotation even as he's sitting down (see "Second-Pass Rotomation," later in this chapter).

The first thing I do, of course, is rotate Andy's COG into position. Once I get his feet fitted, all I have to do is plop him down on that chair!

Well, not quite. Here is a *perfect* example of the necessity of keeping a perspective view panel open and in view at all times! Though it looks like Andy's in the right place in the camera view, you can see that he's intersecting the chair in the perspective view (Figure 12-38). That won't work well with FX Animation!

After a little adjusting, I get our very proper Andy into a more believable position. I also note his

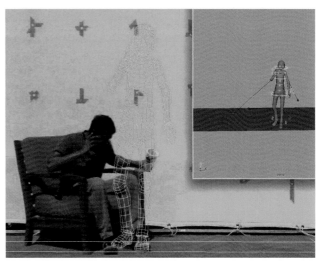

Figure 12-36 From turning to sitting.

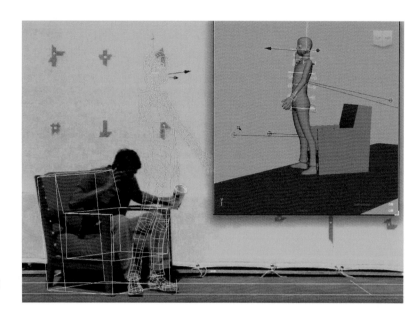

Figure 12-37 Feet planted, COG rotated. Almost ready to sit!

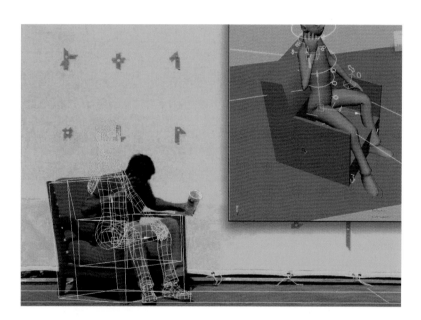

Figure 12-38 Seated, but in the wrong position.

knees don't always line up perfectly — I think his femur might be too short, but it's hard to tell right now. I send a little note to my lead and carry on.

As always, I start posing the rest of Andy's body incrementally away from the COG. Proceeding in this manner, creating poses at all the frames I noted in my clip breakdown, I complete the first pass of this rotomation.

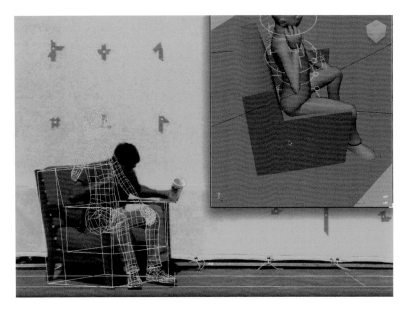

Figure 12-39 Adjusted seated.

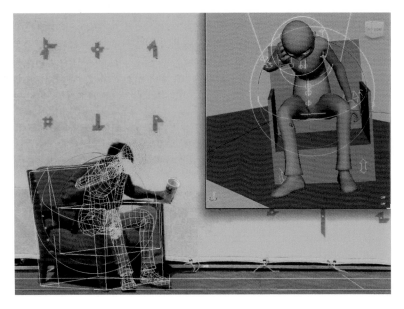

Figure 12-40 Spine adjustment —
all handles at once.

Once I've completed all the keyframes for my first pass, I'll
playblast it to see if anything crazy is happening in the camera
view or in the curves (see "What's Crazy?" in Chapter 10). I
might show it to my lead for grins, or if he or she has asked to
see it. After that, it's time for the second pass!

Second-Pass Rotomation

Figure 12-41 The Wrongest Frame: the height of the COG is almost right, but the twist is missing.

The Wrongest Frame

In Chapter 10, I mention two ways to go about finding the next set of keyframes in your second — and every subsequent — pass at your rotomation. One is complex and finicky, and one is *awesome and works every time*: chose the *Wrongest Frame*.

By definition, the Wrongest Frame between two good keyframes has to be a good frame to create an in-between pose, right? *Something* special is happening there, because in the frames running up to it, your fit just gets worse and worse, and after it, the fit just keeps getting better and better. *Something's going on there*. It doesn't really matter what it is. Just key it! (Of course, if you were also to study what makes that frame special and remember it for later to help you in your fantabulous rotomating career, that would also be acceptable.)

The two most common kinds of Wrongest Frames are represented here: *Major Change In Direction* (Figure 12-41) and *Major Change in Speed* (Figure 12-42).

I mentioned the first type of Wrongest Frame in the previous section, when I purposely left out a pose to see what would happen (see Figures 12-15 through 12-17). This in-between (Figure 12-42) dramatically shows how much our hero is rotating, even as he is sitting down. I actually called it

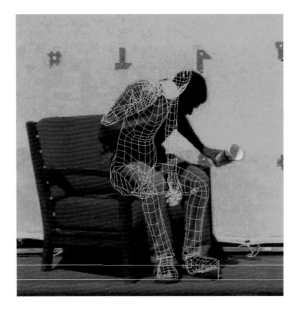

Figure 12-42 The Wrongest Frame: he's too close to the seat. The trajectory's pretty good, but the timing is off.

a keyframe in the clip breakdown, and look — when I left it out between two other good keyframes, it became a Wrongest Frame. *What are the odds?*

The second type of Wrongest Frame, on the other hand, is really more about the rate at which our hero is sitting. If you looked at the curves for this animation, they would probably be pretty straight, and should really be easing in to that seated position, much as the camera curves in the tilt shot ease in and out at the beginning and end of that shot (Chapter 8). This is common for a first pass. You might have two of these types of Wrongest Frame between every two keyframes, one coming out of the pose, and one going in to the next pose. If one is More Wronger than the other, key that one first.

So there you have it! See, I told you rotomation isn't so bad. Now that we've gotten Andy animated to match our hero, let's get that final element in — the magic cup!

Shot Part 2: Cup Rotomation

To Track in Software or Animate by Hand?

Most matchmove-specific programs generate solutions not only for camera tracking, but also for object tracking. Once the camera in a shot has been approved, it's locked, and the same process used to calculate the camera's position is used

Tip: Antici...pation.

As you see, I anticipated the need for a CG character in this shot before I was asked for it. Always ask yourself whether other departments might need more than what your assignment calls for. It's so much easier to give the rest of the facility what they need in the first round than to try to kludge elements in later.

to track an object in the scene. First, the matchmover creates several 2D tracks of the practical object, then he or she constrains those 2D tracks to 3D locators on the CG prop, and then the software triangulates the position of the object based on that data.

Most matchmovers I know would use some form of automated tracker for the cup in this shot. That's fine — as I always say, it doesn't really matter how you get a final, as long as you get there on time and under budget. But using an automated tracker for this shot just sounds crazy to me, for a couple of reasons. First of all, this was originally a cup only shot, but even though I wasn't asked for it, I knew that FX would need that character rotomated at some point, to have something for the sparks to interact with — they might bounce off his arms, or something like that. And look, I was right! So using Andy to drive the cup rotomation makes even more sense now (see "I Need a Guy to Animate a CUP?" this chapter).

Secondly, the cup is of course cylindrical, and in my experience, anything round or cylindrical just doesn't track very well, especially if it's spinning or otherwise rotating a lot in automated solutions. This cup also lacks defining features on the back, further complicating an automated solution. In addition, it's been my experience that when an actor is carrying something, it's much easier to at least rough that actor in with a CG character and animate the object in question through the character, because as the person moves, the rotation of the object which he is holding is constantly changing pivot points — from the wrist, to the elbow, the shoulder, chest, and so on (Figures 12-43 through 12-45). It's much, much easier to manipulate CG props by rotation on those various pivot points rather than translating, rotating, and tweaking the prop without any reference point to gauge the move. As we move through the shot, this concept will become more clear. Blocking an object track with the CG character carrying it is a built-in sanity check, and makes the job easier.

On the other hand, if the chair were being tossed into the pool, I might try to use an automated solver. It has many good features to track, it's easy to tell which way it's facing (as opposed to a cylindrical cup), and it's fairly large in frame. Of course, those attributes also make it easy to hand-animate, which I personally think is faster in almost every case.

So now that we have Andy rotomated, let's set up for the final leg of the shot!

I Need a GUY to Animate a CUP?

Why is it easier to animate a cup with a character rig? It's just a much, much more efficient way of animating an object that is rotating from a pivot point that is not only far away from its actual mass, but also constantly changing. Consider these diagrams:

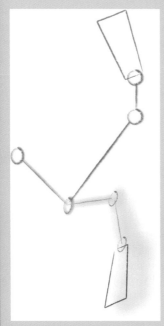

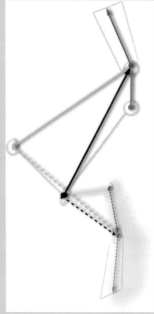

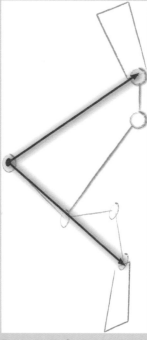

Figure 12-43 Simplified diagram of the prop cup's motion. It pivots from the shoulder, elbow, wrist and fingers — that's a lot to keep track of!

Figure 12-44 The animation of the prop cup is made extremely complex due to being controlled from multiple, moving, inter-locking pivot points — the human arm. Animating the cup without referencing — or even knowing the location of — these pivot points would be extremely time-consuming and frustrating.

Figure 12-45 On the other hand, we could simply attach the cup to a human arm, move the arm, and be done for the day. Sounds a *lot* easier, doesn't it?

So you can see, using a human character in the scene actually makes your job easier (by far) than harder (not to mention the fact that someone down the line in the pipe is going to want that character for something, anyway). So, now that *that's* cleared up, let's look at getting the cup into place and locked on to our character.

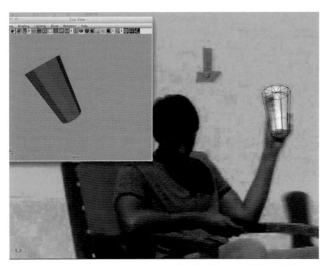

Figure 12-46 Modeling the prop cup. The CG character is in a hidden layer here to make visualizing the prop easier, but I've made sure that the object I'm working on is actually in his hand. I'll check back and forth to confirm that as I work on the prop.

Constraining the Prop Cup

We've all seen a cup like this at any fast food restaurant. I created a quick polygon cylinder, positioned it in my character's hand, then scaled it to line up with the plate. If I didn't have my CG character to work with, I would have had to have gone to much more trouble in modeling this prop — trying to look up measurements online, hoping the actor is actually holding it directly above the chair arm as it seems — but having his hand right there to gauge the cup's size, shape, and position makes everything very simple.

Now that I have my cup, I want to constrain it to the character's hand. This means that I want to attach it in some way, as if the CG character were holding it, just like the actor is holding the practical. Keep in mind he lets go of the cup later in the shot, so I'll need a way to disable the constraint between frames. It looks like he's also rolling it around in his fingers a little, which

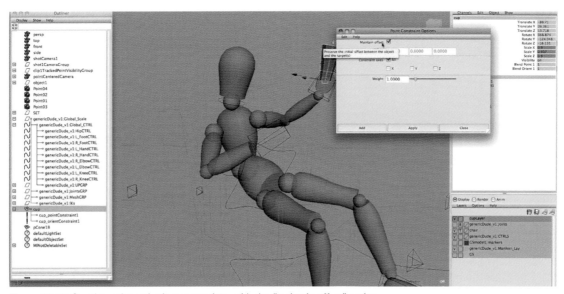

Figure 12-47 Creating point and orient constraints, with the "maintain offset" option.

will change the orientation of the cup itself to the hand, so I'll need to be able to animate the cup independently of the constraint as well. When I choose the way I'm going to constrain the cup to my character's hand, I need to keep all these factors in mind.

Point and Orient Constraints

One way to constrain the cup to the character's hand is to *point and orient–constrain* it to the wrist joint.

Point constraints lock the target object, our cup, to the constraining object: in this case, the hand. You can turn point constraints on and off, so we'll be able to have him let go of the cup when he needs to.

Orient constraints lock the target object's rotations to match the constraining point's rotations. They can also be turned on and off.

Both point and orient constraints actually will snap your target object to the location and orientation of the constraining point; in other words, our cup would normally have snapped to the end of the skeleton joint inside the character's wrist and have been rotated to match the hand's rotation. These constraints can be created in a way that maintains any offset there is between the target and the constraining object; however, that offset isn't animatable. Although your offset is preserved, your actual constraining pivot point is still at the base of the hand. With character rigs, that behavior can be a bit unpredictable (Figures 12-49 and 12-50).

Tip: Not Neutral?

Point and orient constrains are Maya tools, and might not be the same in other animation packages. However, many facilities use Maya to animate, so it's good to know these software-specific tips.

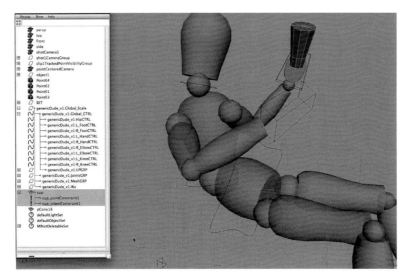

Figure 12-48 The cup is point and orient—constrained.

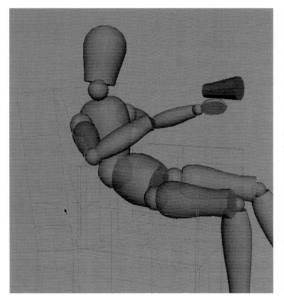

Figure 12-49 The maintain offset feature behaves oddly with character rigs. This isn't the best solution.

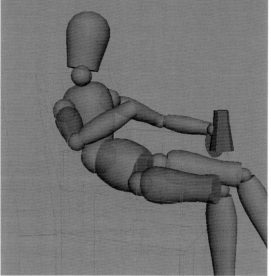

Figure 12-50 Odd offset behavior with point and orient constraints.

Once constrained, the cup can't be animated independently under the hand — if the actor changes the position of the cup in his fingers for example, I won't be able to animate the cup separately to reflect that movement. So point and orient constraints are out for this situation.

Parent Constraints and Parenting Offsets

A better plan is to use *parent constraints*. Parent constraints are similar to point and orient constraints, but they aren't so . . .

Figure 12-51 Create a locator and place it in the character's hand. It will be parent-constrained to the hand and the cup will be parented to the locator.

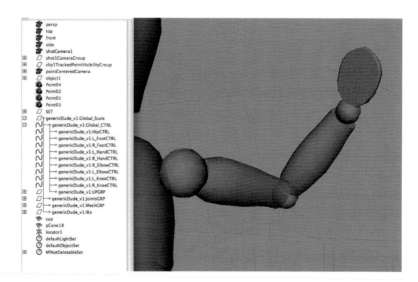

constraining. A parent constraint locks your object to follow a joint or other object, but the nature of any offset relationships are maintained in a parent constraint, and behaves more predictably with character rigs. This constraint can be also turned on and off, so our character can let go of the cup. However, I still can't animate the cup independently from the constraint. What to do?

I have the perfect solution! It's quite simple, actually. Before you parent constrain the cup to your character's hand, create a locator in your scene and position it on the character's palm, as in Figure 12-51.

Next, with your cup positioned in the character's hand the way you want it, simply parent the cup (as opposed to parent constraining) to the locator, and name the locator something like "cupOFFSET." Now, parent-constrain the locator to the

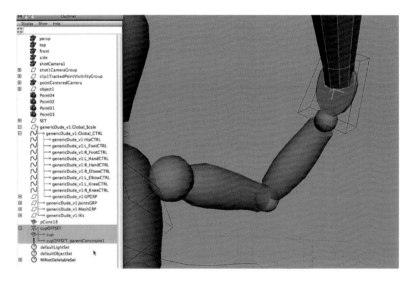

Figure 12-52 With the cup constraints set up this way, it will always follow the hand, yet be animatable independently as well.

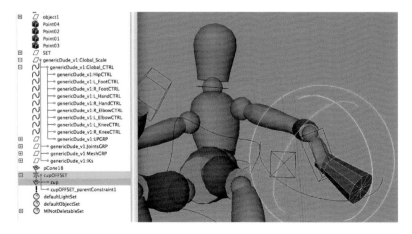

Figure 12-53 The cup is animatable independently of the hand, if need be.

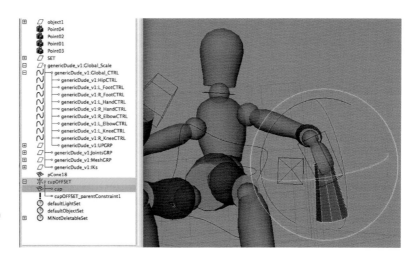

Figure 12-54 Independent rotations of the cup, necessary to match the cup in the actor's fingers.

character's hand (Figure 12-52). In this way, the cup will follow the hand, but you will also be able to animate it independently, if you need to (which I believe we will). Nice!

Animating Constraints On and Off

One of the most important key frames is when our actor lets go of the cup. How do I get that cup out of the character's hand, when it's stuck to it with constraints?

I could just keep animating the cup itself, independently of the arm, as I have been as our actor moves it around in his fingers. However, he is still moving his arm after he lets go of the cup, and if the cup were still constrained to his hand, it would continue to move with the hand, and I would have to do some complicated counter-animation to account for it. In other words, as I animate the cup away from his hand, it would still also

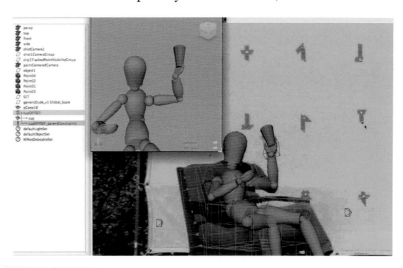

Figure 12-55 Animating the constraint from 1 to 0 over one frame deactivates it and the cup is free to fly across the pool!

follow the motions of his hand, and I'd have to keep moving the cup back to its trajectory to compensate. This kind of counter-animation is not only inconvenient; it makes for jittery animation as well. So getting rid of the constraints at the correct frame is the way to go.

After analyzing the clip, I see that frame 135 is the last frame in which out actor is touching the cup, and in frame 136, he's let it go. This is where we will animate the constraints.

As you can see in Figure 12-56, the parent constraint on the cupOFFSET locator has a channel to turn the constraint itself on and off. To turn it on, you set the value to 1, and to turn it off, set it to 0. At frame 135, I set a key with the value at 1, and at 136 another key with the value at 0. Voilà! Our character has let go of the cup.

Now, if you need to animate his arm further after he lets go of the cup, it won't affect the cup animation at all. Nice!

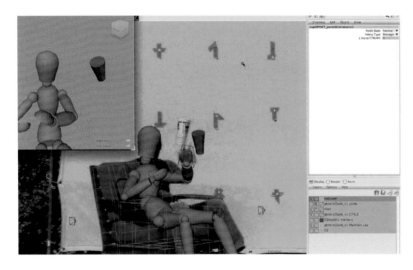

Figure 12-56 The cup is liberated from the parent constraint after frame 136.

Animating the Cup Trajectory

Once our character lets go of the cup, it really tumbles a lot and moves pretty quickly. Keeping track of all the rotations in the animation could be tough; the end-over-end tumble (X and Z rotation relative to the cup) and the spinning (Y rotation, relative to the cup) can get confusing in a fast-moving cylindrical object. There are a couple of methods of attack that we can follow to accurately animate it to match the practical cup:

* I can animate the overall translation of the cup first, knowing that it can't go farther than the width of a residential pool. When I have the translations set, I can then add the rotations to the animation, knowing that the overall position of the cup will be correct as I rotate it.

- I can step ahead frame by frame and animate each rotation as it happens, using the same method I used for my first pass at the beginning of the shot – looking for the major changes in motion, then going back and filling in the in-betweens.

Each of these approaches has its merits, and normally, I would use the second method, because it offers more control over my overall animation. However, because this cup is fairly small in frame, and because it's just generally hard to track cylindrical objects, I'm actually going to employ the first method.

Keeping Track of Cylindrical Spinning

Because I'm concerned about keeping track of that cup spinning and tumbling all over the place, I'm going to employ a quick-and-dirty little trick.

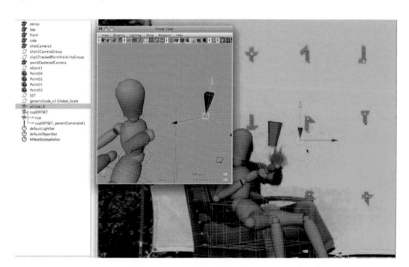

Figure 12-57 Stealing a cone from the (hidden) greenscreen set.

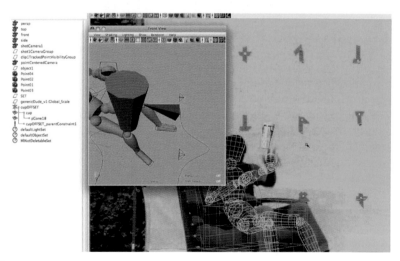

Figure 12-58 Move the cone to the surface of the cup and align it with an easy-to-spot feature on the practical cup.

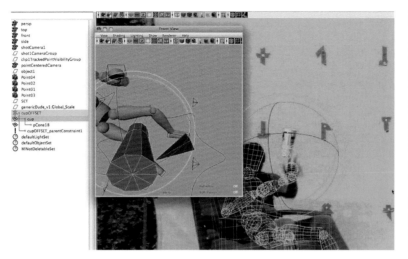

Figure 12-59 With the cone parented to the cup, it's now easy to keep track of the cup's spin through the rest of the shot.

I'm going to copy one of the cones from the greenscreen set (which is in this file, but in a hidden layer) and move it over to the cup. I slide it around on the surface of the cup until it lines up with a good landmark – in this case, the highly visible corner of the black edged graphic (Figure 12-58). Now, I parent the cone to the cup, and ta-da! Whenever I move the cup, the cone comes with it – clearly marking the spinning of the cup as I animate.

Ideal Process vs. Real Life: How It Really Went

Actually, I didn't think to add the cone to the cup until I realized, near the end of the shot, that I had no idea how fast that cup was spinning. So, I came back to this point, added the cup, and started over fresh from here. Sometimes, it's just faster to start over than to try and fix a badly broken animation!

First Pass Over the Pool

The last frame in which the cup is visible is frame 152, so I'll set a key there to get the overall translation across the pool, per the plan.

I am rotating the cup here, but only to make sure I have it in the right place; when the practical cup isn't facing the camera straight on, foreshortening will make it look smaller than it actually is, and I'll end up placing it too far away from the camera. Notice that I'm checking how far I've moved it overall in the perspective window as well (Figures 12-60 and 12-61).

Figure 12-60 The last frame in which the cup is visible. Note how I position the cup off to the side a bit to make it easier to see, then move it into position.

Figure 12-61 Cup in final position.

Once I have the translation for the cup locked in, I delete the rotational keyframes in the curve editor. They won't be correct; I was just randomly rotating the cup to line up with the plate temporarily, in order to get the correct translation — without any attention to its *actual* rotation.

Now, let's look for our next key pose. Going back to the point where our character lets go of the cup, I step forward and find a distinct change in motion at frame 141. Here, the cup changes from rotating more parallel to the ground to tumbling more end over end. This is a great place for a keyframe.

There you go. I actually had to bring the cup forward a tad, but in general, it was in the right place and all I had to do was rotate it. The feature the cone is tracking is on the backside of the cup now. I'll backtrack to the last frame in which it's visible

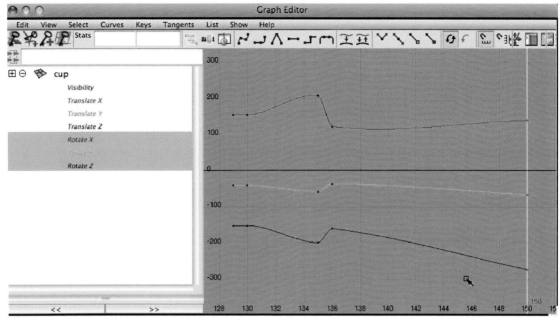

Figure 12-62 Temporary rotation keys.

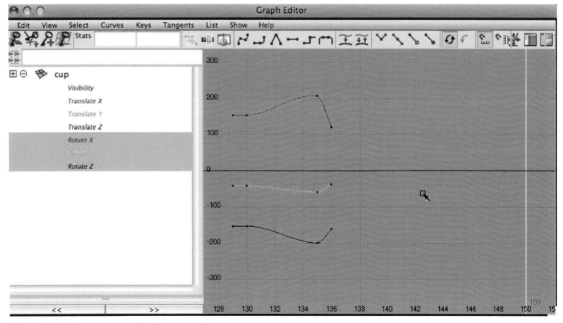

Figure 12-63 Temporary rotation keys gone!

Tip: It's All a Blur

Don't forget which edge of the motion blur to line your cup up with — ask your lead if you're not sure! Here, I'm going for the center.

Figure 12-64 The next keyframe. Here, the cup changes the direction in which it rotates.

Figure 12-65 Checking that the cup is still about a pool length away; my final frame is complete!

and make sure that it lines up there, and then make sure it lines up in the next frame it's visible again.

I continue in this fashion until all the major poses are done. The next step is to version up and refine the in-betweens. A good way to find the best frame to choose when animating in-betweens is to simply choose the frame where the CG cup is farthest from lining up to the practical cup; in other words, the Wrongest Frame! As I have said earlier, that method works really well for me, and it's a lot faster than trying to analyze smaller changes in movement between frames.

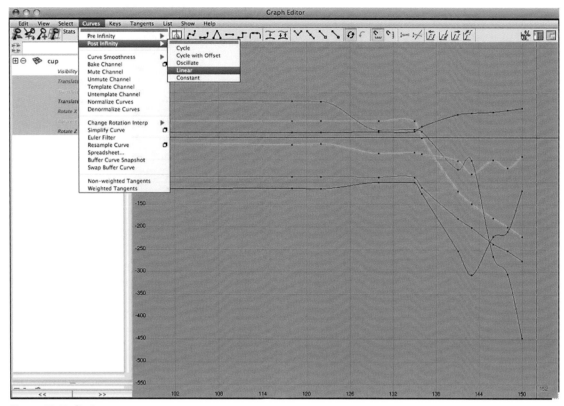

Figure 12-66 Final curves.

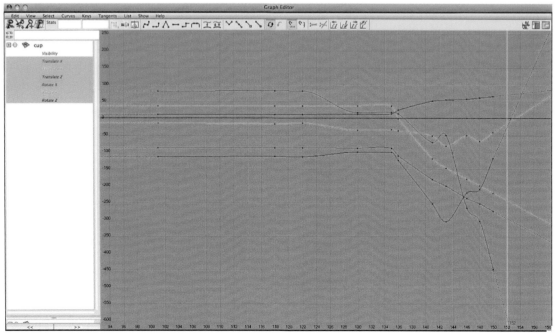

Figure 12-67 Curves with pre- and post-infinity behavior set to linear. This will keep the cup moving on its established path forever, guaranteeing that motion blur and other dynamic effects will be properly calculated.

As always, keep making sure everything makes sense in the graph editor and the perspective view!

Finishing Up

Because the cup obviously keeps moving after it leaves the frame, I'll need to keep it going in a reasonable trajectory so that the dynamic simulations and motion blur will calculate and render properly. The most efficient way to do this, and the way it's most requested by other departments, is to set the animation curve's *pre- and post-infinity behaviors* to *linear* (Figure 12-67).

As you can see in Figure 12-67, the software automatically continues the animation in the direction it was going into infinity. If your software doesn't have this feature, an easy and quick alternative is to simply do the same thing yourself: go 10 frames or so beyond the last frame of the clip, set frames for all the channels you need, and move them by hand to continue just as they would in this example. Do the same for the 10 frames before the beginning of the clip, and you're done.

And there you have it – your first rotomation! Congratulations!

INDEX

A

Academy Award for Visual
 Effects, 17
acting out poses, 199–200
analytical matchmoving, 14
anatomy, knowledge of, 187,
 198–199
Andy (rig), 206–212, 206f, 218
 Arms control, 231–236, 232f
 Body control, 213–215
 COG control, 216–218, 217f
 parenting arms to, 236
 parenting head to, 227, 228f
 parenting legs to, 241
 Elbows control, 236–239
 Fingers control, 247–257
 thumb controls, 249
 Foot control, 239
 Head control, 226–229
 Hip control, 218–219, 219f
 Knees control, 246–247
 Legs control, 239
 Master control, 213–215
 parenting legs to, 241f
 Neck control, 224–226
 Shoulders control, 230–231,
 230f, 231f
 Spine control, 219–223, 221f,
 276, 276f, 280, 280f
 natural manipulation, 222
animation. *see also entries at*
 matchmove; rotomation
 character animation, 35
 constraints on, 292–293
 effects animation, 35
aperture, defined, 71
aperture plate, 40
 defined, 11
arm movement (rotomation),
 207–208
 rig controls (arms), 231–236,
 232f
 rig controls (elbows),
 236–239

rig controls (fingers),
 247–257
 thumb controls, 249
 rig controls (shoulders),
 230–231, 230f, 231f
 rig flexibility, 206
Arms control (Andy rig),
 231–236, 232f
articulated, defined, 37
aspect ratios, 40–41
 changing, lens and, 71–72
 defined, 39, 40f, 71
attacking the shot, 4–5. *See also*
 getting started
autokey, 275
automated matchmoves. *see*
 surveyless matchmoves
automated tracking, 285–287

B

Bakeoff, 17
ball rolls (feet), 245f, 246
barrel distortion, 23f
blue channel, noise in, 39
blur, motion. *see* motion blur
blur, to suppress gain, 39,
 87–88, 87f
body changes, rotomation for,
 189
Body control (Andy), 215–216
breaking CG characters,
 198–199
breaking down clip for
 rotomation, 263–264
building assets, 3–4
building height, calculating, 53
butterfly shutter (rotating
 shutter), 25f

C

camera(s)
 creating, 38–41
 camera tilt example, 133
 focus pull example, 120

lockoff shot example, 107
 from researched data,
 58–60
 height of
 calculating from mined
 data, 61, 66
 incorrectly recorded, 80–82
 lining up shot, 61–67
 locking for rotomation, 192,
 193
 notes on, 27. *See also* note
 taking
 research on, 59
camera (film), about, 16.
 See also lenses
 collecting camera notes, 27
 shutter angle and motion
 blur, 25–26
Camera Manipulators (Maya),
 63
camera moves, 79–92. *See also*
 camera pans; camera tilts;
 camera tracking; focus
 pulls; lockoff shots;
 steadicam and handheld
 shots
 crane shots, 10, 88–89
 dolly and tracking shots, 88
 evaluating (focus pull
 example), 127–130
 where to start, 91–92
 with zooms, 91
camera pans, 82–88, 83f
 whip pans, 87–88, 87f
camera solution, defined, 8
camera tilts, 82, 82f, 131–157
 adding guestimate geometry,
 151–156
 evaluating camera move,
 156–157
 getting started, 131–132
 handoff, 147–151
 finding handoff areas,
 133–139

camera tilts (*Continued*)
 nodal rotation, 83–85, 84f, 86
 for non-nodal movement,
 142
 reviewing information, 132
 setting up shot, 133
 survey constraints, 140–142
 3D solve, 142–147
 2D tracking, 133–139
camera tracking. *see* 2D
 tracking
camera view, defined, 7
case studies. *see* example
 subheads under
 matchmoving process
CCD chips in digital cameras,
 59, 59f, 69f
 actual measurements, 77–78
 squeezed plates, using. *see*
 squeezed plates
 zoom factor, 72
center of gravity, CG character,
 194, 198, 216–218, 217f
 adjusting rotation (example),
 275–276, 276f
 exceptions to using, 194
 parenting arms to, 236
 parenting head to, 227, 228f
 parenting legs to, 241
 weight distribution and,
 211–213
 when not visible, 198
CG characters. *see entries at*
 character
CG environment, defined, 3
channel box values, scrubbing,
 63
channel swapping, 103–105
channels, keying for
 rotomation, 200–202.
 See also rotomation
 Andy's channels, list of, 214
 Arms control, 231–236, 232f
 Body control, 215–216
 COG control, 216–218, 217f
 Elbows control, 236–239
 Fingers control, 247–257
 thumb controls, 249
 Foot control, 239
 Head control, 226–229
 Hip control, 218–219, 219f

Knees control, 246–247
Legs control, 239
Master control, 213–215
Neck control, 224–226
Shoulders control, 230–231,
 230f, 231f
Spine control, 219–223, 221f,
 276, 276f, 280, 280f
 natural manipulation, 222,
 224f
char, defined, 190
character(s), computer-
 generated
 acting out poses for, 199–200
 anatomy of, knowing, 187,
 198–199
 animating, in graphics
 pipeline, 35
 getting to know, 205–206
 introducing for sanity checks,
 114f, 116
 not having a rig, 191–192
 reasons for rotomation,
 189–190
 scale, accuracy of, 192, 261
 terminology for, 189, 190
 unvetted, using, 262
 where rigs come from,
 190–191
character matchmoves. *see*
 rotomation
character models, defined, 4
checkerboard, for evaluating
 camera moves, 129–130,
 129f
chips in digital cameras, 59, 59f,
 69f
 actual measurements, 77–78
 squeezed plates, using. *see*
 squeezed plates
 zoom factor, 72
circle take, defined, 31
Clavicle control. *see* Shoulders
 control
cloth simulation, 35
clothing changes, rotomation
 for, 189
COG. *see* center of gravity, CG
 character
COG control (Andy rig),
 216–218, 217f

collecting data for matchmoves,
 2–3, 9–10, 33–36
 how to, on set, 26–32
 greenscreen markers, 28
 note taking, 29–30
 survey data and LIDAR,
 29–30
 matchmoving without,
 10–11, 10f, 11f, 41
color grading, 34
color-corrected plates
 creating, 38f, 39, 40f, 96
 camera tilt example, 133
 handheld shot example,
 164
 lockoff shot example, 96
 defined, 39
 overwriting plates with
 (stomping), 37
color-correction filters, 97–103
communication, 33
 show culture, 42
compositors, role of, 36
compound camera moves, 91
computer services, 34
constraining props, 288–292
 animating constraints,
 292–293
 parent constraints and
 offsets, 290–292
 point and orient constraints,
 289–290
constraints, animation,
 292–293
contrast, 2D tracking and, 96
crane, defined, 26
crane shots, 10, 88–89
Create Camera Menu (Maya),
 59f
culture of filmmaking, about, 42
cup. *see* props, constraining
Cup control, 256f, 257

D
dailies, defined, 41
daily status reports, 192
data gathering, for
 matchmoves, 2–3, 9–10,
 33–36
 how to, on set, 26–32
 greenscreen markers, 28

note taking, 29–30
 survey data and LIDAR,
 29–30
 matchmoving without,
 10–11, 10f, 11f, 41
depth of field, 20–21, 21f
 focal length and, 20
detail, deciding on level of, 37,
 106
digital cameras, research on, 59
digital models, defined, 3
director of photography (DP),
 20
distortion (lens), 18, 22–24, 23f
dolly, defined, 26
dolly shots, 88
Doublestein, John, 206
drift in X translation, 180–182,
 180f
Dutch angle. *see* Z rotation
 (roll)
Dykstra, John, 15

E
effects animation, in graphics
 pipeline, 35
Elbows control (Andy rig),
 236–239
email messages, reading, 66
evaluating camera moves
 camera tilt example, 156–157
 focus pull example, 127–130
 rotomation, 202
examples of matchmoving. *see*
 example *subheads under*
 matchmoving process

F
face changes, rotomation for,
 189
feet, walking and, 263
feet controls (rigs), 240, 241f,
 242–246
field of view (FOV)
 calculating from mined data,
 61f
 camera tilt example, 132, 132f
 defined, 89
file naming conventions, 52
film back (aperture plate), 40
 defined, 11

film camera, about, 16. *See also*
 lenses
 collecting camera notes, 27
 shutter angle and motion
 blur, 25–26
film gate, 59, 60f
film gate, defined, 71
film plane, defined, 8
film stock, defined, 24
film weave, 80–82
 defined, 82
filmbacks, 69, 69f, 70, 70f
 changing, lens and, 71–72
 squeezed plates, using. *see*
 squeezed plates
filmmaking, 15–43
 communication, 33
 film camera, about, 16.
 See also lenses
 gathering information on set,
 26–32
 greenscreen markers, 28
 note taking, 29–30
 survey data and LIDAR,
 29–30
 information integration,
 33–36
 lens and focus. *see* focal
 length; focus; lenses
 setting up scene, 37–42.
 See also cameras, creating
 importing models, 38–39
 prepping plates, 39
 publishing, 41–42
 reading notes and
 reviewing shot, 37–38
 show culture, 42
 show culture, 42
 shutter angle and motion
 blur, 25–26
filters, color-correcting, 97–103
final, approved camera,
 defined, 12
finger controls (rigs), 233f
Finger Spread control,
 249, 255f
Finger Squeeze control, 249,
 256f
Fingers control (Andy rig),
 247–257
 thumb controls, 249

first foot plant (walking), 264
first frame lineup
 camera tilt example, 133
 character and object
 rotomation example, 264
 focus pull example, 120
 lockoff shot example,
 107–109
first pass through (walking),
 265–266
fisheye lenses, 17, 19f
 depth of field, 20
 distortion from, 23f
fit, defined, 8
FK. *see* forward kinematics
FK/IK Snap feature, 213
flats, defined, 80
flattening the plate, 22, 23
flexibility, rig, 206
flexible, being, 218
fly in (fly out), 79
 defined, 80
focal length, 16–19, 19f, 72
 calculating from mined data,
 63, 63f
 defined, 7
 depth of field and, 20
 incorrectly recorded, 80–82
 rack focus. *see* focus pulls
focus
 depth of field, 20–21, 21f
 focal length and, 20
 motion blur. *see* motion blur
 rack focus. *see* focus pulls
focus pulls, 21–22, 22f, 90–92,
 117–130
 color-correcting plates, 119
 evaluating camera move,
 127–130
 solid, 128
 wireframe, 128
 getting started, 117–118
 model and camera creation,
 120
 recognizing, 90–91
 reviewing information, 119
 sanity checks, 127
 survey constraints, 122–123
 3D solve, 123–126
 2D tracking, 121–122
 workflow for solving, 145

follow focus. *see* focus pulls
Foot control (Andy rig), 239,
 242–246
foot plants (walking), 264, 266
foot rolls, 245f, 246
forward kinematics (FK),
 215–216, 219–223
 arm movement, 207–208
 COG and weight distribution,
 211–213
 leg movement, 209–211
 spine controls, 220, 221f
FOV. *see* field of view (FOV)
frame rate, defined, 24
FX animations, 192

G
gamma level, 99f, 100
ganging, 222
gathering data for matchmoves,
 2–3, 9–10, 33–36
 how to, on set, 26–32
 greenscreen markers, 28
 note taking, 29–30
 survey data and LIDAR,
 29–30
 insufficient data. *see* missing
 information, handling
 matchmoving without,
 10–11, 10f, 11f, 41
gathering data *with*
 matchmoves. *see*
 preliminary matchmoves
Gaussian Blur filter, 101, 102f
getting started
 camera tilt example, 131–132
 character and object
 rotomation example,
 260–261
 character matchmoves
 (rotomation), 190–192
 focus pull example, 117–118
 handheld shot example, 160
 lockoff shot example, 93–94
Google Earth, 50–51, 53, 57
Google Maps, 48–50
Google SketchUp, 53, 53f, 57
grain, suppressing with
 blur, 39
graphics pipeline, explained,
 33

greenscreen markers, 28
guestimate geometry, 135,
 150–156

H
hair simulation, 35
hand tracking, 121
handheld shots, 89, 159–185
 getting started, 160
 one-point solve, 183–185
 reviewing information,
 162–163
 setting up shot, 163–164
 color-correcting plates, 164
 picking good features, 160
 3D solve, 168–172
 refining translations,
 176–182
 refining X and Y rotation,
 174–175
 refining Z rotation,
 172–180
 2D tracking, 164–167
handoff
 camera tilt example, 147–151
 finding handoff areas,
 133–139
 length of handoff track, 136
hands control. *see* Fingers
 control
Head control (Andy rig),
 226–229
height, calculating, 53
height of camera
 calculating from mined data,
 61, 66
 incorrectly recorded, 80–82
highlights, for 2D tracking, 162
Hip control (Andy rig),
 218–219, 219f
hips (character), 194, 198
 exceptions to using, 194
 sitting and, 271–274
 walking and, 263
 when not visible, 198
HSB filter, 100, 100f

I
IK. *see* inverse kinematics
image plane, 4, 4f
 defined, 7

importing models, 38–39
incorrect keyframes. *see* pops
insufficient data. *see* missing
 information, handling
integrating collected data,
 33–36
intuitive matchmoving, 14
inverse kinematics (IK),
 215–216
 arm movement, 207–208
 arms and elbows, 237
 COG and weight distribution,
 211–213
 knee controls, 246–247
 leg movement, 209–211, 239
 spine controls, 220, 221f

J
jitter, 82
 deciding to stabilize shot, 118
 defined, 82
 steadicam and handheld
 shots, 89
 workflow for eliminating, 145

K
keyframes
 autokey, 275
 for character matchmoves,
 194–198, 202–203
 incorrect. *see* pops
 selecting, 194–198, 202–203
Knees control (Andy rig), 239

L
last frame lineup, 133
lead, defined, 1
leg movement (rotomation),
 209–211
 rig controls (feet), 239,
 242–246
 rig controls (knees), 246–247
 rig controls (legs), 239
 walking and, 263
Legs control (Andy rig), 239
Leica survey head, 30, 30f
lenses, 16
 changing filmback and,
 71–72
 depth of field, 20–21, 21f
 focal length and, 20

distortion from, 18, 22–24, 23f
field of view (FOV)
 calculating from mined data, 61f
 camera tilt example, 132, 132f
 defined, 89
 focal length. *see* focal length
 incorrectly recorded, 80–82
level of detail (LOD), 37
Levels filter (for color correction), 98, 98f
LIDAR (light detection and ranging)
 collecting data, 29–30
 defined, 2
 modeling from data, 36–37
lighters, role in graphics pipeline, 36
lighting department, defined, 31
lighting diagrams, 31
lighting interactions, rotomation for, 189
lining up shot from mined data, 61–67
LINUX file naming, 52
"living in the world", 46
location, incorrectly recorded, 80–82
locators. *see* 3D locators
locked channels, defined, 86
locking camera for rotomation, 192, 193
lockoff shots, 5, 79–82, 93–116
 defined, 8
 getting started, 93–94
 lockoff shot example, 111–113
 reviewing information, 94–95
 sanity check, 113–116
 setting up shot, 96–105
 color-correcting plates, 96
 creating camera, 107
 first frame lineup, 107–109
 modeling set, 106–107
 survey constraints, 110–111
 3D solve, 111–113
 2D tracking, 109–110
LOD (level of detail), 37
logical matchmoving, 14

long lenses, defined, 17
look development (look dev)
 defined, 1
 in graphics pipeline, 35

M
Major Change in Direction (Wrongest Frame), 284f
Major Change in Speed (Wrongest Frame), 285f
manipulators (user interface), 63
markers, for greenscreen, 28
masking movement for 2D tracking, 165–166, 166f
Master control (Andy rig), 213–215
 parenting legs to, 241f
matchmoves, types of, 8–14
 camera tracking, 8–11
 character matchmoves. *see* rotomation
 object matchmoves, 12–13
 preliminary matchmoves, 13–14
 surveyed, 5–6
 surveyless, 10–11, 10f, 11f, 41
matchmoving personalities, 14
matchmoving process, 1–8.
 See also getting started
 getting started
 camera tilt example, 131–132
 character and object rotomation example, 260–261
 character matchmoves (rotomation), 190–192
 focus pull example, 117–118
 handheld shot example, 160
 lockoff shot example, 93–94
 in graphics pipeline, 35
 steps of
 planning, 1
 gathering data, 2–3
 building assets, 3–4
 attacking the shot, 4–5
matchmoving process examples

camera tilt, 131–157
 adding guestimate geometry, 151–156
 evaluating camera move, 156–157
 getting started, 131–132
 handoff, 133–139, 147–151
 reviewing information, 132
 setting up shot, 133
 survey constraints, 140–142
 3D solve, 142–147
 2D tracking, 133–139
character and object rotomation (character part), 259, 261–263
 breaking down clip, 263–264
 first frame lineup, 264
 first-pass rotomation (sitting), 281–283
 first-pass rotomation (turning), 277–281
 first-pass rotomation (walking), 263–264, 274–281
 foot plants and pass through, 264–267
 getting started, 260–261
 keyframe selection, 271–274
 second-pass rotomation, 284–285
 setting up shot, 261–263
 sit, 269–271
 turn, 267–269
character and object rotomation (object part), 259, 261–263
 animating constraints, 292–293
 constraining the prop, 288–292
 continuing animation off-frame, 300
 cylindrical spinning, 294–295
 first-pass rotomation, 295–300
 getting started, 260–261

matchmoving process examples
(*Continued*)
 hand- or software-based
 tracking, 285–287
 trajectory animation,
 293–294
focus pull, 117–130
 color-correcting plates, 119
 evaluating camera move,
 127–130
 getting started, 117–118
 model and camera
 creation, 120
 reviewing information, 119
 sanity checks, 127
 survey constraints,
 122–123
 3D solve, 123–126
 2D tracking, 121–122
handheld shot, 159–185
 getting started, 160
 reviewing information,
 162–163
 setting up shot, 163–164
 3D solve, 168–172
 2D tracking, 164–167
lockoff shot, 93–116
 getting started, 93–94
 lockoff shot example,
 111–113
 reviewing information,
 94–95
 sanity check, 113–116
 setting up shot, 96–109
 survey constraints,
 110–111
 3D solve, 111–113
 2D tracking, 109–110
mathematical matchmoving, 14
measuring for matchmoves,
 2–3. *See also* gathering
 data for macthmoves
 prop measurements, 31, 32f
MEL scripts, defined, 38
Miniature Land, 192
mining data. *see* missing
 information, handling
missing information, handling,
 45–68
 building set from found data,
 52–57

creating camera, 58–60
lining up shot, 61–67
searching the Web, 47–48
using Google Earth, 50–51
using Google Maps, 48–50
where to start, 46–47
MOCO. *see* motion control data
modeling department, 36–37
 defined, 3–4
 in graphics pipeline, 35
modeling sets
 camera tilt example, 133
 focus pull example, 120
 lockoff shot example,
 106–107
models, 36–37
 importing, 38–39
motion blur, 25–26
 defined, 24
 steadicam and handheld
 shots, 89
 2D tracking features and,
 166–167, 167f
 whip pans, 87–88, 87f
motion control data
 collecting with matchmoves.
 see preliminary
 matchmoves
 defined, 12
motion picture camera, about,
 16. *See also* lenses
 collecting camera notes, 27
 shutter angle and motion
 blur, 25–26
motionless shots. *see* lockoff
 shots
movement, masking for 2D
 tracking, 165–166, 166f
moves, camera. *see* camera
 moves; camera tracking
movie screen, virtual camera.
 see image plane
moviemaking. *see* filmmaking
moving objects, for 2D tracking,
 162

N
naming conventions, 52
 flexibility with, 218
 2D tracks, 112
neck, parenting head to, 227, 228f

Neck control (Andy rig),
 224–226
Neck IK control. *see* Head
 control
need, interpreting. *see* getting
 started
next setup, defined, 27
nodal mount, defined, 83
nodal point, defined, 85
nodal rotation, 83–86, 84f
 for non-nodal movement, 142
noise, defined, 39
note taking, 31–32. *See also*
 gathering data for
 matchmoves
 communicating notes, 33
 incorrectly recorded data,
 80–82
 reading notes, 37–38
 reporting on rig needs, 192

O
object matchmoves, 12–13
 character and object
 rotomation example, 259,
 261–263
 animating constraints,
 292–293
 constraining the prop,
 288–292
 continuing animation off-
 frame, 300
 cylindrical spinning,
 294–295
 first-pass rotomation,
 295–300
 getting started, 260–261
 hand- or software-based
 tracking, 285–287
 trajectory animation,
 293–294
 spinning, 294–295
 trajectory animation,
 293–294
objects, movable, 79
offset, parenting, 290–292
one-off, defined, 93
one-point solve, 183–185
orient constraints (object),
 289–290
Oscar for Visual Effects, 17

P

padded versioning, 53
paint clouds, 11
painters, role of, 36
panels, tearing off, 62f
pans (camera shots), 82–88, 83f
 nodal rotation. *see* nodal
 rotation
 whip pans, 87–88, 87f
parallax
 defined, 83
 pan and tilt shots, 83
parenting (rotomation)
 arms, 234–236
 head, 227
 legs, 241, 241f
 prop constraints, 290–292
pass through (walking),
 265–267
personality, matchmoving, 14
Peterson, Eric, 27, 30, 30f
photographic lenses. *see* lenses
photographing for matchmoves,
 2–3
pickup shots, defined, 33
pincushion distortion, 23f
pitch. *see* X rotation
pivot control, foot, 242–246
planning matchmoves, 1
 2D track attack, 88
plates, 4
 color-corrected. *see* color-
 corrected plates
 defined, 7
 flattening (removing
 distortion), 22, 23
 marking important details on.
 see 2D tracking
 name for, about, 25
 overwriting (stomping), 37
 prepping, 39
 squeezed, 70f, 73
 working with, 73–78
 stabilizing, deciding to, 118
 unknown. *see* missing
 information, handling
plug-ins, defined, 38
point cloud, 170f
point constraints (object),
 289–290
popping, defined, 36

pops (incorrect keyframes),
 174–176, 174f, 175f, 176f
 removing cause of, 176
practicals, defined, 4
preliminary matchmoves,
 13–14
prepping plates, 39
primary photography, defined,
 32
prime lens, defined, 91
problem solving, in general, 67
production staff, defined, 5
profiles, for 2D tracking, 162
props
 constraining, 288–292
 animating constraints,
 292–293
 parent constraints and
 offsets, 290–292
 point and orient
 constraints, 289–290
 defined, 4
 movability of, 79
 taking notes on, 31, 32f
publishing, 41–42
 defined, 41–42
pulldown claw, 24

R

rack focus. *see* focus pulls
reading email messages, 66
real-life examples. *see* example
 subheads under
 matchmoving process
reflections
 defined, 41
 rotomation for, 189
refractions, defined, 41
replicating real-life set. *see*
 virtual sets
reporting on rig needs, 192
research on plate data. *see*
 missing information,
 handling
reviewing shot and sequence,
 38
rigging department
 defined, 3
 in graphics pipeline, 35
rigs. *see* character(s), computer-
 generated

roll (Dutch angle). *see* Z
 rotation
roll control (feet), 246
rotating shutter (butterfly
 shutter), 25f
rotation
 camera pans, 82–88, 83f
 nodal rotation. *see* nodal
 rotation
 whip pans, 87–88, 87f
 COG (character), 276f,
 277–278, 278f
 with crane shots, 88–89
 with dolly and tracking shots,
 88
 incorrect keyframes in. *see*
 pops
 nodal rotation, 83–86, 84f
 for non-nodal movement,
 142
 with pan and tilt shots,
 86–87
 with steadicam and handheld
 shots, 89
 thumbs (rotomation), 251f
 tilts (camera shots). *see*
 camera tilts
 trajectory animation,
 293–294
 X rotation (pitch), 81, 81f
 with handheld shots,
 174–175
 with pan and tilt shots,
 86–87
 solving for, 145
 trajectory animation,
 293–294
 Y rotation (yaw), 81, 81f
 with handheld shots,
 174–175
 with pan and tilt shots,
 86–87
 solving for, 145
 trajectory animation,
 293–294
 Z rotation (roll), 81, 81f, 89f
 with handheld shots, 89,
 172–180
 with pan and tilt shots,
 86–87
 solving for, 144

rotation (*Continued*)
 trajectory animation,
 293–294
roto, defined, 191
rotomation (character
 matchmoves), 13, 187–204,
 215
 becoming good at, 188
 character and object example
 (character part), 259,
 261–263
 breaking down clip,
 263–264
 first frame lineup, 264
 first-pass rotomation
 (sitting), 281–283
 first-pass rotomation
 (turning), 277–281
 first-pass rotomation
 (walking), 263–264,
 274–281
 foot plants and pass
 through, 264–267
 getting started, 260–261
 keyframe selection,
 271–274
 second-pass rotomation,
 284–285
 setting up shot, 261–263
 sit, 269–271
 turn, 267–269
 character and object example
 (object part), 259, 261–263
 animating constraints,
 292–293
 constraining the prop,
 288–292
 continuing animation off-
 frame, 300
 cylindrical spinning,
 294–295
 first-pass rotomation,
 295–300
 getting started, 260–261
 hand- or software-based
 tracking, 285–287
 trajectory animation,
 293–294
 first pass (large to small),
 193–198
 acting it out, 199–200

 analyzing clip, 194
 evaluating matchmoves,
 202
 how to watch shot,
 194–198
 keying channels, 200–202
 not breaking character,
 198–199
 not doing anything crazy,
 199
 selecting keyframes,
 194–198, 202–203
 Set-Delete-Set technique,
 203–204
 getting started, 190–192
 getting to know rigs, 205–206
 inverse vs. forward
 kinematics, 215
 arm movement, 207–208
 COG and weight
 distribution, 211–213
 leg movement, 209–211
 reasons for, 189–190
 using Andy rig, 206–212,
 206f, 216–218
 Arms control, 231–236,
 232f
 Body control, 213–215
 COG control, 216–218, 217f
 Elbows control, 236–239
 Fingers control, 247–257
 Foot control, 239
 Head control, 226–229
 Hip control, 218–219, 219f
 Knees control, 246–247
 Legs control, 239
 Master control, 213–215
 Neck control, 224–226
 Shoulders control,
 230–231, 230f, 231f
 Spine control, 219–223,
 221f, 224f, 276, 280
Ruler function (Google Maps), 51

S
salient details, deciding on, 37,
 106
sanity checks, 56
 focus pull example, 127
 lockoff shot example,
 113–116

 not using computers for, 114
Satellite view (Google Maps),
 48, 48f
saturation, 100, 100f, 101f
saving multiple versions, 53,
 141
scale, CG characters, 192, 261
scanning department, 34
scene, setting up, 37–42
 creating cameras, 38–41
 camera tilt example, 133
 focus pull example, 120
 lockoff shot example, 107
 from researched data,
 58–60
 importing models, 38–39
 prepping plates, 39
 publishing, 41–42
 reading notes and reviewing
 shot, 37–38
 show culture, 42
scene structure, 38–39
 defined, 38
screen left/right, defined, 119
searching Web for plate data,
 47–48
 Google Earth, 50–51
 Google Maps, 48–50
second foot plant (walking), 266
second pass through (walking),
 267
secondary photography (Second
 Unit), 28, 32
sensor sizes, 69, 69f
 actual measurements, 77–78
 CCD chips in digital cameras,
 59, 59f
sequence (of shots), 25
 reviewing, importance of, 38
Set-Delete-Set technique,
 203–204, 281
sets
 modeling
 camera tilt example, 133
 focus pull example, 120
 lockoff shot example,
 106–107
 movability of, 79
 replicating. *see* virtual sets
setting up shot (example).
 see also cameras, creating

camera tilt, 133
character and object rotomation, 261–263
focus pull, 119
handheld shot, 164
lockoff shot, 96–109
setup, defined, 27
shader writers, role of, 36
shadow casting, defined, 40
shadowing, rotomation for, 189
shoot, defined, 33
short lenses, defined, 17
shot sequence, 25
reviewing, importance of, 38
shots
attacking. *see* attacking the shot
lining up, 61–67
moving. *see* camera moves
setting up (examples)
camera tilt, 133
character and object rotomation, 261–263
focus pull, 119
handheld shot, 164
lockoff shot, 96–109
stabilizing, deciding to, 118
"should work," problems with, 67
shoulders, parenting arms to, 235–236
Shoulders control (Andy rig), 230–231, 230f, 231f
show, defined, 1
show culture, 42
Shrug control. *see* Shoulders control
shutter angle, 25
defined, 25
single-channel plates, color-correcting, 97
sitting (character), rotomation of, 269–271, 281–283
skeletons, defined, 4
sketching, 2–3, 3f
SketchUp, 53, 53f, 57
slide, defined, 23
smoothing Z rotation, 173f
software
in graphics pipeline, 34
how it works, 5–8

which to select, 6
solid objects, as not solid, 79
solids, for evaluating camera moves, 128, 129f
special effects, visual effects vs., 5
Spine control (Andy rig), 219–223, 221f
example, 276, 280, 276f, 280f
natural manipulation, 222, 224f
Spine Root, Andy, 216–218, 217f
spinning (object), animating, 294–295
squeezed plates, 70f, 73
working with, 73–78
stabilizing the shot, deciding to, 118
status reports, 192
steadicam and handheld shots, 89, 159–185
getting started, 160
one-point solve, 183–185
reviewing information, 162–163
setting up shot, 163–164
color-correcting plates, 164
3D solve, 168–172
refining translations, 176–182
refining X and Y rotation, 174–175
refining Z rotation, 172–180
2D tracking, 164–167
sticks, defined, 26
stomping, 37
Street View feature (Google Maps), 48, 49f
stretch control (arms), 234, 234f
sup (supervisor), 28
contacting, 68
defined, 1
survey, defined, 11
survey constraints
camera tilt example, 140–142
defined, 110
focus pull example, 122–123
lockoff shot example, 110–111

survey data
collecting, 29–30
modeling from, 36–37
survey heads, 29, 30f
defined, 2
surveyed matchmoves, 5–6
surveyless matchmoves, 10–11, 10f, 11f, 41
Swap Channel filter, 103, 104f
swapping channels, 103–105
Sweatbox, 41

T
take, defined, 31
tearing off panels, 62f
telephoto lenses, 17, 19f
defined, 91
depth of field, 20
distortion from, 23f
testing camera moves
camera tilt example, 156–157
focus pull example, 127–130
texture painting, 36
35 mm camera, about, 16. *See also* lenses
collecting camera notes, 27
shutter angle and motion blur, 25–26
3D body scan, defined, 2
3D locations, defined, 9
3D locators, 6f, 7–8, 7f
computer-defined (surveyless matchmoves), 10–11, 10f, 11f, 41
greenscreen markers, 28
guestimate geometry, 135, 150–156
tracking to, 6–8. *See also* 2D tracking
3D solve
camera tilt example, 142–147
checking. *see* sanity checks
focus pull example, 123–126
handheld shot example, 168–172
one-point solve, 183–185
refining translations, 176–182

3D solve (*Continued*)
 refining X and Y rotation, 174–175
 refining Z rotation, 172–180
 lockoff shot example, 111–113
thumb controls, 249
Thumb Reach control, 252f
Thumb Spread control, 253f
Thumb Twist control, 254f
tilts (camera shots), 82, 82f, 131–157
 adding guestimate geometry, 151–156
 evaluating camera move, 156–157
 getting started, 131–132
 handoff, 147–151
 finding handoff areas, 133–139
 nodal rotation. *see* nodal rotation
 reviewing information, 132
 setting up shot, 133
 survey constraints, 140–142
 3D solve, 142–147
 2D tracking, 133–139
toe rolls (feet), 246, 246f
track point handoff, defined, 87
tracking. *see* 2D tracking
tracking shots, 88
 handoff track. *see* handoff
trajectory animation, 293–294
translation
 with crane shots, 88–89
 with dolly and tracking shots, 88
 incorrect keyframes in. *see* pops
 refining (handheld shot example), 176–180
 bump in Z translation, 182
 drift in X translation, 180–182
 trajectory animation, 293–294
triangulation, 7–8
 defined, 9
truck shots, 88

turning (character), rotomation of, 267–269, 277–281
2D tracking, 6–11, 6f, 7f.
 See also camera moves; 3D solve
 channel selection for, 97
 computer-defined. *see* surveyless matchmoves
 defined, 9
 examples of
 camera tilt, 133–139
 focus pull, 121–122
 handheld shot, 164–167
 lockoff shot, 109–110
 hand tracking, 121
 naming tracks, 112
 picking good features for, 160
 planning, 88
 planning 2D attack, 88
 survey constraints. *see* survey constraints
 using fewest tracks possible, 140
 when not needed, 138
 where to start, 91–92

U
UNIX file naming, 52
unknown plates. *see* missing information, handling

V
versioning, 141
versioning numbers, 53
VFX pipeline, defined, 12
video chips. *see* CCD chips in digital cameras
virtual camera
 defined, 6
 movie screen of. *see* image plane
virtual sets, 3f
 building from found data, 52–57
visual effects
 Academy Award for, 17
 pipeline for, explained, 33
 special effects vs., 5
visual effects supervisor, 28

W
walking (character), rotomation of, 263–264, 274–281
Web, obtaining plate data from, 47–48
 Google Earth, 50–51
 Google Maps, 48–50
weight distribution, CG character, 211–213
"weird". *see* sanity checks
whip pans, 87–88, 87f
wide-angle lenses, 17, 19f
 depth of field, 20
 distortion from, 23f
wireframe, defined, 128
workflow, 134f, 135, 144
 with handheld shots, 164
World control. *see* Master control (Andy rig)
World panel (Andy), 213–215
wrap, defined, 33
Wrongest Frame, 284, 284f, 285f

X
X rotation (pitch), 81, 81f
 with handheld shots, 174–175
 with pan and tilt shots, 86–87
 solving for, 145
 trajectory animation, 293–294
X translation, 80f, 81
 crane shots, 88–89
 dolly and tracking shots, 88
 handheld shots, 176–182

Y
Y rotation (yaw), 81, 81f
 with handheld shots, 174–175
 with pan and tilt shots, 86–87
 solving for, 145
 trajectory animation, 293–294
Y translation, 80f, 81
 crane shots, 88–89
 dolly and tracking shots, 88
 handheld shots, 176–178
yaw. *see* Y rotation

Z

Z rotation (roll), 81, 81f, 89f
 with handheld shots, 89,
 172–180
 with pan and tilt shots, 86–87
 solving for, 144
 trajectory animation,
 293–294

Z translation, 81
 crane shots, 88–89
 dolly and tracking shots,
 88
 handheld shot example,
 176
 bump in Z translation,
 182

 drift in X translation,
 180–182
zoom factor, 72
zoom lenses, 17, 19f
 defined, 91
 depth of field, 20
 distortion from, 23f
zooms, 91